Pioneering Painters | THE GLASGOW BOYS

D1354882

Pioneering Painters | THE GLASGOW BOYS

This catalogue was first published on the occasion of 'Pioneering Painters: The Glasgow Boys 1880–1900', an exhibition from Culture and Sport Glasgow in association with the Royal Academy of Arts.

Kelvingrove Art Gallery and Museum
9 April–27 September 2010

Royal Academy of Arts, London
30 October 2010–23 January 2011

All text and images © Culture and Sport Glasgow (Museums)
unless otherwise acknowledged

ISBN 978 0 902752 92 4

Reprinted 2010 (twice)

All rights reserved. No part of the contents of this book may be reproduced, stored in a retrieval system, or transmitted in any form or by any means electronic, mechanical, photocopying, recording, or otherwise, now known or hereafter discovered, without the written permission of Culture and Sport Glasgow (Museums).

Edited by Susan Pacitti and Fiona MacLeod.

Designed by Fiona MacDonald.

Photography supplied by Glasgow Museums' photographers and Photo Library
www.glasgowmuseums.com/photolibrary

Printed in Scotland by Allander

www.glasgowmuseums.com

Acknowledgements

All efforts have been made to trace copyright holders but if any have been inadvertently omitted, please notify the publishers. The publishers gratefully acknowledge the following for permission to reproduce illustrations:

Aberdeen Art Gallery & Museums Collections: Cat.13, 66*, 80, 105; Annan Photographs, images from www.annanphotographs.co.uk: p.x, pp.122–128; The British Museum, Figs 24–28; Cecil Higgins Art Gallery, Bedford: Cat.107*; Collection Miss Flure Grossart: Cat.90; CJT & KD Kitchen: Cat.36; Duncan R Miller Fine Arts, London: Cat.128; Dundee Art Galleries and Museums, Dundee City Council: Cat.12, 103*, Fig.45; The Ellis Campbell Collection: Cat.22; Gallery Oldham: Cat.99; Göteborg Museum of Art, Göteborg Sweden, Fig.6; Government Art Collection (UK): Cat.64*; Falmouth Art Gallery Collection: Cat.6; Fife Council Libraries and Museums: Kirkcaldy Museum & Art Gallery, photograph Antonia Reeve Photography: Cat.96; The Fine Art Society, London: Cat.24; The Fleming-Wyfold Art Foundation: Cat.100*, 130; Frank Brangwyn, Fig.42; Freeman Spogli Collection: Cat.7; Hugh Lane Municipal Gallery of Modern Art, Dublin, Fig.16; Hunterian Museum and Art Gallery, University of Glasgow: Cat.14, 20, 39, 51, 20, 54, 70, 78, 82, 110, 125, 125; Mackelvie Trust Collection, Auckland Art Gallery Toi o Tamaki, Fig.37; The Metropolitan Museum of Art, New York / Art Resource / Scala / Florence, Fig.10; Michael DCC Campbell/The Ellis Campbell Collection: Cat.19; Musée d'Orsay, Paris, Figs 39, 47; Museum of Fine Arts, Ghent © Lukas-Art in Flanders vzw: Cat.31; National Gallery of Ireland: Cat.42*, 67*; National Gallery of Scotland: Cat.11, 15, 28, 34, 35, 57, 85, 89, 95, 101*, Fig.21; National Trust for Scotland: Broughton House: Cat.23, 118, Fig.30; Ny Carlsberg Glyptotek, Copenhagen; photographer Ole Haupt: Cat.1, Fig.7; Paisley Art Institute Collection, held by Paisley Museum, Renfrewshire Council: Cat.122; Paisley Museum, Renfrewshire Council: Cat.40; Private Collections: Cat.4, 5, 7, 16, 17, 21, 22, 23, 25, 29, 32, 33, 36, 37, 38*, 47, 48, 50, 53, 56, 59, 61, 62, 63, 68, 69, 72, 79, 83, 84, 86, 87, 93, 94, 97*, 104*, 107*, 106*, 120, 121, 123, 124, 127, 128, 129, 136, Figs 7, 9, 20, 41, 43, 48; Private Collection, courtesy of The Fine Art Society, London: Cat.45*, 126, Fig.26; Private Collection, courtesy of the Hunterian Museum and Art Gallery, University of Glasgow: Cat.46; Private Collection, courtesy of Karen Reihill Fine Art, Dublin: Cat.92*; Private Collection, courtesy of Pyms Gallery, London: Cat.43*, 44*, 116*; Private Collection, photograph courtesy of Bonhams, Fig.46; Private Collection, photograph courtesy of Sotheby's, Figs 40, 43; Private Collection, photographer Peter Schächli, Zürich: Cat.114*; The Robertson Collection, Orkney: Cat.21, 59, 134, 135; Royal Scottish Academy, Edinburgh, Fig.36; Scottish Gallery, Edinburgh, and Ewan Mundy Fine Art, Glasgow: Cat.132; Scottish National Portrait Gallery: Cat.117; Tate, London 2009: Cat.30, Fig.34; Trustees of the Cecil Higgins Art Gallery, Bedford: Cat.107*; Ulster Museum, Belfast, Figs 8, 14; V&A Images/Victoria and Albert Museum, London: Cat.133, Fig.29; Walker Art Gallery, National Museums Liverpool, Figs 18, 35; Yale Center for British Art: Cat.73, 77, 81, 115*, 141, 138

Images marked * and the following 65, 91, 102, 111, 113 are by courtesy of Felix Rosenstiel's Widow and Son Ltd, London, on behalf of the Estate of Sir John Lavery

Details
p.12: Cat.13; p.26: Cat.51; p.40: Cat.42; p.56: Cat.47; p.76: Cat.63; p.90: Cat.132; p.100: Cat.77

Contents

Preface

In 1888, an International Exhibition was held in Glasgow on the banks of the River Kelvin with profits from it earmarked for the building of a new museum and art gallery to house the City's rapidly growing collections. The centrepiece of that exhibition was a display of paintings, contemporary and historical, in which a group of young local artists played a crucial role. Their developing reputation encouraged the organizers to both include their paintings in the displays and seek their opinion on other exhibits, thus ensuring that the exhibition reflected the best of contemporary work from Scotland, England and Europe. They even produced a group of decorative murals for the main building of the exhibition. In all, the Glasgow International Exhibition of 1888 was a great success, providing the initial funding for the splendid building that opened on the same site in 1901 and is now universally known simply as Kelvingrove.

Those same artists went on to create international reputations in the arts, both for themselves and for the city with which they will always be associated. The city took them to its heart, heeding their encouragement to buy the first painting by James McNeill Whistler to enter a public collection anywhere in the world, ahead of Paris, London, New York and elsewhere. And it was to the Boys that the city turned for the mural paintings that adorned the banqueting hall of its new City Chambers.

In the decades that followed 1888, the reputations of the Glasgow Boys rose and fell, not unlike the reputation of Glasgow itself. In the last 30 years or so, however, they have been on the ascendant, and there has been a growing demand for an exhibition in the city to commemorate their achievements. And where better to show it than in Kelvingrove?

Liz Cameron
Chair, Culture and Sport Glasgow

Cat.102

vi

Foreword

It's now over 50 years since I first became aware of paintings by the Glasgow Boys. In fact, I probably first saw them, without knowing anything about these artists, when I was taken to 'the Art Galleries' at Kelvingrove as a small boy, over 75 years ago. As I learned more about Scottish painting I began to realize what a huge contribution these 20 or so artists had made, not just to Scottish art, but on an international stage as well.

By the late 1960s this kind of painting was beginning to be reclaimed from museum stores around the country, and in 1968 the Scottish Arts Council assembled the finest collection of their work seen since the turn of the century. It opened many eyes, but for me it confirmed the Boys as my favourite, and most exciting, group of painters. My business took me around Britain as well as Europe, where the Boys had been among the most important British exhibitors in the years before 1914. Their reputations had faded however, and they were little known in the 1960s and 1970s, except perhaps in London where they were frequently celebrated by Andrew McIntosh Patrick, the illustrious Managing Director at The Fine Art Society.

Gradually, as more paintings by the Boys began to appear in dealers' exhibitions and at auction, their reputation grew once more. Now they were always referred to as the Glasgow Boys and their newfound celebrity acted as a splendid advertisement for the city. Few schools of painting are so inextricably linked with a city, certainly not in Britain. Unlike the Scottish Colourists, the works of these talented painters acted as ambassadors for the city wherever they were seen. Along with Charles Rennie Mackintosh and the artists of the Glasgow Style, the Glasgow Boys reinforced the link between Glasgow and culture everywhere they were shown.

It seemed obvious, therefore, that the first major art exhibition organized for the re-modelled Kelvingrove Art Gallery and Museum should be devoted to the Boys. As a member of the Board of Culture and Sport Glasgow I am delighted to have been associated with this exhibition. It brings together loans from many private collections – some whose owners have only recently discovered the Boys, and others who have held their work for generations – and displays them alongside the many key pictures that have entered public collections across Scotland, Britain, the USA and Europe. It builds on the admirable foundations of the 1968 exhibition, and extends it in the light of recent discoveries and research to form the definitive and the most comprehensive exhibition of the Glasgow Boys ever assembled.

This exhibition is the culmination of several years of work by a small group of colleagues centred on Kelvingrove. Many thanks are due to all staff involved and particular thanks are extended to Roger Billcliffe, Patrick Bourne and Kenneth McConkey for their valuable assistance.

At the Royal Academy, MaryAnne Stevens and her team have ensured a smooth transition of the exhibition from Glasgow to London. All of them deserve congratulations on what will be a major contribution to the reputation of the Glasgow Boys and to the commitment of the City of Glasgow to its cultural heritage.

The Rt. Hon. The Lord Macfarlane of Bearsden KT

President's Foreword

The radical group of young Scottish artists who became known as the 'Glasgow Boys' were given their last representative exhibition in London 120 years ago at the Grosvenor Gallery. Thus, when Lord Macfarlane of Bearsden suggested the Royal Academy as the London venue for this new, comprehensive exhibition we agreed with alacrity.

From informal beginnings in around 1880, the Glasgow Boys moved to the forefront of British contemporary art for the next two decades. They took a stand against what they saw as the stylistically unadventurous art being shown at the annual exhibitions of the Royal Scottish Academy in Edinburgh and the Royal Academy of Arts in London. They drew inspiration from such continental exemplars of Realism as the painters of the Barbizon School in France and its counterpart in the Netherlands, the Hague School. They were influenced by the work of Jean-François Millet, the great French painter of peasants, and the French naturalist painter Jules Bastien-Lepage. They championed *plein-air* painting, bold brushwork, a lighter and more intense palette, high horizon lines and directly observed subject-matter drawn from contemporary rural and city life. After their recognition for the first time as a specific artistic movement at the 1885 exhibition of the Glasgow Institute of Fine Arts, their reputation soon spread to London, and subsequently to Munich and other cities in Germany, to Barcelona, Budapest, Brussels and Venice, and in the United States to Chicago, Pittsburgh and New York. Their achievement was also signalled by the Royal Academy shortly after 1900 when, in the wake of its acceptance of the English equivalent of these Scottish radicals – the New English Art Club – the institution elected two Glasgow Boys, George Henry and John Lavery, as Academicians. It is therefore fitting that the work of these pioneering Scottish artists should be presented in London.

The Royal Academy wishes to express its deep gratitude to Lord Macfarlane for all he has done to bring the exhibition into being. We also acknowledge the expert work of the curators, Roger Billcliffe and Patrick Bourne, and Hugh Stevenson and Jean Walsh of Kelvingrove Art Gallery and Museum, which has organized the exhibition and at which it will first be shown.

Many public institutions have lent important works. In addition an exceptionally large number of loans from private collections will bring a significant body of unfamiliar paintings to the public for the first time.

The Royal Academy is most grateful to JTI, our Season Supporter of exhibitions in the Sackler Wing of Galleries. We also sincerely thank Culture and Sport Glasgow for its generous support of the exhibition.

Sir Nicholas Grimshaw CBE
President, Royal Academy of Arts

Supporter's Statement

FirstGroup is delighted to sponsor the *Pioneering Painters: The Glasgow Boys 1880–1900* exhibition. Their work is now recognized as groundbreaking and remarkably skilled, and it is a privilege to be able to show new audiences just how innovative and influential the Glasgow Boys were.

First is now very much a global company, but we will never forget our Scottish roots. We started 21 years ago as a small bus operator in Aberdeen and have grown to become one of the world's largest transport companies. We will always consider ourselves to be a Scottish company and Glasgow, in particular, has played a huge role in our success – First operates the city's largest local bus service and of course our First ScotRail operations are headquartered in the city. Therefore, as a company, we were keen to put something back into Glasgow.

My particular favourite example of the Glasgow Boys' work is William Kennedy's painting of Stirling Railway Station in 1887. I am very nostalgic, as one might expect, when it comes to public transport, and in particular buses and trains. In my opinion, Kennedy's painting sums up an era when the routes of public transport were just beginning to sprout. We should never forget just how pioneering and innovative our predecessors in the transport industry were more than 100 years ago. William Kennedy's canvas has, over the years, been something of an inspiration to me.

Sir Moir Lockhead
Chief Executive of FirstGroup

FirstGroup plc is the leading transport operator in the UK and North America. Based in Aberdeen, it employs more than 130,000 staff worldwide and transports some 2.5 billion passengers every year. **www.firstgroup.com**

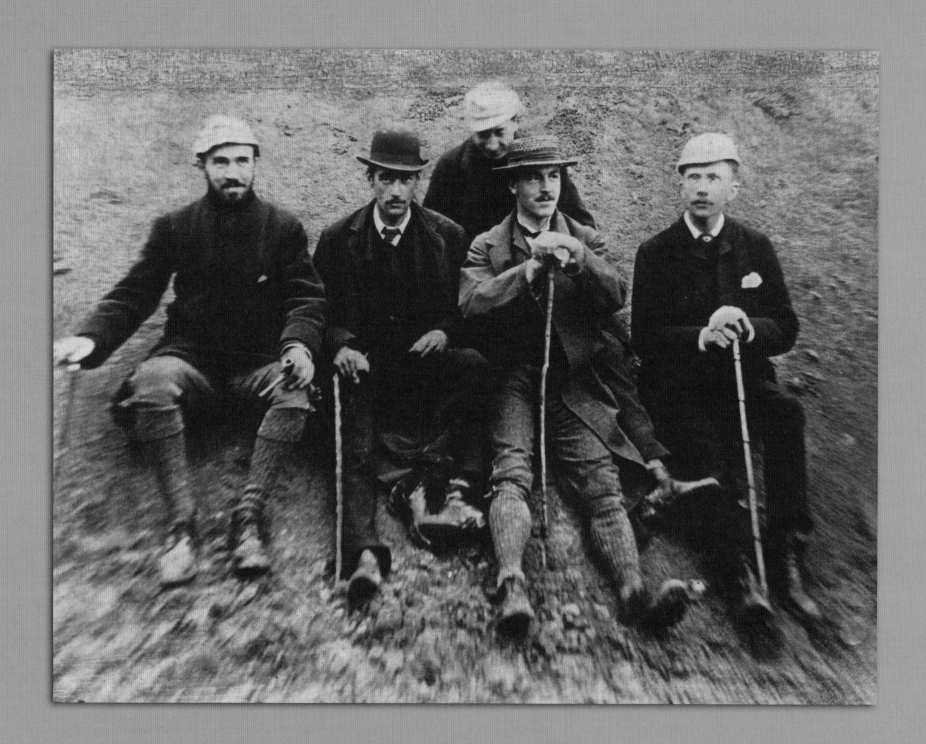

Roger Billcliffe

Who were the Glasgow Boys?

Opposite:
Some of the Glasgow Boys at Cockburnspath in 1883.
In the front row from the left: EA Walton, Joseph Crawhall, James Guthrie and James Whitelaw Hamilton. Behind is Walton's brother George, a Glasgow Style furniture designer.

'They were just the Boys' is how Robert Macaulay Stevenson, one of the last surviving members of the group, dismissed the aggrandizing tendencies of journalists and critics to categorize the young painters who appeared in Glasgow in the 1880s as 'The Glasgow School of Painters'. Writing to Dr Tom Honeyman at Glasgow Art Gallery (now Kelvingrove) in 1941, Stevenson succinctly summarized the intensity of the friendships and artistic activity which flourished in Glasgow in that decade as the result of casual camaraderie among a group of young painters with common aims, ambitions, enemies and supporters. In a typical Glasgow throwaway line, he pricked the balloon of metropolitan London's – and Europe's and America's – feverish attention which enveloped his friends after 1890, at a time when each of them began to go his own way, leaving behind the passionate search for a new style that had brought them together in the first place. But Stevenson's intention was not to belittle their achievements: as one of the chief apologists for the Glasgow Boys he realized the extent of the success of their efforts to drag painting in Scotland out of the narrow, blinkered and old-fashioned routines that had befallen it. What he was emphasizing was that this was a movement whose main virtues were its informality, its refusal – inability, even – to set rules, its disdain of the established, but above all its commitment to the validity and importance of modern painting in

Scotland. For Stevenson, the Boys did not even need the tag 'Glasgow', for it went without saying that such innovation, such dismissal of the accepted mediocrity that dominated art in Scotland in 1880, could only have come out of the Second City of the British Empire.

The movement that burst upon the public at the Glasgow Institute of the Fine Arts exhibition in 1885 had simple and informal beginnings in a group of loose friendships or shared training – James Paterson and William York Macgregor; James Guthrie, Edward Walton, Joseph Crawhall and George Henry; and a group of young men (John Lavery, William Kennedy, Alexander Roche and Thomas Millie Dow) who all enrolled in Parisian ateliers (informal studios where young artists learned from established painters) in the early 1880s and then worked in Grez-sur-Loing. The groups did not interact a great deal, although several of the artists would have met at the St Mungo Society or later at the Pallett Club, both of which offered informal meeting places for young (and not so young) artists denied membership of more established clubs and societies such as the Glasgow Art Club. Outside these groups were artists who passed back and forth, fellow travellers almost, or who enter the story at a later stage in its development – Arthur Melville, Alexander Mann, Edward Hornel, James Nairn, Robert Macaulay Stevenson and David Gauld. They all shared, to a greater or lesser degree, common aspirations and

ambitions; a desire to have their paintings recognized within Scotland as valid and serious; a dislike of the hackneyed and shallow work of established genre, landscape and history painters; a high regard for French plein-air painting (painting outdoors) and the handling of tonal values (the effect of light and shade on colour); and, for most of them, a growing admiration through the early 1880s of the work of a young French artist, Jules Bastien-Lepage (1848–84).

Challenging the Status Quo

Young artists of every generation challenge, to greater or lesser degree, the status quo. The styles, opinions, standing and power of their seniors are there to be questioned; it is only when young painters embrace those that art loses its drive and originality. But this is what happened in Scotland from the mid nineteenth century onwards. Painters were content to plod the same old byways and became protective of their status, reputations and income. For some young men, and it *was* men, frustrated by their inability to break the existing deadlock, the road to London beckoned, where they could establish themselves on their own merits. And for young artists in Glasgow, keen to test the boundaries, there was a double barrier. Not only did they have to breach artistic and intellectual obstacles, they had to contend with the hauteur of the supposedly supreme artistic body in Scotland, the Edinburgh-based Royal Scottish Academy, with its inherent antipathy to any artists not living in the capital, and particularly to those with a Glasgow address. But Glasgow itself was not without its hierarchy. The Glasgow Art Club was keen to protect its established members from the impudence of the young, and barred membership to those who might challenge it. On the other hand, the Glasgow Institute of the Fine Arts, the Academy's

counterpart in the west, operated a more open policy, encouraged by its lay members, primarily collectors. They were much more receptive to the developments in contemporary painting, particularly from France, which were to attract the young men we now call the Glasgow Boys. It was through the activities of such collectors, and some Glasgow art dealers, that the Boys were able to see works by Hague School and Barbizon painters from the late 1870s onwards

With the exception of Macgregor and Mann, who had the support of their families, the Boys all needed to earn a living from their painting. They knew that recognition from the Glasgow Institute, the Glasgow Art Club and the Royal Scottish Academy would be instrumental to their commercial success as artists. In the late 1870s and early 1880s many of these young painters applied in vain for membership of Glasgow Art Club. They were almost all refused, perhaps not surprisingly as some of them were barely in their twenties and almost all of them had openly ridiculed the work of many of the Club's members. They called them 'Gluepots' because of their practice of using megilp (a brown medium made by boiling linseed oil with mastic varnish) to give their work an instant patina of age. (The first of the Boys to gain membership, Lavery in 1881, was very much a novice Gluepot at the time, in subject matter if not technique.) The Royal Scottish Academy remained virtually a closed book to the Boys until the later 1880s, and most of them refused to submit work before Guthrie was made an Associate in 1888. But the Institute offered them a place almost from the beginning of their careers, with Paterson, Macgregor and Walton showing from the mid-1870s, and Guthrie from 1882. Macgregor's studio took the place of the Art Club smoking room, giving the Boys a place to meet and discuss their aims and problems in those years. Glasgow was where they would all meet

up in the autumn and winter, after spending summers in the countryside making sketches that would be worked up in the city for submission to the grand annual exhibitions of the Institute, the Royal Academy in London, the Liverpool Autumn exhibition and so on – but not the 'Edinburgh Academy', as they dismissed the RSA. Only Guthrie and Paterson regularly missed these meetings at Macgregor's; Guthrie because he was either in London or in Helensburgh, where he rented a studio, and Paterson because he spent the winters of 1877–78 to 1881–82 as a student in the Paris ateliers.

To Pastures New

Paterson was thus immersed in French practice at first hand; his friend Macgregor acquired it at the feet of Alphonse Legros, head of the Slade School, London, where he studied after working with Glasgow landscapist, James Docharty. Paterson and Macgregor first met at school and remained friends for life, spending their early summers as artists working alongside each other in Scotland. Another group of friends followed a similar pattern of working together in the summers and retiring to their studios in the winter to complete their exhibition submissions. Guthrie's and Walton's applications to join the Art Club in 1877 were rejected, and they turned to the St Mungo Society for artistic support, where they became firm friends. Walton had studied at Dusseldorf Academy, Germany, in 1876–77, and Guthrie had just persuaded his father to allow him to follow a career as a painter rather than a lawyer. Walton's brother Richard had married Judith Crawhall from Newcastle-upon-Tyne, and the young Teddy Walton soon took up with her brother Joseph, encouraging him to come to Glasgow to meet Guthrie and his other artist friends. Guthrie spent his winters in London working with artist John Pettie, regularly visited by Crawhall and occasionally by Walton, but they would spend their summers together on painting expeditions. These culminated in 1881 in a visit to Brig o'Turk in the Trossachs where they were joined by George Henry, the oldest of the four, who had given up his mundane job in Glasgow to become an artist. Henry, like some of the other Boys, had probably attended classes at the Glasgow School of Art, fitting them in, either in the early morning or late at night, around his paid employment, as Paterson had done when working as a clerk in Glasgow. None of them enjoyed the experience, as it was not until after the arrival of Francis Newbery as headmaster in 1885 that the School acquired any reputation for the quality of its teaching.

John Lavery started his career apprenticed to a photographer, where he no doubt learned the camera's value as an aid to portrait painting, but by 1879 he was working full-time as an artist. He was ambitious, and in November 1881 became the first of the Boys to be accepted into the Art Club, alongside Macgregor – the latter for his earnest landscape paintings, and his friendship with Art Club member James Docharty, and Lavery for his adoption of Gluepot imagery and values in his early work. Lavery also realized that greater things lay outside Glasgow, and he went first to London (bolstered by the insurance money from a fire which destroyed his studio), in 1879, and then to Paris in November 1881. He would have heard from Paterson of the training to be had in the ateliers, and he settled down to a winter of hard study at the Académie Julian. Lavery would have encountered the early plein-air paintings of Guthrie, Macgregor *et al.* in Glasgow and, an accomplished technician, soon mastered the rudimentary teaching at Julian's. He was quick to achieve results, with *Les Deux Pêcheurs* hung

at the Paris Salon in 1883. Lavery was also the only one of the Boys to meet their hero Jules Bastien-Lepage, who advised him to always carry a sketchbook to record his immediate memories of scenes that caught his eye.

Bastien-Lepage was a growing force for these young Glasgow painters. His training at the Ecole des Beaux-Arts, where he was a star pupil, led him to paint the *grandes machines*, large-scale historical paintings needed to make an impact at the Salons and Academies. But his failure to win the Prix de Rome caused him to falter, and he retreated to his home village of Damvillers. There he began to paint its daily life, adjusting his academic manner to accommodate *plein airisme*, filling his canvases with figures of peasants and street urchins. His use of detailed finish on hands and faces, with a broader handling for distance and landscape, heavily reliant on the marks left by a square brush, along with his ability to capture the natural daylight of the countryside, created a new movement, Naturalism, which seized the imaginations of the Boys, both at home in Glasgow and in France. Bastien-Lepage exhibited regularly at the Salon and in Britain, with a small retrospective at the Grosvenor Gallery in 1880 and showing in at least three venues in London in 1882.

In Paris Lavery met William Kennedy, who had spent his winters there since 1880, studying in the ateliers and returning to Scotland for the summer, a practice Lavery was to follow until 1883. That year, with Kennedy, Alexander Roche and Thomas Millie Dow, whom he had also met in Paris, Lavery decided to spend the summer at Grez-sur-Loing, a village not far from Paris. His three companions may have been there before him, but Lavery was to make it his Damvillers, just as Guthrie was doing with Cockburnspath back in Scotland.

By 1883 the Boys were already on the course that would end at the Glasgow Institute Annual Exhibition in February 1885. They had spent five peripatetic years searching Scotland, England and France for the kind of painting grounds that would enable them to settle to develop the ideas they had been working on. Guthrie, Walton, Crawhall and Henry chose Cockburnspath in Berwickshire; Lavery, Roche, Kennedy and Dow found Grez, a village visited by Melville in 1879–80, who was now visiting Guthrie in Cockburnspath. Over the next few years they would produce the paintings that startled and impressed at the Institute in 1885, paintings that convinced Lavery and the other Grez artists that their future lay in Scotland, not France. The scene was set for another five years of intense activity, with changes of emphasis, leadership and style leading to the mature phase of the Boys' development, culminating in their exhibition in London at the Grosvenor Gallery in 1890. There they were transformed from 'The Glasgow Boys' to 'The Glasgow School of Painting'.

Roger Billcliffe
Roger Billcliffe Gallery

Mark O'Neill

Economy and Society in Nineteenth-century Glasgow

The 1851 census revealed that Britain had become the first country in the world in which more than half the population lived in cities. But it did not, however, reveal something equally remarkable – the attachment people felt to these new or expanding cities. Glasgow was part of this, and its people acquired their own strong sense of identity, their own fierce pride in their entrepreneurship, energy and resilience. Glaswegians believed that their city was unusual, special, in the achievements of its industries, in its civic institutions, in its artistic creativity – and in the extremity of its poverty. Of course all cities are different. To understand the place of the Glasgow Boys in history the question we need to answer is whether Glasgow was merely a 'normal' variation, or genuinely exceptional in its economic, civic and artistic life.

The Economy

Glasgow's achievements as 'the Workshop of the World' and the Second City of the British Empire are well known. By 1900, Glasgow and the west of Scotland were producing half of the UK's shipping and a quarter of the world's locomotives, as well as bridges, and machine tools of every kind. Glasgow was not only a centre of production, but also of critical technical innovations, from James Watt's modification of the steam engine to Neilson's invention, the hot blast method of smelting iron. While the fame of Glasgow's heavy industry is

understandable, it has obscured the myriad other industries and services necessary to meet the daily requirements of over a million people. Clothing, food processing, brewing, distilling, shoemaking, and every kind and scale of shop all provided opportunities for employers and entrepreneurs. The most successful of these moved from local to global markets and became household names. There was a good chance that any of the Queen Empress's subjects sailing to an outpost of her empire did so on a Clyde-built ship, and when they reached their destination, travelled inland on a Glasgow-built locomotive. But it was also likely that the Bible they read was printed by Blackie and Son Ltd or Collins, and the tea they drank packaged by Lipton. In addition to the manufacturing and trading economy, the professions, in finance and, increasingly towards the end of the century, public administration, provided opportunities for the educated and well-to-do. This is

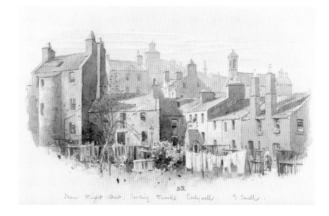

Fig.1
From Wright Street looking towards Ladywell, 1885, David Small, Glasgow Museums Resource Centre

not to underestimate the economic importance of the heavy industry sector, which was the main driver of the city's economy.

All these businesses needed labour, and provided an incentive for hundreds of thousands of migrants. While many made good lives and some great fortunes, substantial proportions – about a third – of incomers (and their descendants) were crowded into horrific and unhealthy slums. Poverty, disease (including cholera outbreaks in 1832, 1848 and 1854), crime and violence were rife. Life expectancy did not return to its 1820 level of 42.27 years for men and 45.24 years for women until the 1890s (Fraser and Maver, 1996, p.352). Other industrial cities, such as Manchester, Liverpool and Birmingham faced similar issues, but they were more intense in Glasgow, which, in the 1830s, was the fastest growing city in Europe.

The Civic Gospel

As a result of the 1833 Burgh Reform Act, which introduced elections for town councillors, the first elected Town Council took on responsibility for managing the burgeoning city. The electorate was limited by property qualification to a fraction of the male population (women were allowed to vote in civic elections in 1882). By the middle of the century, from a mixture of religious principle, fear of anarchy and disease, and a belief in action, there was a consensus amongst Glasgow's elite that something had to be done about the city's appalling conditions. This led to an apparent contradiction, with industrialists who believed in laissez-faire building a huge array of publicly funded and managed facilities. The Corporation provided clean water from Loch Katrine in the Trossachs, built a vast sewerage scheme, installed street lighting, took over 'natural monopolies' such as trams, gas electricity and built civic amenities such as libraries, parks, museums and hospitals. Even before UK housing legislation was passed, Glasgow secured a private Act of Parliament to establish the Glasgow Improvement Trust to tackle the problem of slums. Laissez-faire, business, philanthropy and 'municipal socialism' were not seen to be in conflict, not least because the men who managed them all belonged to the same class, social organizations and religion (despite tensions after the Great Disruption of 1843, Presbyterianism was a uniting factor). The contradictions inherent in the idea of 'managed capitalism' were pointed out by a commentator at the time:

'The practical man, oblivious or contemptuous of any theory of the social organism or general principles of social organization, has been forced, by the necessities of the time, into an ever-deepening collectivist channel. Socialism, of course, he still rejects and despises. The individualist town councillor will walk along the municipal pavement, lit by municipal gas, and cleansed by municipal brooms with municipal water, and seeing, by the municipal clock in the municipal market, that he is too early to meet his children coming from the municipal school, hard by the county lunatic asylum and municipal hospital, will use the national telegraph system to tell them not to walk through the municipal park, but to come by the municipal tramway, to meet him in the municipal reading-room, by the municipal art gallery, museum, and library, where he intends to consult some of the national publications in order to prepare his next speech in the municipal town hall, in favour of the nationalisation of canals and the increase of Government control over the railway system. "Socialism, Sir", he will say, "don't waste the time of a practical man by your fantastic absurdities. Self-help, Sir, individual self-help, that's what's made our city what it is."'

(Webb, 1890, pp.116–7)

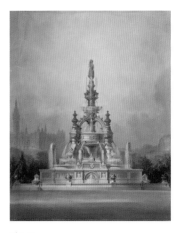

Fig.2
Preparatory drawing of Stewart Memorial Fountain, c.1871, Glasgow Museums Resource Centre

Though this creed has been known as the Civic Gospel and as 'municipal socialism', it could equally well be described as 'municipal capitalism.' Many of the city's services were enterprises designed to make money and reduce the rates to pay for services that the paternalistic Town Council decided were necessary.

Glasgow Exceptionalism?

Looking over these developments, the single most striking characteristic of capitalist, urban and municipal development in Glasgow is their intensity. The first stage of capitalism – what Fulcher (2004) calls the 'anarchic' phase (c.1760–1850) was characterized by 'a high rate of industrial investment ... a paucity of social investment [and] a total indifference to social costs' (Briggs, 1968). In this stage Glasgow industrialized and expanded faster than anywhere else in Europe. In the second stage – what Fulcher calls 'managed capitalism' – Glasgow again followed the general pattern earlier and more intensively than elsewhere. Birmingham under Chamberlain 'in the late 1860s and 1870s... was a "Mecca" of local government...[but] in the earlier period it was behind ... Liverpool and Glasgow in many fields' (ibid.). When the city of Houston, Texas, commissioned a study of European cities to research the best-managed cities, Glasgow was the only UK city outside London reported on, portraying it as the model of civic government (Putnam, 1913).

While elements of this unusual intensity are hard to explain – were Glaswegian businessmen and politicians more driven than those elsewhere? – some contributory factors can be identified. Geography played its part. Proximity to rural areas suffering massive and rapid depopulation (Highland and Lowland Scotland, famine-ridden Ireland), to large deposits of iron and coal and, in sailing terms, to America, all helped create the vortex. The Scottish feudal system of landownership meant that land and rents were expensive, creating an incentive to build upwards and to concentrate population and businesses. Thus many of the wealthy lived in (luxurious) multi-occupancy tenements, while slum landlords exacerbated the overcrowding by subdividing big rooms and in-filling backcourts. Glasgow's specialization in exporting capital goods (ships, locomotives and machine tools) rather than consumer products meant that it was more exposed than most cities to the rises and falls in the global business cycle. (Capital goods tend not to be replaced in a recession.) This created an unusual degree of economic volatility, perhaps the final ingredient in Glasgow's intense urban culture.

The civic gospel that emerged in Glasgow seems to have been even more intense than in English comparators. Like its English counterparts, Glasgow looked for inspiration to classical and renaissance models of civic government – expressed in the use of all three classical orders and the sheer opulence of the City Chambers, which opened in 1888. But unlike its English counterparts, the city also looked to the ideal of 'the godly, regulated, seventeenth-century Scottish burgh, with a controlled and orderly people' (Fraser and Maver, 1996, p.433). And, again unlike Birmingham and Manchester, Glasgow had an older tradition of urban management to draw on, with a number of major institutions founded before 1700, such as the University, the Faculty of Procurators, the Trades' House and the Merchants' House which generated cohesive leadership and concerted action. This had led to the Magistrates and Town Council as early as 1760 endeavouring to make the River Clyde navigable up to the city centre. These historical factors made Glasgow industrialists and politicians even more willing to take on managing the

city. By 1900, the Corporation not only ran the trams, provided electricity and gas and a myriad other services, but was also the largest landowner in the city.

Identity and Culture

As the new middle class, and an elite of super rich, emerged across Europe and America, with them came a market for luxury goods – carriages, yachts, mansions with extravagant interiors and fine and decorative arts objects of all kinds – along with the artisans, artists and art schools required to supply them. Equally widespread were some elements of bourgeois taste: 'engravings of work-worn peasants praying, illicit lovers smitten with pangs of conscience, alcoholics and adulterers suitably punished remained favourites among nineteenth-century consumers across Europe' (Gay, 1998, p.107). Art critics came along to educate their taste and art clubs to enable them to buy (the Glasgow Art Club was started in 1867). At the time when the Glasgow Boys began to emerge there was a rebellion against the clichés of genre and academic painting, especially amongst those who wanted to be 'modern'. 'From the 1880s, collectors and consumers of high culture put academic Victorianism under pressure everywhere, in the drama, the novel, music and architecture as much

as in painting and sculpture' (ibid.p.163). This was, in most cases a rebellion about artistic style by a new generation – art remained a middle-class product for a middle-class market. Thus the culture of art collecting which developed in Glasgow was not unique, but it did have distinguishing features and rise occasionally to international distinction. Within this framework it is possible to speculate on why the Glasgow Boys would have appealed to the Glasgow art-buying public.

The taste of Glasgow purchasers and collectors seems to have been shaped by a number of factors, not least by the art dealers who set up to serve the new market. The most notable of these was Alexander Reid, immortalized in the portrait by Vincent van Gogh (now in Kelvingrove Art Gallery and Museum), with whose brother Theo he had learned his trade in Paris and come into contact with the latest artistic trends. While Archibald McLellan's collection could be said to emulate (extremely successfully) the taste of aristocratic collectors for Old Masters, the late Victorian middle classes found themselves much closer in spirit to their European contemporaries, who were interested in work which said something about their lives. Modern work was also simply more available, in the sense of not being limited in number like Old Masters and more affordable, so that even those of relatively modest fortune could own works of quality.

The dense, compact nature of Glasgow meant not only that the countryside was nearby, but that it provided a desirable relief from the pressures of the city. The railways provided easy access to the Ayrshire coast and to Loch Lomond and the Highlands. Many wealthy Glaswegians had second houses to which their families moved in the summer, and some built full-blown aristocratic mansions in the Borders with their newfound wealth. The countryside became both a site

Above Left:
Fig.3
West Lodge, Pollokshields, c.1889, Glasgow Museums Resource Centre

of leisure and a symbol of a more authentic, lost, past – a tough life assuredly, in which women and children worked hard, but somehow less corrupted than the life of the city. The middle classes were not only aware of the desperate situation of the poor (and the damage it did to their city's reputation); they had financial worries of their own. Except for the very rich, the threats of illness, unemployment and the slumps of the business cycle could push people into poverty, as could financial 'disasters like "the spectacular failures" of the Western Bank in 1857 and the City of Glasgow Bank in 1878' (Fraser and Maver, op.cit. p.231, 294). These were compounded by the status anxieties of 'conspicuous consumption'. An art which was both romantic and realistic, humane but politically unchallenging provided reassurance without admitting anxiety. The wealthy could invest in high-value works of art which depicted the austere values of the rural poor, helping them to avoid thinking about the urban masses.

At the same time cultural (not political) nationalism led many collectors to promote the work of local artists. In England these tendencies led to support for the Pre-Raphaelites, and ultimately to the development of the Tate as a gallery of British (in practice, English) and modern art.[1] In the west of Scotland they meant support for the Glasgow Boys.[2] The Hague School was preferable in almost every cultural register to the allegorical fancies and the sheer Englishness of the Pre-Raphaelites – and pre-Raphaelite also mean pre-Reformation, making them unappealingly Catholic to the Presbyterian elite in Glasgow. A far more important factor than nationalism, however, was civic pride. Again this was a common feature across the urbanizing west, but Glasgow's citizens' identification with their city was second to none. This is probably best revealed by the contrasting bequests of Liverpool's and Glasgow's

greatest art collectors. Sir Henry Tate, a Liverpool merchant, saw London as the appropriate home for his collection, as the place where his social status and a form of immortality would be secured. Sir William Burrell (after considering London venues) chose his own city. Once the Glasgow Boys added the cachet of national and international recognition to the allure of being modern, they became a vehicle for articulating a Glaswegian/ Scottish identity without any political complications.

Art collecting was a largely male activity (especially at the high end, where large sums were involved). It provided a leisure interest, or passion, and a subject of conversation and competition with others, who would be met at a wide range of societies, clubs and organizations. These exclusively male organizations all had more or less elaborate rituals, which included processions involving wearing regalia and, above all, the public dinner. Perhaps it is therefore noteworthy – another aspect of the intensity – that the name of Glasgow's first home-grown school of artists includes a reference to their gender – as if, even by Victorian standards, Glasgow was an exceptionally male-dominated city. In the 1909 edition of *Who's Who in Glasgow*, only five of the c.500 entries were women (Gordon and Nair, 2009). However, women were fighting their way through – one of these five women was Miss Cranston, successful restaurant entrepreneur and Glasgow's first significant female art patron.[3] Less than a generation after the Glasgow Boys, another artistic movement emerged.[4] The Glasgow Style, created by Charles Rennie Mackintosh, Margaret MacDonald, Herbert McNair and Frances MacDonald, was, apart from Impressionism, the first modern artistic movement in which women played a leading role. All of these artists reflected the influence of another major Glasgow institution – the Glasgow School of Art (GSA). It was

founded in 1845, primarily to support the decorative and applied arts, providing training not just for fine artists, but for all the craft and design skills required to decorate and furnish the interiors of houses and luxury ships and to manufacture everything from ceramics to carpets for global export. The School of Art's Board included members of the commercial and industrial elite, such as Sir John Richmond (1869–1963). As well as being senior deputy chairman of pump manufacturers G&J Weir, Richmond was chairman of the GSA and donated his fine collection of French and Scottish paintings to the National Gallery and to Glasgow Museums.[5]

The cultures of art and of municipal provision reached their climax in two institutions. The City Chambers not only celebrated the Town Council's civic pride and confidence, but its commitment to art, through the murals commissioned from the Glasgow Boys. The contribution of John Lavery is unusual in representing industrial Glasgow, rather than a rural scene – its presence in the banqueting hall, where the City showed hospitality to important visitors, showed that, while they may have preferred images of the countryside for their domestic pictures, this did not infer lack of pride in the source of their wealth. The year 1888 also saw Glasgow's first great industrial exhibition, the profit from which was put towards the costs of creating a new museum and art gallery in Kelvingrove Park. When this opened in 1901 it was successfully presented as a facility for all the people, not just the educated elite. To this day Kelvingrove Art Gallery and Museum has the widest social range of visitors of any of Britain's large museums. Along with the People's Palace, which had opened in 1898 in the city's industrial east end, the opening of Kelvingrove also reflected another aspect of Glasgow's exceptional commitment to art for the public. Since that time, Glasgow's civic authority

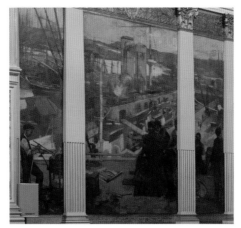

Fig.4 *Shipbuilding on the Clyde*, 1889–1901, John Lavery, Banqueting Hall, Glasgow City Chambers

Fig.5 Princess Louise, Duchess of Fife, at the opening of Kelvingrove, 1901

has spent more on running its museums than any other municipality in Britain.

When English novelist and journalist Israel Zangwill reported in 1896 on his visit to Glasgow, he was impressed by its commitment to art. He saw this at least in part as an escape – 'Like the kings daughter, Glasgow is all glorious within and its inner artistic aspirations make up for and are perhaps inspired by its outer unloveliness.' Perhaps the reality of the city was too overwhelming to be embraced by painting – not just the horror of the slums, but what Zangwill called the 'commercial dinginess' of the city centre, even its newer buildings blackened with soot, and the atmosphere opaque from 'a choking yellow fog'. Only outsiders like Whistler or Monet could see beauty in the smog. It wasn't until the next generation of artists that urban artistic languages were developed. The Glasgow Style still focused on interiors, bringing in an abstracted nature, while Muirhead Bone looked at the modern city, for the first time, in the spirit of both documenting and celebrating its complexity. Only with the New Glasgow

Boys of the 1980s did an urban art which reflected the harsher realities of city life emerge.

In an article discussing whether capitalism is inimical to the arts, Bernard Porter quotes the Scottish businessman and travel writer Samuel Lang:

'The lisping amateur hopping about the saloons of the great, may prattle of taste, and refined feeling in music, sculpture, painting, as humanizing influences in society...; but the plain, undeniable, knock-me-down truth is, that the Glasgow manufacturer, whose printed cotton handkerchiefs the traveller Lander found adorning the woolly heads of negresses far in the interior of Africa,...has done more for civilisation, has extended humanising influences more widely, than all the painters, sculptors, architects, and musicians of our age put together. ' (Porter, 1991)

In a response (to Laing as much as to Porter), JA Smiechen quotes Glasgow as a key counter-example – it was both 'the capitalist city par excellence' where 'the rising bourgeois industrialists defined themselves through a new artistic environment' and exemplary in its support of the arts, to the degree that it is the only city to have a chapter to itself in the *Cambridge Guide to the Arts in Britain: The Later Victorian Period* (Smiechen, 1991). The social, economic and cultural realities behind this reflected British and European trends with an unusual intensity, an intensity which may go some way to explaining why late Victorian Glasgow generated not one, but two artistic movements which bear its name – a unique achievement.

REFERENCES

Bold, V (2001). *Smeddum: A Lewis Grassic Gibbon Anthology*. Edinburgh, Canongate Books.
Briggs, A (1968). *Victorian Cities*. London, Penguin.
Eyre-Todd, G (1909). *Who's Who in Glasgow* 1909. Glasgow, Gowans & Gray.
Ford, B (1989). *Cambridge Guide to the Arts in Britain: The Later Victorian Period*. Cambridge, Cambridge University Press.
Fraser, WH and Maver, I (Eds) (1996). *Glasgow Vol II: 1830 to 1912*. Manchester, Manchester University Press.
Gordon, E and Nair, G (2009). 'The economic role of middle class women in Victorian Glasgow'. *Women's History Review*, 9:4, pp.791–814.
Fulcher, J (2004). *Capitalism*, Oxford, Oxford University Press.
Gay, P (1998). *Pleasure Wars: The bourgeois experience from Victoria to Freud, V.* London, Fontana.
Porter, B (1991). '"Monstrous Vandalism": Capitalism and philistinism in the works of Samuel Laing (1780–1868)'. *Albion: A Quarterly Journal Concerned with British Studies*. 23:2, pp.253–268.
Putnam, F (1913). City government in Europe. http://www.archive.org/details/citygovernmenti02texgoog, 15/02/2010.
Smiechen, JA (1991). 'Free Market Capitalism: Fundamentally Philistine?'. *Albion: A Quarterly Journal Concerned with British Studies*. 23:2, pp.253–68.
Webb, S (1890). *Socialism in England*. London, Swan Sonnenschein and Co.
Zangwill, I (1896). *Without Prejudice. A collection of articles on various subjects*, out of print.

NOTES

[1] The communist novelist and journalist James Leslie Mitchell, also known as Lewis Grassic Gibbon, author of *A Scots Quair*, looking back on this period from 1934, wrote, 'One of the best loved pictures of an earlier generation of Glasgow intellectuals was Josef Israel's *Frugal Meal* in the Glasgow Galleries. Even yet the modern will halt you to admire the chiaroscuro, the fine shades and attitudes. But you realise he is a liar. He is merely an inhibited little sadist, and his concentrated essence of enjoyment is the hunger and dirt and hopelessness of the two figures in question. He calls this a "robust acceptance of life".' (Bold, 2001).
[2] In the East, the Royal Scottish Academy adhered to the academicism for another 20 years.
[3] Three of the others were the wives of lords, noted for their philanthropic works – the one acceptable role for women in the public sphere. The fourth was the first of two women factory inspectors in the UK.
[4] In 1890, the average age of the key 14 Glasgow boys was 44, of the Four, 32.
[5] His name is commemorated in the Richmond Chair of the History of Art in Glasgow University, which is founded from an endowment he created.

Roger Billcliffe

Early Years

In the early 1880s, the Boys generally spent their summers in the country making sketches, watercolours and small finished paintings – increasingly *en plein air* – before returning to the city in the autumn. Macgregor and Paterson favoured Nairn, Aberdeenshire, and St Andrews; Walton and Alexander Mann visited Stonehaven, and Mann also worked in Berkshire and Venice; Macaulay Stevenson visited Luss; Lavery, Roche, Millie Dow and Kennedy went to Paris to undertake more formal study in the ateliers. Over the winter in their studios they would complete paintings based on this work for submission to the large annual exhibitions; in January for the Glasgow Institute, and March/April for the Royal Academy in London (at this date they rarely submitted to the Royal Scottish Academy in Edinburgh).

A clear progression can be seen in Guthrie's work from 1880, and similarly in the work of his friends, and usual painting companions, Crawhall, Walton and, increasingly, Henry. The paintings become more and more focused in subject matter, moving away from the wider vistas they painted at Rosneath in Argyll and in Surrey in 1879 and 1880, and concentrating more and more on simple subjects such as a cottage on a hillside at Brig o'Turk in the Trossachs (Henry), or a cottar's garden (Guthrie). Figures, particularly single figures, seen in a tightly focused landscape 'setting' began to appear in Guthrie's work from 1881, occasionally with undertones of his experiences studying with John Pettie (*The Pedlar*, Private Collection) but increasingly, as in *Paid-Off* (Private Collection), more a record of contemporary life than anecdotal incident. Handling of the painting also changed, with colour gradually becoming secondary to tone and the paint being more robustly applied, with finish sacrificed to honesty, almost brutality, of brushwork.

'Hack the subject out as you would were you using an axe.'

Contemporary critics remarked upon the blackness of several of these paintings, particularly *A Funeral Service in the Highlands* (Cat.9), although Guthrie is known to have finished this painting in a higher key and only darkened it at the suggestion of Walton. Six months after he finished this painting, Guthrie's palette had lightened considerably. Despite the growing influence of Bastien-Lepage, Guthrie did not paint in the so-called 'bright painting' manner of his idol, with its cool tonality and narrow range of colours. Guthrie would have seen several examples of Lepage's work in London in 1882, but at the Glasgow Institute in 1883 he had an opportunity to study at first hand, and for some time, one of his major works, *Le Mendiant* (Cat.1).

Painted in 1880, *Le Mendiant* was given the place of honour in the main gallery and virtually every review of the exhibition paid attention to it. The critics were fairly evenly divided in their attitudes to the painting. Some saw in it a great masterpiece, full of pathos and sensitive observation, finely handled with a dexterity that all artists should aspire to. Others compared it unfavourably to Millet's *Going to Work* (Cat.3), also in the exhibition, finding it lacking in genuine sympathy either for the sturdy beggar it portrayed or the plight of the rural poor in general; its cool tones were thought to be too extreme and the whole composition was criticized for its unnatural arrangement and studio atmosphere. Its price of £1260 also attracted much

comment (it was the most expensive painting in the exhibition), but only the painting's detractors thought it unreasonable. Guthrie's *A Funeral Service in the Highlands* was also in the Institute exhibition and was well received. Its dark tonality was not dissimilar to *Le Mendiant*, which is darker than many of Lepage's rural subjects, but even those seem pale in comparison to the painting that Guthrie was working on during the course of the Institute exhibition, *To Pastures New* (Cat.13). Perhaps its handling of sunlight was influenced by William Stott's *The Bathers, c.*1881–2 (Neue Pinakothek, Munich), also shown at the Institute in 1883.

The 1883 Glasgow Institute exhibition included Macgregor's *The Millpond, Dunottar,* 1882 (Perth Museum and Art Gallery), painted under an even east coast sky and the largest work that Macgregor had painted to date. Like Guthrie, he would have been studying the exhibition carefully. He would undoubtedly have registered Guthrie's advances in *A Funeral Service* but Lepage's painting probably reinforced his decision to work on an urban subject for *The Vegetable Stall* (Cat.15), a costermonger counting her takings at her stall. Unlike Guthrie's steady progression, where he had first absorbed and then rejected the manner of his mentor Pettie before adopting a plein-air style, Macgregor had worked consistently with his friend James Paterson, painting a series of small landscapes in a slowly developing tonal manner, drawing

on his training under Legros at the Slade. Just as Guthrie's *To Pastures New* marks his first major step forward, Macgregor's painting of the costermonger is an unexpected leap. It confirms Macgregor's own acceptance of his maxim 'Hack the subject out as you would were you using an axe'. Had its creator followed his first instincts and left the painting unchanged (and had the Royal Academy not rejected it in 1884), the course that the Boys were taking might well have been substantially altered.

Cat.1
Le Mendiant, also known as
The Beggar, 1880
Jules Bastien-Lepage
Oil on canvas
199 x 181cm
Ny Carlsberg Glyptotek,
Copenhagen

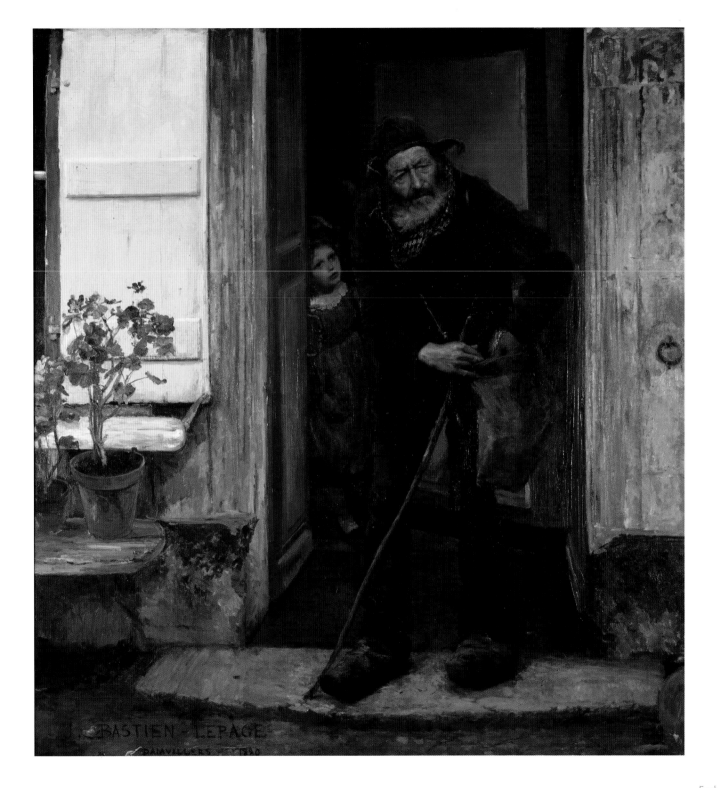

Guthrie, Walton, Crawhall and Henry chose Brig o'Turk in the Trossachs for their painting expedition in 1881. However, the picturesque qualities of the area that had appealed to Horatio McCulloch and Sam Bough, and contemporaries such as James Docharty, were not what attracted these young men. They sought out the unremarkable, the everyday, choosing a corner of a field or an isolated cottage for their subjects. These were painted with bold strokes and an emphasis on 'values' – a balance between tonal relationships and local colour – a manner that was the life-blood of the French atelier system, but one that Guthrie and his friends arrived at through their own experiments.

At the end of their stay a young boy drowned in the river, and Guthrie witnessed his simple funeral in the village. Funerals were an important subject for artists attracted to painting real and contemporary life, particularly in France. But such a subject also appealed to the 'Gluepots', and Guthrie trod a fine line between maintaining appropriate sympathy within his composition and avoiding the mawkish sentimentality of many British painters or the political undertones of Courbet's funeral paintings.

He had little time to complete more than a few drawings and sketches on the spot (primarily of the minister), and the painting was made in a borrowed studio at Helensburgh, using local characters in place of the Highland farmers and labourers. It was completed quickly for such a large painting, the largest work Guthrie had painted to date, and it remained so until the equestrian portrait of George Smith of 1889 (Private Collection). Apparently *A Funeral Service* was completed in quite a high key, but Walton persuaded Guthrie to darken it, giving it a sombre, somewhat Presbyterian feeling in keeping with the subject. For a young man of 22 this work was a considerable achievement. It was boldly painted, obviously with some speed as it was ready to send to the Royal Academy in the spring of 1882. It is not without youthful faults, but Guthrie obviously experienced a confidence in tackling such a complicated composition that eluded him a few years later (and, in fact, for the rest of his life) when he embarked on similarly complex groupings of figures.

It was well received and well-placed at the Academy, and later at the Glasgow Institute in 1883, but by that time Guthrie had moved on and the picture could already be seen as old-fashioned compared with *To Pastures New*, painted exactly one year later.

Cat.9
A Funeral Service in the Highlands, 1881–2
James Guthrie
Oil on canvas
129.5 x 193cm
Kelvingrove Art Gallery and Museum

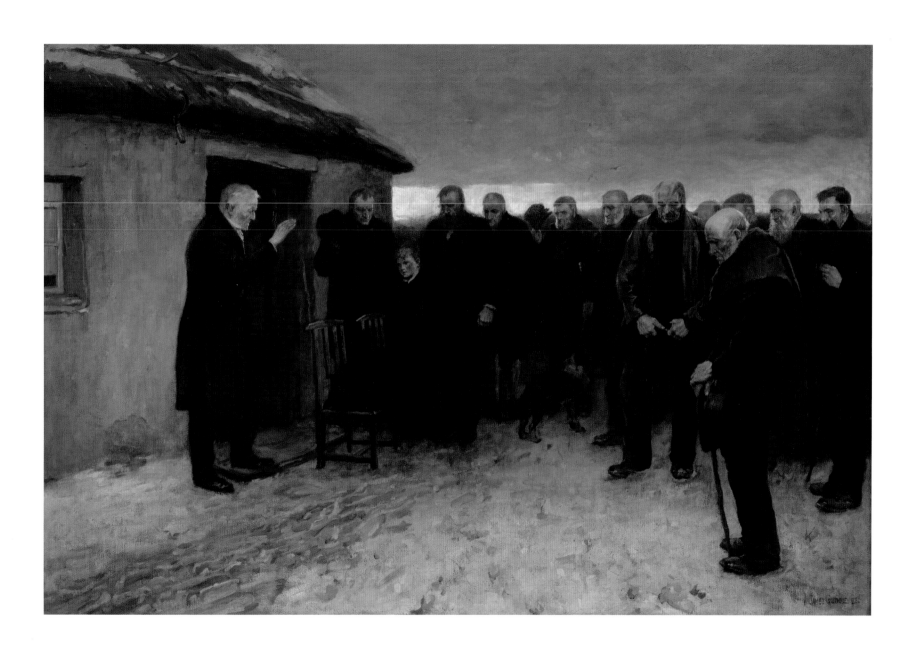

Helen Sowerby was the daughter of JG Sowerby of Hall Garth near Darlington, chairman of Sowerby's Ellison Glassworks, Gateshead. Guthrie appears to have been commissioned to provide two portraits, this of Helen and a second of her brother, John Lawrence Sowerby (Private Collection).[1] The commission, one of the first Guthrie received for such portraits, probably came through Crawhall's father, Joseph Crawhall Snr, who had many such connections in the Newcastle area. Guthrie seems to have visited Newcastle with Crawhall on their way back from Crowland in the autumn of 1882, the most likely date for this otherwise unrecorded painting. Also dating from this period is a vivid sketch in oils showing Crawhall and his sister Judith, who married Walton's oldest brother Richard, sitting at a breakfast table, seen *contre-jour*, with a sunlit garden behind them.

The brighter palette and higher key of the later Crowland paintings is reflected in the portrait of Miss Sowerby. Guthrie also declares his debt to another artist whose work he could have seen in London earlier that year, James McNeill Whistler. There are several elements of the composition which recall Whistler's portraits of the 1870s – the placing of the subject within the canvas, the use of a patterned but undefined backdrop, the silhouette of the girl's head against it. Combined, they illustrate a skill and feeling for portraiture which neither Guthrie nor any other of the Boys had shown previously. There is an assuredness and confidence in the handling of both composition and paint here that sets out Guthrie's intentions for *To Pastures New*.

The portrait of Helen Sowerby's brother (known from a contemporary photograph of the room where they hung), in contrast, shows the influence of John Pettie. The background of the boy's portrait is much more clearly defined, with a staircase behind him, and his pose brings him more directly into contact with the artist and viewer. This painting thus looks backward to Guthrie's artistic past, while the other looks forward to more accomplished things to come.

NOTES

[1] Information from family members via the National Gallery of Scotland.

Cat.11
Miss Helen Sowerby, 1882
James Guthrie
Oil on canvas
161 x 61.2cm
National Gallery of Scotland

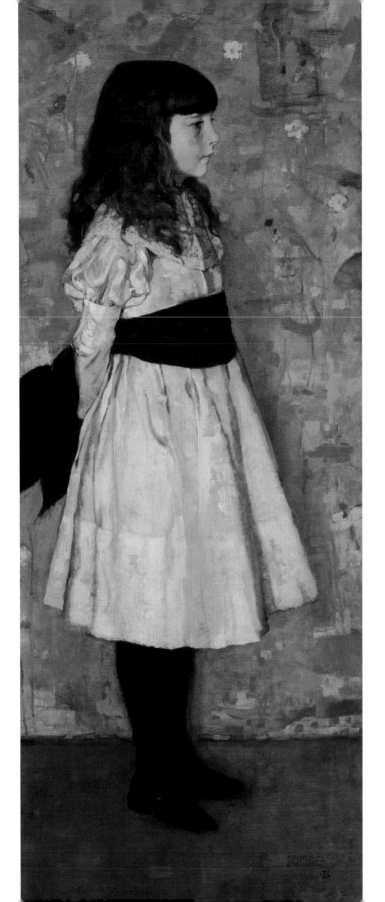

In the summer of 1882, Guthrie, Walton and Crawhall arrived in Crowland in Lincolnshire to spend the summer painting, probably attracted by the steady light of the English eastern counties. Certainly its easy access to London, where Guthrie's *A Funeral Service in the Highlands* was on show at the Royal Academy, would have appealed to them. Also, perhaps unknown to them when they chose Crowland, paintings by Bastien-Lepage were to be on show in three London venues, and a selection of paintings from the Paris Salon would be displayed at The Fine Art Society later that year.

Crowland is a relatively unremarkable Lincolnshire village, distinguished from a dozen others only by the remains of its monastery, destroyed by Cromwell in the 1530s. Crawhall produced studies that were transformed into at least one major oil, *A Lincolnshire Pasture* (Cat.12) but nothing by Walton with a specifically Lincolnshire provenance survives.

Guthrie's first paintings at Crowland, such as *The Wash* (Tate Gallery), retain the darker tonality of *A Funeral Service in the Highlands* but in this, his most important painting of 1882–83, he adopts a much higher key and more colourful palette. The subject matter, a straightforward account of a daily village task, is influenced by Bastien-Lepage, but the low horizon and clear colour are not attributable to the French painter. Perhaps Guthrie had seen William Stott's *The Ferry* (Cat.37) at the Salon when he visited Paris in 1882 or at The Fine Art Society that year, as the strong horizontality owes much to Stott's painting (as does Crawhall's *A Lincolnshire Pasture*).

He adopted Bastien-Lepage's square brush technique, with the foreground painted in some detail and a broader handling for the further distance and the sky. The full sunlight, however, is very different from the cool plein-air tone of the Frenchman's work. The sun is behind the viewer, and the strong shadows thrown diagonally across the composition reinforce a definite impression of movement in the progression across the canvas of the flock of geese and their keeper. In cutting off the left-hand goose by the edge of the canvas Guthrie emphasizes this movement, creating a space outside the picture into which an unknown number of birds have already passed. Similarly, on the right of the canvas we are very aware of the space that the procession has just left.

Guthrie appears to have made a preliminary sketch in Crowland, but the final picture was painted over the winter of 1882–83 in Helensburgh, using his landlady's daughter, one live goose and one stuffed goose as models. It was shown at the Royal Academy in 1883 and first shown publicly in Glasgow at the Institute in 1885.

Cat.13
To Pastures New, 1882–3
James Guthrie
Oil on canvas
92 x 152.3cm
Aberdeen Art Gallery and Museums Collections

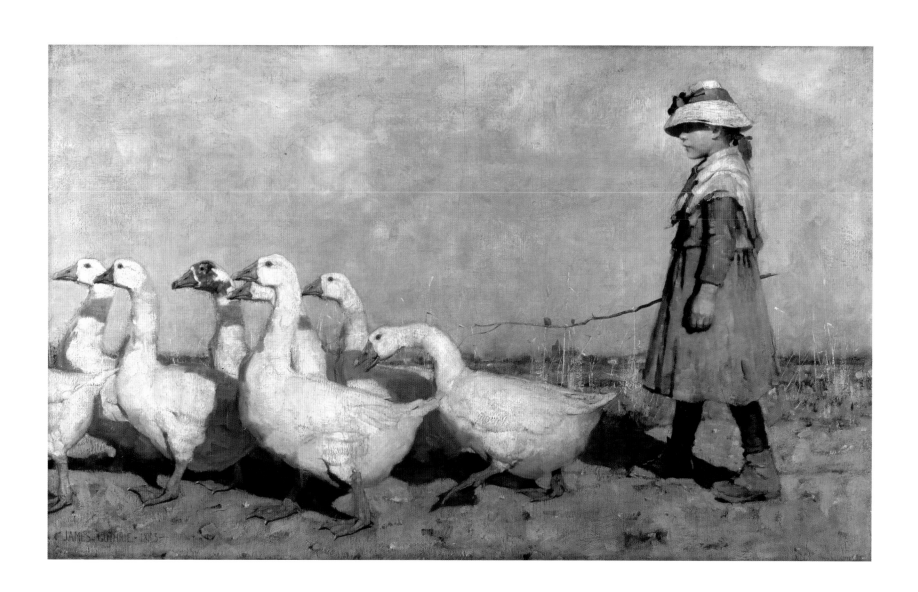

In the spring of 1883, Guthrie and Macgregor were busy putting finishing touches to two large exhibition paintings before setting out on their summer painting expeditions, Guthrie to Cockburnspath and Macgregor to Crail in Fife. Guthrie's *To Pastures New* was hanging in his Helensburgh studio, unseen by any of his Glasgow friends, except perhaps Crawhall and Walton. It was shown in the Royal Academy that summer, and Macgregor either saw it there or as it passed through Glasgow en route to London. We can assume that it had a profound effect on Macgregor, as he chose to withhold from public view his own major painting of that winter, 1882–3, later amending it before sending it to the Royal Academy in 1884, where it was rejected. He never again submitted it for public exhibition.

This painting is now known as *The Vegetable Stall*. While still in the studio in April 1883 it was described in *The Bailie*, a Glasgow social magazine, as a newly finished study of a costermonger counting her takings. As such, this is a major realist painting, one of the first urban subjects painted by the Boys. The figure, however, has been painted out and the painting bears the date 1884, a year after it was said to have been finished. Radiographs of the painting show the concealed figure of the girl, on the right, in the space now occupied by the knife on the table and strings of onions. Her removal transforms the picture from a realist tour-de-force into an unusual and enigmatic still life on an epic scale.

Why did Macgregor choose not to send the painting to the Royal Academy in 1883, as Guthrie did with *To Pastures New*, and why did he then change it? Perhaps it can be explained by artistic rivalry. Until this date Macgregor was seen as the elder statesman among the Boys, with his Slade training, well-appointed studio and generally superior demeanour. But he possibly realized that with *To Pastures New* Guthrie had achieved something at a different level. In particular, he showed a mastery of handling figures that eluded Macgregor, who prior to this painting was primarily a landscape painter. Certainly, in the works that he completed at Crail that summer and autumn, his handling of figures does not match Guthrie's work from Crowland or Cockburnspath.

But despite Macgregor's apparent dissatisfaction with this painting, it remains a milestone in the development of the Boys and their attitude towards modern subjects and the importance of capturing tonal values. In its handling, composition and clarity of vision it remains Macgregor's masterpiece.

Cat.15
The Vegetable Stall, 1882–4
WY Macgregor
Oil on canvas
106.5 x 153cm
National Gallery of Scotland

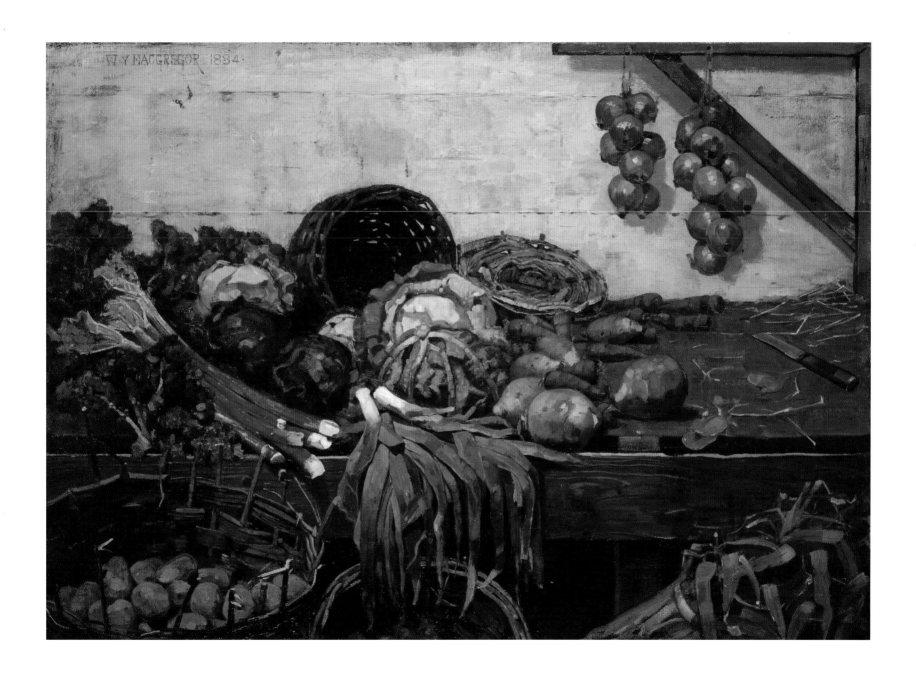

Mann's private means (he was the son of a successful Glasgow warehouseman) allowed him to travel freely – in Scotland, England and in Europe, where he lived for a period in Paris. Although he knew several of the Boys and often worked alongside Walton and Millie Dow, he never formed close allegiances, as Guthrie did with Walton and Crawhall, and Paterson with Macgregor. He was an eclectic artist, absorbing the ideas of naturalism and realism, but also just as aware of the skills of the *Salonniers* in making large paintings for formal exhibitions such as the Royal Academy, Glasgow Institute and the Paris Salon.

Hop-pickers Returning (Cat.14) is a substantial contribution in the development of naturalist painting by the Boys, and certainly the most accomplished of Mann's plein-air paintings of the 1880s. The large central figure owes debts to Millet and Bastien-Lepage, the latter's detailed handling of foregrounds and faces being particularly relevant here. But there is a gentleness about the composition, a hint of incident or anecdote, which subtly distances it from the naturalism of contemporary works by Guthrie, Lavery and Macgregor. We engage with the girl walking home from the fields; she is perhaps a little too clean and fragrant to be a sister to the girl in *A Hind's Daughter* (Cat.28), also painted in 1883, and perhaps more readily identifiable with the middle-class model Guthrie used for the girl in *To Pastures New* when he worked on it in the studio in Helensburgh.

Cat.14
Hop-pickers Returning, 1883
Alexander Mann
Oil on canvas
117.1 x 96.7cm
Hunterian Art Gallery, University of Glasgow

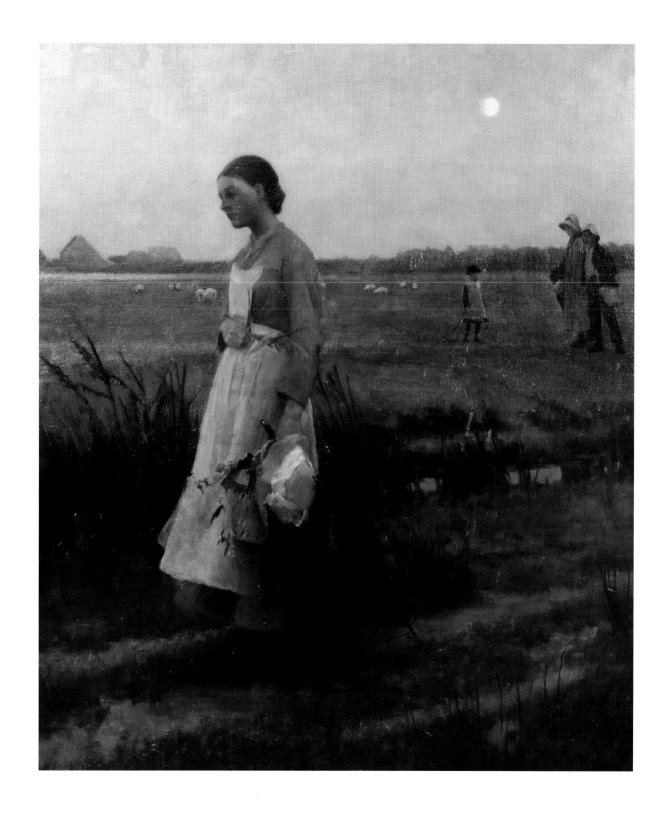

Roger Billcliffe

The Boys in Scotland:
Cockburnspath, Moniaive and Kirkcudbright, 1883–86

In May 1883, Guthrie and Walton set out to find a suitable place for their summer painting expedition. They knew the east coast would suit them best because the light was less changeable, and first looked at Fife before moving to Cockburnspath in Berwickshire, a mile or so from the sea, where Crawhall joined them. Guthrie was looking for somewhere to set down roots for longer than a season; he wanted to follow Bastien-Lepage, who worked primarily in his home village of Damvillers. Guthrie felt that this total immersion in the life of a village would lead to a better understanding of its people, its life, its light and its setting.

At the end of the first summer Walton and Crawhall returned to their studios in the city, but Guthrie remained behind, accompanied by his mother. He settled into the factor's house at nearby Dunglass at the beginning of 1884, which he retained until the end of 1885. He was right that a prolonged stay would be good for his painting, as much of his best work of the 1880s was produced here. However, he underestimated both the social and intellectual isolation of a bleak, rural Berwickshire village in winter, and how he would feel when his friends returned to the city. Arthur Melville, then living in Edinburgh, made welcome visits but Guthrie missed the camaraderie of his friends and the opportunity to share ideas and problems. Several ambitious large paintings planned, and sometimes started, were abandoned, destroyed or cut down as Guthrie succumbed to fear of his inadequacies as a painter of large and complicated compositions. What he does not seem to have realized, or at least accepted, was that his own particular gifts lay in single figure subjects – or at least no more than two or three figures. In 1885 he asked one of his Gardiner cousins in Glasgow for a university calendar as he was determined

'...nearly every cottage had an artist lodger and easels were to be seen pitched...' [1]

to return to academic study. They dissuaded him, or at least postponed the final step, by commissioning a portrait of their father, the Rev. Andrew Gardiner (National Gallery of Scotland).

But at least for the summers of 1883–85 he had the companionship of his friends and regular visits from other Boys – George Henry, Corsan Morton, Whitelaw Hamilton, Melville, Walton, Crawhall and Roche. They all produced excellent work here, particularly Walton and Henry – Walton making a series of superb watercolours, perhaps spurred on by Crawhall, and Henry producing two of the major paintings of his career, *Playmates* (Cat.29) and *Noon* (Cat.33). There are distinct differences, however, between the paintings Guthrie made at Cockburnspath and those of his friends. Guthrie's earliest major work made there, *A Hind's Daughter* (Cat.28), is painted in a sombre light, the light of approaching winter (it was completed in December 1883), while Walton's work, in particular, celebrates the clear sunlight of summer. Guthrie does

not return to the similar full sunlight of *To Pastures New* in any of his Cockburnspath works, although his palette does lighten through *Schoolmates* (Cat.31) and *In the Orchard* (Cat.32).

Almost all of Walton's Cockburnspath works are painted in full sunlight – indeed this light is almost the actual subject of the paintings. *Berwickshire Fieldworkers* (Cat.30), *Autumn Sunshine* (Cat.20), *Noon-day* (Hunterian Museum and Art Gallery) are all bathed in warm sunlight, but this light is seen at its most intense in the watercolours *The Herd Boy* (Cat.35), *Grandfather's Garden* (Cat.21) and *The Duckpond* (Cat.19). In *The Herd Boy,* Walton chose a brightly lit format and delighted in the use of clear and strong colours. This is one of his most powerful watercolours, and we now see him deliberately choosing to produce finished works in this medium, giving it the importance that Melville and, gradually, Crawhall did for their exhibition watercolours. Significant changes in his compositions over the previous two years had led him to experiment with bold, more decorative, arrangements in the placing of his figures; here the boy is on the frontal plane of the picture, recalling the pose of the two children in his Cockburnspath masterpiece *A Daydream* (Cat.34). Walton returns to a more typical naturalist key in *A Gamekeeper's Daughter* or *Phyllis* (Cat.27). He had painted an oil portrait of his mother in 1885, almost a pair to Guthrie's portrait of the Rev. Andrew Gardiner,

and in this watercolour the same seriousness of pose and narrow tonal range is repeated. Walton, like Guthrie, would become a fine portraitist but it would never become the focus of his career.

James Paterson had married in 1884 and settled in Moniaive where, as Guthrie did at Cockburnspath, he set out to record the life of the village in all its moods and seasons. He built a moveable outdoor studio that protected him from the wind and rain and allowed him to continue working *en plein air*. He had regular visits from the Boys, particularly from Macgregor and George Henry, who presumably called at Moniaive on his way to Kirkcudbright.

Henry seems to have met EA Hornel in 1885, who possibly joined him and Guthrie at Cockburnspath. Hornel's family lived in Kirkcudbright, and he invited Henry and Guthrie to join him there later in 1885. Guthrie probably finished *In the Orchard* at Kirkcudbright and certainly worked on a number of canvases there, notably *Old Willie – the Village Worthy* (Cat.49). Henry became firm friends with Hornel, and continued to work with him in Galloway for the next four or five summers, gradually abandoning naturalism in favour of a more personal, 'symbolist', manner which suffused the work of both artists.

A Hind's Daughter

This was the first major work that Guthrie completed at Cockburnspath. It shows a young girl cutting cabbage for a family meal (a 'hind' was a skilled farmworker). Cabbages (kail) were a staple diet of rural workers, and cabbage gardens became a regular feature in the Boys' paintings – they appear in the work of Guthrie, Melville, Henry, Hornel, Macgregor and Spence.

After the full sunlight of *To Pastures New* Guthrie adopted a more muted range of colour and tone here, painting under an overcast sky, and in autumnal weather without a glimpse of the sun, save for the flash of light on the blade of the girl's knife. Bastien-Lepage's influence is apparent in the choice of subject and composition, possibly derived from *Pas Mèche*, 1882 (National Gallery of Scotland) which was exhibited in London in 1882.

The strong verticals (cabbages, the girl's body, background trees) are intersected by a clear horizon, and at that point Guthrie places the head of the girl, the focus of the composition. Although she faces us, her stare is dispassionate, and there is no interaction between sitter and viewer as there is in *Pas Mèche* and *Pauvre Fauvette* (Cat.2). A warmer range of colour replaces Lepage's bright tonality, but the use of a square brush and an aerial perspective reflect his manner. Most of Guthrie's later paintings at Cockburnspath contained more than one figure, but as the compositions became more elaborate his confidence faltered and several paintings were either cut down to single figures or destroyed.

This painting succeeds because of its, for Guthrie, spontaneity. Its surface is not overworked, as in *Schoolmates* (Cat.31), or severely reworked, as *In the Orchard*. But gradually Guthrie came to simplify his compositions, placing emphasis on the figures they contained, rather than the setting. So the carefully painted landscape of *A Hind's Daughter* is replaced by a less detailed setting in *Schoolmates*. The relationship and the tension between foreground figures and their landscape background was possibly the problem, which caused Guthrie to abandon more ambitious figure subjects begun at Cockburnspath, and ultimately to concentrate on single figure portrait painting.

Cat.28
A Hind's Daughter, 1883
James Guthrie
Oil on canvas
91.5 x 76.2cm
National Gallery of Scotland

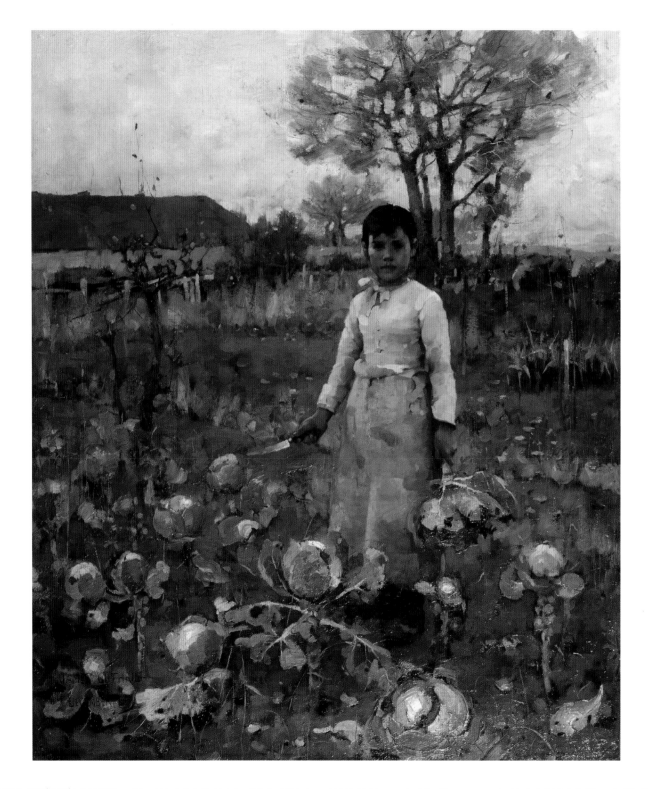

Playmates

Cat.29
Playmates, 1884
George Henry
Oil on canvas
69 x 122cm
Private Collection

Henry began to visit Berwickshire in 1883, probably with James Nairn, as they both exhibited paintings of Eyemouth over the winter of 1883–4. That winter *The Bailie* noted Henry as a 'pupil' of Macgregor in the latter's Glasgow studio, and in the spring recorded them both leaving Glasgow for Dunbar. Henry was soon to join Guthrie in Cockburnspath but we do not know whether Macgregor accompanied him.

Playmates, completed in 1884 and exhibited at the Glasgow Institute in 1885, was Henry's most ambitious painting to date. Children had become a favourite theme for the Boys; Henry would certainly have already seen Guthrie's *A Hind's Daughter* and probably Kennedy's *Mademoiselle Cunégonde* (untraced) when it was exhibited at the Glasgow Institute in 1884. While children play a major part in both these compositions, they are not as straightforwardly presented as the two girls in Henry's painting. The critics noted the similarity to the French 'school' (meaning Bastien-Lepage and his followers), and also commented unfavourably on the serious demeanour of the two sitters, failing to distinguish between the sentimentality of 'Gluepot' paintings of children and the more factual and dispassionate paintings of the Boys.

The design of this painting, with the girls' bodies making distinct shapes against the neutral tones of the ground and the wall behind, presages Henry's fascination with pattern and more decorative elements of painting in his later works. Caw, Guthrie's biographer, also notes such 'decorative' compositions entering Guthrie's work at this time. What he is noticing is an emphasis on the shape and pattern of figures, silhouetting them against their backgrounds to focus attention on them, rather than on their setting. In this, Henry is the most adventurous of Guthrie's followers, as design became more and more important to him. This interest is reflected here in the placing of the potted geraniums between the two girls, creating an almost abstract pattern on the blank wall between them; Bastien-Lepage had used a very similar device in *Le Mendiant*.

The Boys would have seen *Playmates* as a major step forward for Henry, confirmed by its inclusion in a book of reproductions of members' work published by the Glasgow Art Club in 1885, and by its acquisition from the Glasgow Institute that year by WY Macgregor.

Noon

Henry developed his growing interest in compositional design and pattern in this painting. The canvas is divided into quarters by the horizontal line of shadow and the vertical of the tree trunk. Against this relatively featureless rendering of field and sky Henry concentrates our attention on the figure of the girl leaning against a tree, the switch in her hand forms the only diagonal in a composition of horizontal and vertical lines. Her head, although in shade, is placed at eye level and clearly silhouetted against the sunlit field, thus emphasizing it as the centre of attention within the composition. As in Guthrie's *A Hind's Daughter*, this is a simple and dispassionate rendering of everyday life in a rural community, with none of the sentimentality and anecdotage of a contemporary 'Gluepot' painting.

The bright sunlight is similar to that appearing at the same time in Walton's Cockburnspath paintings, rather than the more overcast lighting seen in most of Guthrie's contemporary works. Henry is probably using the same model who appears on the left in *Playmates*, suggesting that the painting was at least begun in Cockburnspath alongside Guthrie, but 1885 is the year that Henry met Hornel and first visited him in Kirkcudbright. Hornel painted *Resting* (Cat.48) that year, almost certainly in Kirkcudbright. Its composition, while less accomplished, owes much to *Noon*, although the handling of the latter in certain areas suggests that it may have been finished, or reworked, while Henry was painting alongside Hornel in Kirkcudbright.

'a simple and dispassionate rendering of everyday life in a rural community...'

Cat.33
***Noon**, 1885*
George Henry
Oil on canvas
51 x 61cm
Private Collection

Schoolmates

Schoolmates develops elements first seen in *To Pastures New* – the movement of figures across the canvas – and *A Hind's Daughter* – a careful balance of colour and tone, moving away from the 'bright painting' of Bastien-Lepage. It also shows the growing importance of design in Guthrie's compositions, with the background muted in detail and tone to emphasize the three-dimensionality of the children. Again, we do not engage with the children, whom we see going about their daily lives as if unobserved.

Guthrie made a number of drawings and oil sketches for this painting. He formally broke away from Bastien-Lepage here, square brush-strokes giving way to a broader, painterly manner, with a more homogeneous surface. Tones are warmer, although there is no direct sunlight. He had intended sending the painting to the 1885 Glasgow Institute exhibition, but was unable to complete it to his satisfaction. Finishing it proved difficult, and the surface of the painting shows repeated efforts to resolve problem areas. Had it been shown at the Institute, when the Boys made such an impact with their exhibits, *Schoolmates* would have confirmed, alongside his *To Pastures New*, Guthrie's leadership of the group. Like Henry's *Playmates,* it was included in the Glasgow Art Club Book of 1885. It remains the most substantial work from Guthrie's Cockburnspath period.

Having missed the Institute, Guthrie submitted the painting to the Royal Academy where it was rejected; Guthrie did not send another painting to the Academy until he was made an Honorary Member in 1911, following his election as President of the Royal Scottish Academy. It was first publicly exhibited at the Glasgow Institute in 1886, and later shown in 1892 at the New Salon, Paris, and in Brussels. Following this, the Museum at Ghent asked to acquire it, and its then owner, TN Whitelaw, Guthrie's brother-in-law, agreed to sell.

Cat.31
Schoolmates, 1884–5
James Guthrie
Oil on canvas
118.2 x 91.6cm
Museum voor Schone Kunsten,
Gent, Belgium

A Daydream

In its subject *A Daydream* owes much to Bastien-Lepage, while its handling, with foreground detail, carefully drawn faces and softer background brushwork, is reminiscent of Lavery's *Under the Cherry Tree,* (Fig.8). The woman with splayed legs in Lepage's *Les Foins*, 1877 (Musée d'Orsay, Paris) is the source for the girl here, but her compositional relationship to the young boy and the landscape in the background is of Walton's own devising. The painting has a spatial complication not encountered before in any of the Boys' work. The girl's legs form one diagonal extending towards the viewer; the body of the boy forms another diagonal, this time receding into the canvas; while behind the couple the movement of the cattle across the horizon introduces a third directional plane. Over all of these elements Walton has applied a grid of vertical trees and strong horizon of water, and against the latter he has silhouetted the girl's head, focusing our attention as Guthrie had done in
A Hind's Daughter.

Walton started work on this canvas, the largest he had ever painted, at Cockburnspath in the summer of 1885. He returned to Glasgow with it, and the painting was finished at Helensburgh in the autumn of 1885; it was hanging in Walton's Glasgow studio in January 1886. Although the painting was finished in time for sending to the Glasgow Institute Walton held it back, supposedly to send to the Royal Scottish Academy or the Grosvenor Gallery in London. It was not shown in Edinburgh in 1886, presumably rejected by a body that had still not come to terms with what was happening in Glasgow, nor did it appear in London that year. Its first public showing was at the Glasgow Institute in 1887, along with Guthrie's *In the Orchard*. Critical reaction to both paintings was generally favourable, although each was considered to be painted on too large a scale for its subject.

Over the next year or so Walton gradually moved away from naturalism towards a style owing more to Whistler than Bastien-Lepage. *A Daydream* remained his most substantial painting in a naturalist manner.

Cat.34
A Daydream, 1885
EA Walton
Oil on canvas
139.7 x 116.8cm
National Gallery of Scotland

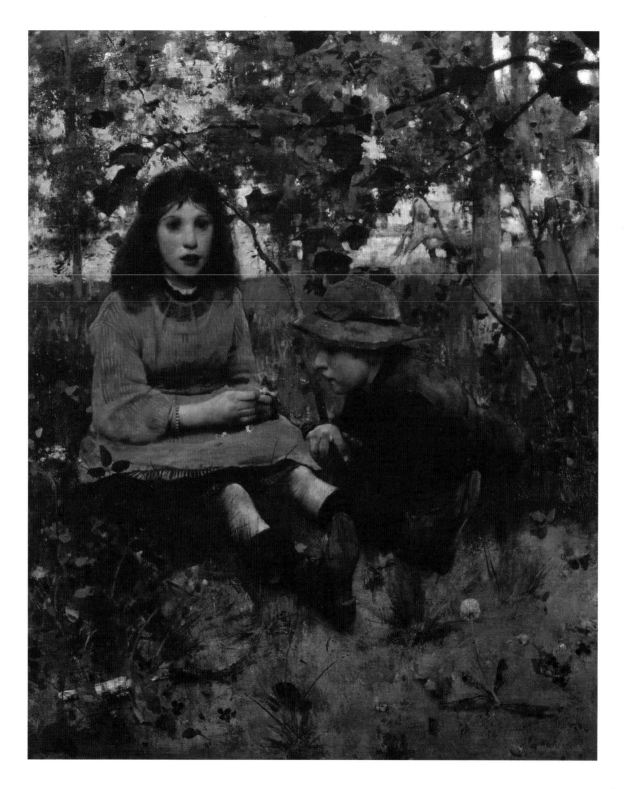

Moniaive

Paterson married in 1884 and settled with Eliza, his wife, in Kilniess Cottage, Moniaive, given as a wedding present by Paterson's parents and later extended by James Burnet to provide a large studio. Paterson was a keen photographer, and took many photographs of the village and surrounding countryside which he almost certainly used as *aides-memoires* while working on some of his larger canvases. These were started on the spot, in the French manner that Paterson had learned in the Paris ateliers in the late 1870s. While painting the Dalwhat Water running through the village Paterson used a moveable studio that he built at the side of the river to protect him from the elements.

Paterson had spent more time studying in Paris than any of the Boys, and he was immersed in the French techniques of capturing tonal values. *Moniaive* shows him at his most literal in their application – this is a painting that would not have been out of place in any French salon. It has the naturalist devices of strong verticals and a high horizon, foreground detail and aerial perspective achieved through varying brushstrokes. It is almost without incident or human presence – the diminutive figure, row of cottages and various fences token references to man's intrusion on the natural landscape.

A photograph in the Paterson archives shows almost the exact view. Paterson may have used it to ensure an accurate rendering of the trees, but the fence which runs horizontally across the painting is his own invention, as the photograph shows an all-too-solid wall, and the row of cottages and hills beyond are lost in the photograph in an impenetrable mist. The painting was illustrated in *The Glasgow Art Club Book* of 1885, which confirms that Paterson made some changes to it after publication. Surprisingly, he does not seem to have exhibited *Moniaive*, even at the Glasgow Institute, despite it being his largest and most important painting to date. Perhaps it was submitted to the Edinburgh and London Academies and rejected, as happened to Guthrie and others at this date.

NOTES

[1] Caw, J (1932). *Sir James Guthrie*. London, Macmillan and Co., p.22.

Cat.51
Moniaive, 1885–6
James Paterson
Oil on canvas
102 x 152.5cm
Hunterian Art Gallery, University of Glasgow

Jean Walsh

Grez-sur-Loing:
A Chronicle of Friendships

'My happiest days in France were passed in the colony outside Paris at Grès–sur–Loigne, an inexpensive and delightful place sheltering not only painters but an occasional writer....'

John Lavery

In the late 1870s and early 1880s, several of the Glasgow Boys spent the summer months painting out-of-doors at the ancient village of Grez-sur-Loing, on the edge of the Fontainebleau forest, about 50 miles southeast of Paris. Melville, Kennedy, Roche, Mann, and Dow, who were amongst the first of the Boys to train in Paris, certainly visited in the early 1880s, and Lavery spent two summers there in 1883 and 1884, and again in 1900. Gauld visited in 1895.[1]

There were several reasons for their attraction to Grez. Since the early 1870s it had been renowned as an artists' colony, not just for painters but also for writers. Indeed, the Boys were well aware of the famous Scottish writer who had visited and written so eloquently about the place – Robert Louis Stevenson recorded his account of this lyrical spot in his *Forest Notes* of 1875–76, a compelling account that even today tempts one to make the journey there.

'And Grez, when we get there, is indeed a place worthy of some praise. It lies out of the forest, a cluster of houses, with an old bridge, an old castle in ruin, and a quaint old church. The inn garden descends in terraces to the river; stable-yard, kailyard, orchard, and a space of lawn, fringed with rushes and embellished with a green arbour. On the opposite bank there is a reach of English-looking plain, set thickly with willows and poplars. And between the two lies the river, clear and deep, and full of reeds and floating lilies.'[2]

However, for the Boys the lure was not just the wealth of motifs that the place offered, but also the opportunity to meet and work with like-minded artists, who were all influenced by the French Naturalist master, Jules Bastien-Lepage. He advocated that for an artist to make his pictures as natural and real as possible he had to live amongst the community he painted, getting to know the local people, their daily routines at work and at leisure, and the surrounding landscape that made up their environment. He achieved this in his own art by immersing himself at the

village of Damvillers. Similarly, the village of Barbizon, home of the Realist painter Jean-François Millet, had provided stimuli for many European artists, but by the 1870s had become overcrowded not just with artists but also with tourists. A group of students, training at the Paris studio of Carolus Duran, were looking for somewhere new to paint, somewhere with a river nearby (which Barbizon lacked), and they were the first to 'discover' the quiet beauty of Grez. Amongst them were Robert ['Bob'] Allan Mowbray Stevenson (1847–1900), cousin of the famous Robert Louis Stevenson, the Irish artist Frank O'Meara (1853–1932), and the Americans John Singer Sargent (1856–1925) and Will Hickock Low (1853–1932).

Several practical considerations made Grez an enticing destination for painting out-of-doors. With the opening of the Bourron–Marlotte–Grez railway in 1860, it was only two hours away from Paris by train. On arrival at the station it was a short carriage journey or a walk of about a mile across the fields to the village itself, where artists could lodge and eat quite inexpensively at one or other of the two hotels there – the Hotel Chevillon or the Hotel Laurent.[3] The village offered picturesque remnants of its earlier significance – a twelfth-century church, the fortified Tour de Ganne, a handsome old stone bridge, the old water mills and communal washing places, but most importantly the River Loing itself. This provided the artists with a place to bathe and relax in the long hot summers, free from all social conventions. As the American artist Will Low recalled,

'The view of a stalwart gentleman clad in a straw hat, bathing trunks and bathing sandals as his only wear, traversing the village streets on his way to the bureau de tabac was not unusual; and at first must have rudely shaken the local ideas of the convenances. …They were largely amphibious, and with a devotion to "exercise"

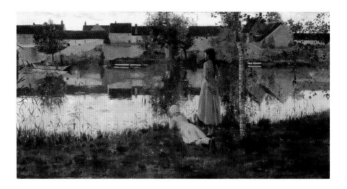

Left:
Cat.37
The Ferry, c.1882
William Stott of Oldham
Oil on canvas
109.2 x 214cm
Private Collection

which worked havoc to the arts, the canoes multiplied, and the river up and down was explored, as I venture to say it had never been since it first took its interrupted course to the sea….'[4]

Of the original group of artists at Grez, only Lavery's fellow Irishman O'Meara stayed on, settling in Grez for the next 11 years. He was joined in the late 1870s and early 1880s by other British and American artists, most notably William Stott of Oldham (1857–1900) [Cat.37] and Birge Harrison (1854–1929), and in 1882 by a large number of Scandinavian artists, including Carl Larsson (1855–1919) [Fig.6]. The Boys' connection to the village during these years can be confirmed by a number of Grez pictures exhibited by Melville at the Glasgow Institute and Royal Scottish Academy in the years 1880–81. These included a watercolour of the *Old Bridge at Grez* (GI 1880, untraced), *Paysanne à Grez* (Cat.5) and *On the Seine* (RSA 1880, untraced), and *Les Laveuses* (*The Washerwomen*) (Cat.36).

By the early 1880s, Grez-inspired subjects were being shown at several important exhibitions. As Robert Louis Stevenson recorded, the old bridge, in particular was, 'beaming on the incurious dilettante from the walls of a hundred exhibitions. I have seen it in the Salon; I have seen it in the Academy; I have seen it in the last French Exposition, excellently done by Bloomer;…Long

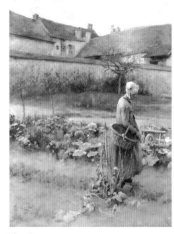

Fig.6
October or *The Pumpkins*, 1882,
Carl Larsson
Watercolour
Göteborg Museum of Art, Göteborg, Sweden

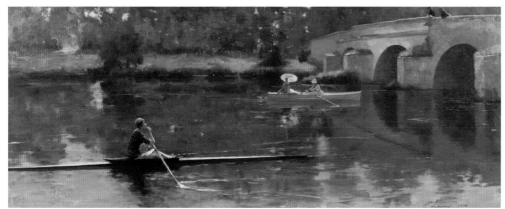

Fig.7 *A Passing Salute: The Bridge at Grez*, 1883, John Lavery, oil on canvas, 76 x 183.5cm, Private Collection

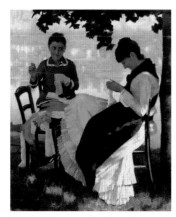

Cat.43 *Sewing in the Shade*, 1884, John Lavery, oil on canvas, 56 x 46.5cm, Private Collection, courtesy of Pyms Gallery, London

Cat.41 *The Hammock – Twilight, Grez-sur-Loing*, 1884, John Lavery, oil on canvas, 48.5 x 63.5cm, Private Collection

suffering bridge! And if you visit Grez tomorrow, you shall find another generation, camped at the bottom of Chevillon's garden under their white umbrellas, and doggedly painting it again.'[5]

The success at the Paris Salons of 1881 and 1882 of artists such as Louis Welden Hawkins (1849–1910), and William Stott of Oldham would not have been lost on the Boys, and no doubt enticed Lavery in particular to visit Grez in pursuit of a 'masterpiece'.[6]

Of all the Boys, Lavery was the one who represented the full range of village activities as it affected both the local people and expatriate painters. At the end of his two periods at Grez in 1883 and 1884 he had produced an impressive volume of work which included two major exhibition pieces, *A Passing Salute: The Bridge at Grez* [Fig.7] and *Under the Cherry Tree,* (Fig.8), and a group of pictures showing the villagers going about their everyday tasks, *La Rentrée des Chêvres,* 1884 (National Gallery of Ireland, Dublin), *La Laveuse,* 1883 (Private Collection), *Return from Market* (Cat.45), *Sewing in the Shade* (Cat.43). He was also one of the few Grez artists to record the relationship between the villagers and their artist guests in such works as *On the Bridge at Grez* (Cat.42), *Study for*

A Pupil of Mine, Grez-Sur-Loing (Cat.114) and *The Principal Street at Gretz* (Cat.116),[7] *On the Road to Fontainebleau,* 1884 (Private Collection) and *A Stranger,* 1884 (Private Collection). There was however, one further ingredient in Lavery's work at Grez that heralded his future ambitions. Pictures such as *A Grey Summer's Day, Grez* (Cat.38), and *The Hammock – Twilight, Grez-sur-Loing* (Cat.41), depicting the people at leisure, were a preparation for the pictures that were to follow on his return to Glasgow.

NOTES

[1] Only a few works by Melville, Kennedy and Gauld have been traced to their months in Grez. Two works by Roche are thought to represent Grez; one Dow (Private Collection) represents the mill at Grez.

[2] Stevenson, RL. *Forest Notes* 1875–6. Chapter 5 from *Essays of Travel,* http://robert-louis-stevenson.classic-literature.co.uk/essays-of-travel/, 15/03/10.

[3] The official names of the two hotels were Hôtel de la Marne (Chevillon) and Hôtel Beau Séjour (Laurent). Chevillon and Laurent were the surnames of their proprietors, and most artists' memoirs refer to them as the Chevillon and the Laurent.

[4] Low, W (1908). *A Chronicle of Friendships* 1873–1900. New York, Scribner's Sons, pp.176–7.

[5] Stevenson, RL (1884). 'Fontainebleau: Village Communities of Painters', in *The Magazine of Art*, pp.340–5.

[6] Hawkins showed *Les Orphelins* at the Paris Salon of 1881 and won a third class medal. The French government later purchased the picture for the collection of the Luxembourg Museum. In 1882 Stott submitted *The Ferry* and *The Bathers*, and was awarded a third class medal.

[7] The name of Grez is written variously as Grèz, Gréz, Grès, Grés, or Gretz in artists' memoirs and on their pictures. According to Grez historian Fernande Sadler (1869–1949), documents give the Latin spelling of the name as Gressium, so her writings refer to the village as Grès, translated into English as Grez.

Paysanne à Grez

From the surviving works painted at Grez by Melville, we see that two main themes seemed to have preoccupied him – the washerwomen or laundresses at the riverbank and single figure peasant subjects. Melville's early training at evening art classes and at the Schools of the Royal Scottish Academy in Edinburgh meant that he would have received lessons in how to capture basic forms and anatomy. Only after his drawing was perfected would he have moved on to the application of colour. And indeed, several of his early exhibition pieces at the Royal Scottish Academy and Royal Academy in London were figure subjects, such as *A Scotch Lassie* (RSA 1875, untraced) and *The Gardener's Daughter* (RSA 1878, untraced) and *A Cabbage Garden* (RA 1878, National Gallery of Scotland).

This interest in figures or rural workers had been fostered in Melville by James Campbell Noble (1846–1913), his tutor at the RSA Schools and a keen admirer of the work of the Hague School artists Anton Mauve (1838–88), Josef Israels (1824–1911) and Jacob Maris (1837–99). Melville could see pictures by these artists first hand at the Glasgow Institute, which had gained a reputation as *the* venue to see works by modern European artists. From 1871 paintings by Israels and Mauve were shown, and the following year pictures by the Barbizon artists Jean-Baptiste Camille Corot (1796–1875), Charles-François Daubigny (1817–78), and Jean-François Millet (1814–75). They were also noted for their pictures portraying the realities of everyday rural life. Both these groups of artists were extremely popular amongst Scottish collectors, the subjects of their pictures possibly reassuring middle-class buyers of their own social progress or a nostalgic reminder of their roots.[1]

In 1878, Melville travelled to Paris to complete his artistic training and enrolled at the Académie Julian. James Paterson was among the first of the Boys to experience the Parisian atelier method of teaching, and his comments were echoed by other artists who took lessons at these independent studios.[2] The studios were:

'often dirty, and even squalid... the almost constant noise and inevitable tobacco smoke frequently disturb the equanimity of youths gently nurtured in the prim proprieties of British Art Schools; but a few months' inoculation generally accustom the most particular to the change, and one gets to like it. Very earnest work is pursued in this dirty, comfortless room, and the latest arrival is soon deeply engrossed in search of les valeurs.'[3]

This training in tonal painting was vital for the development of the Boys' aesthetic. Melville's *A Peasant Girl* (Cat.6) with its Corot-inspired grey, green and brown tonalities is evidence of lessons well learnt. Given Paterson's description of the cramped conditions of Parisian studio life, it is hardly surprising that many art students left the city at weekends or during the summer months to paint out-of-doors. They were following in the footsteps of the artists they most admired – Millet and Corot had painted out-of-doors at Barbizon, and Jules Bastien-Lepage (1848–84) at Damvillers. For Bastien-Lepage, this didn't just mean painting outside, but being part of a community and getting to know the local inhabitants and their daily routines.

At Grez, Melville continued the process of his

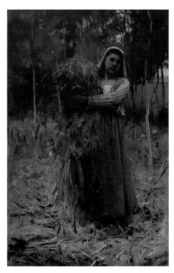

Cat.6
A Peasant Girl, 1880
Arthur Melville
Oil on canvas
96 x 65cm
Falmouth Art Gallery, Cornwall

Opposite:
Cat.5
Paysanne à Grez (*Peasant Girl at Grez*), 1880
Arthur Melville
Oil on canvas
53.3 x 30.4cm
Bourne Fine Art, Edinburgh

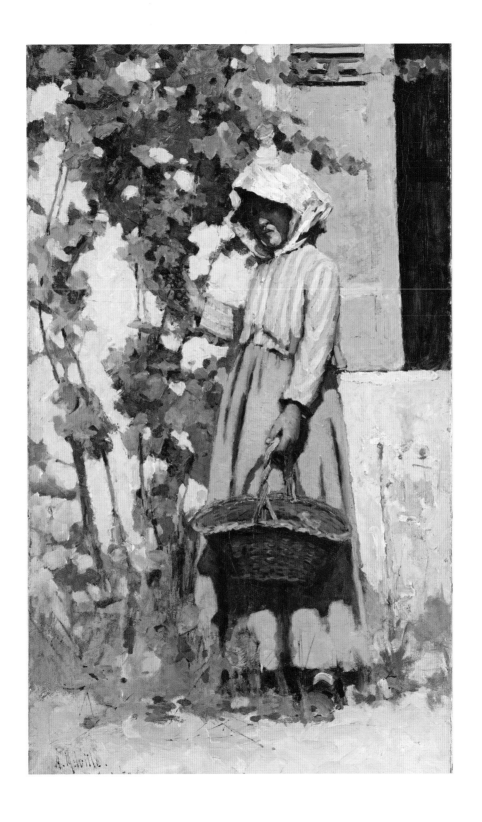

training. Still focusing on rural workers, he captured them at their everyday tasks tending sheep, shelling peas or gardening in their courtyards. He recorded the precise nature of their task and the details of their costume to make his pictures location-specific. Grez also provided him with an opportunity to study the effects of light on his subject. *Paysanne à Grez* brings all these elements together. Frozen in time like a snapshot, he captures the young peasant girl close-up, just on the verge of harvesting a bunch of grapes from a vine. The intense heat of the day is portrayed by the startling whiteness of the walls of the building behind her and the reflections on her traditional headgear that cast the top part of her face into shadow. The vegetation that surrounds her is rendered in bold, broad brushstrokes so that the figure seems very much rooted in the landscape she occupies. Here and there touches of bright red paint add to the liveliness and freshness of the scene. In his pictures of washerwomen at the river, Melville's technique became even freer. Whether using oil or watercolour, large brushstrokes were used to define broad areas of a composition encompassing both people and landscape. This can be seen best in the tiny *Les Laveuses* (*The Washerwomen*) (Cat.36), a gem-like study of the effects of sunlight where the washing huts which lined the river, the laundresses, and the river itself all merge into a delightful syncopation of light and shade. Throughout the rest of his career, Melville was to draw on his experiences at Grez, particularly in his travels to Spain and Morocco, to seek out situations where strong sunlight became the main source of visual drama.

Cat.36, *Les Laveuses (The Washerwomen),* 1880, Arthur Melville, oil on canvas, 11.5 x 44.5cm, Private Collection

NOTES

[1] Collecting pictures by Hague School and French Barbizon artists had reached such an extent in Scotland that as early as 1873 John Forbes White was able to mount an exhibition including pictures by these artists in Aberdeen's Town Hall. By 1878 Glasgow held a loan exhibition in its Corporation Gallery, containing a mixture of Barbizon and Hague School works. Even the small town of Helensburgh in Dunbartonshire in 1882 could put together an exhibition of paintings by Corot, Mauve, Breton, Neuhuys and Gérôme from local collections alongside local artists' work. Fowle, F (2009). *Impressionism in Scotland*. Edinburgh, National Galleries of Scotland, pp.12–3.
[2] The American artist, Henry Ossawa Tanner found the conditions at the Académie Julian appalling, '*Never had I seen or heard such bedlam… I had often seen rooms full of tobacco smoke, but not as here in a room never ventilated – and when I say never, I mean not rarely but never, during the five or six months of cold weather. Never were windows opened. They were nailed fast at the beginning of the cold season. Fifty or sixty men smoking in a such a room for two or three hours would make it so that those in the back rows could hardly see the model.*' Quoted in *Americans in Paris 1860–1900* (2006), London, National Gallery Company Limited, p.33.
[3] Paterson, J (1888). 'The Art Student in Paris'. *Scottish Art Review*, 1: 5, pp.118–120.

Under the Cherry Tree

At first, painters who worked out-of-doors devoted themselves mainly to the execution of fairly moderately sized landscapes. By the 1880s however, they had taken on the challenge of painting *en plein air* large-scale figure subjects. Artists who were at the start of their careers, like Lavery, were usually advised by their tutors and fellow artists not to attempt any ambitious canvases until they had spent at least one season in the country doing nothing but outdoor sketching and smaller scale pictures.

Lavery seems to have followed this advice, spending one Sunday in the summer of 1882 at Nogent-sur-Marne, near Grez, where he painted a small canvas of two fishermen on the banks of the Marne – *Les Deux Pêcheurs* (Private Collection), shown at the Paris Salon of 1883. Much to his surprise, it was hung in a good position, 'on the line', and 'was purchased by Saint-Marceaux, the sculptor, for three hundred francs'.[1] The sale of his picture won the admiration of his fellow students, and may have given him the incentive to develop further his *plein-air* painting.

Lavery recalled that his introduction to the place was through the artist Eugène Vail,

'I came to know Gres-sur-Loing through Eugène Vail. We were both at the atelier Julian and we decided to go there to spend the weekend. I remained there for nine months. It was the first colony of artists to which I went and I was so much seized by the novelty and the beauty of the place and the inhabitants after my hard work in Paris that I renounced Paris and the drawing of the nude and I came to paint landscapes influenced by Bastien-Lepage and Cazin.'[2]

Like Melville, Lavery used his time at Grez to continue his artistic training. Faced with the challenge of quickly capturing the scene in front of him, he drew on the painting lessons he had received in the studio. Lavery carried with him 'pochade'[3] boxes of various sizes for producing small on-the-spot oil sketches, a practice he probably started at Grez and continued to develop on his return to Scotland.[4] He used these sketches for blocking in the key elements of a composition, the broad effects of his arrangement free from any detail, and using a light sable brush, would provide outlines for figures.

Under the Cherry Tree may well have started as a preparatory oil sketch for *Under the Cherry Tree,* [Fig.8], but as McConkey points out, it 'is in itself a very complete statement' and is a much larger picture than normally executed for a preparatory sketch.[5] Lavery returned to the theme of the village washerwomen that had preoccupied him the year before in *La Laveuse,* [Fig.9], but this time there are three figures taking part in a riverside encounter – the laundress who leans against the fence, a girl who sits on the barrow containing the bundle of washing and a passing boatman who stops for an afternoon chat. The setting of the figures in the landscape and their relationship in space to each other are very confidently handled, possibly clearer than in the larger version. The large watering can used to keep the washing damp in the afternoon sun acts as a barrier between us and the figures. We are not allowed to interrupt this gentle, leisurely scene, only to witness it. Each element in the composition is painted with broad soft brushstrokes, almost as if a 'soft-focus' camera lens had been used to

Overleaf:
Cat.44
Under the Cherry Tree, 1884
John Lavery
Oil on canvas
79 x 76cm
Private Collection, courtesy of
Pyms Gallery, London

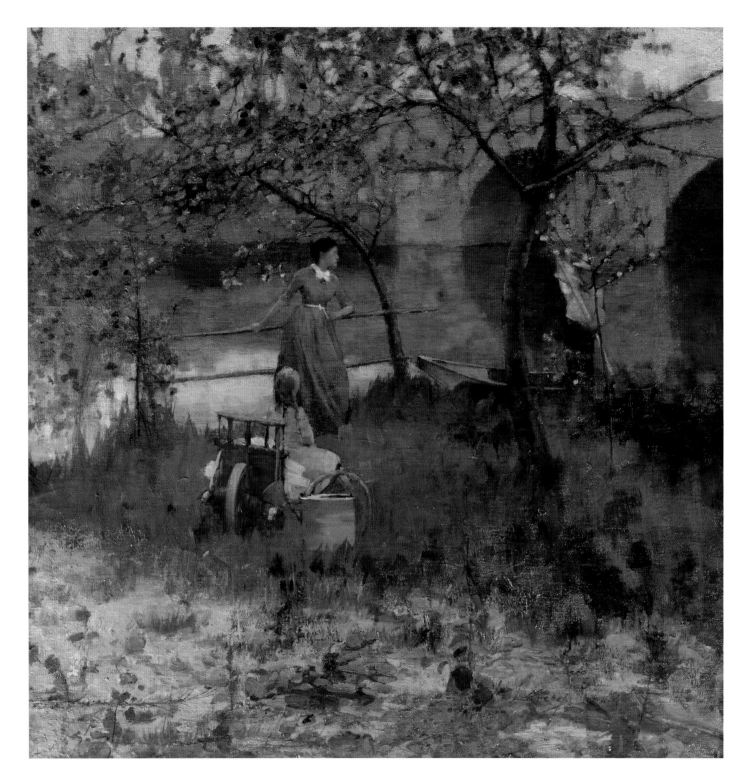

Right:
Fig.8
Under the Cherry Tree, 1884
John Lavery,
Oil on canvas
150.8 x 150.8cm
Ulster Museum, Belfast

Far right:
Fig.9
La Laveuse, 1883
John Lavery,
Oil on canvas
63.5 x 44.5cm
Private Collection

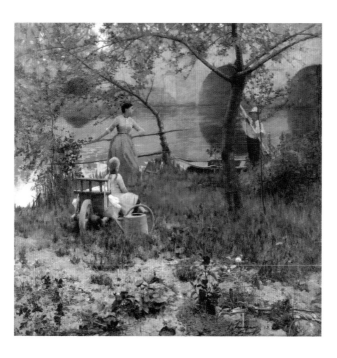

capture the scene. This diffuseness makes the smaller version more intimate and atmospheric. In the larger version, Lavery worked up the foreground details, giving greater emphasis to the two female figures while leaving the face and figure of the boatman in the background slightly hazy with less definition. When the finished picture was shown at the Glasgow Institute in 1885, the reviewer in *The Glasgow Herald* finally felt able to praise *'J Lavery, a Glasgow artist who alternately surprises and disappoints us…Mr Lavery's success of the year is, "On the Loing – An Afternoon Chat' (No 697), a large canvas , in which, except that we find repeated here a curious liking for horizontal lines, there is nothing but excellent work, air space and light and colour and pleasant feeling all going to make up a picture of undoubted charm. The foreground is filled with especial care, its verdure warmed with touches of yellow and scarlet bloom.'[6]*

Also shown at the Glasgow Institute of that year was Guthrie's *To Pastures New* (Cat.13). It was the sight

of this picture, according to Guthrie's biographer James Caw, that made Lavery decide to remain in Glasgow and not return to France – *'It was finer than anything I had seen in Paris …. Other influences came in later, Whistler and others, but from then till now, Guthrie has remained the master for me.'[7]*

NOTES

[1] Lavery, J (1940). *The Life of a Painter*. London, Cassell, p.51.
[2] Letter from Lavery to Fernande Sadler and quoted in her *L'Hôtel Chevillon et les Artistes de Gres-sur-Loing*. Contribution in *l'Histoire regionale*. (1938). L'Informateur de Seine-et-Marne, p.14.
[3] Boxes for carrying tubes of paint and finished paintings.
[4] See amongst others, Sotheby's *The Irish Sale*, 9 May 2007, Lot 63 *Sketch for The Tennis Party* and *Study for "The Visit of Queen Victoria to the International Exhibition, Glasgow"*, Aberdeen Art Gallery.
[5] McConkey, K (1984). *Sir John Lavery RA 1856–1941*. Ulster Museum Exhibition Catalogue, p.19, Cat.10.
[6] *Glasgow Herald*, Wednesday February 18, 1885, p.9
[7] Caw, J (1932). *Sir James Guthrie*. London, Macmillan and Co., pp.30–1.

Spring

Pictures of children in cottage gardens or orchards became a common theme for the Boys, and Kennedy's *Spring*, painted at Grez in 1884, is a charming early example. Unlike the hind's daughter in Guthrie's Cockburnspath picture of 1883 (see p.61), whose stare confronts us, the children here are completely absorbed in their tasks. One child picks blossom from a tree, while another, seated on the grass, appears to be decorating her bonnet.

This picture may have been painted in the gardens of the Hotel Chevillon.[1] Both the Chevillon and Laurent hotels had gardens with family vegetable plots that connected onto the River Loing, and these provided inspiration for many of the artists who visited Grez. Lavery himself recalled the gardens at the Chevillon with fondness,

'The garden, which ran down from the house to the river, was completely shut in and became an ideal open-air studio for models… making it a small and very select nudist camp which would have been a complete success if it had not been for the mosquitoes'.[2]

Certainly this sense of intimacy or enclosure can be detected in Kennedy's picture. The girls in the picture are too young to be Madame Chevillon's daughters Ernestine and Berthe[3], but they may well be other village children who were happy to pose for the artist 'for a few coins.'[4] When her husband Jules died in 1881, Mme Chevillon became the so-called 'Mère Chevillon', taking good care of all the artists who stayed

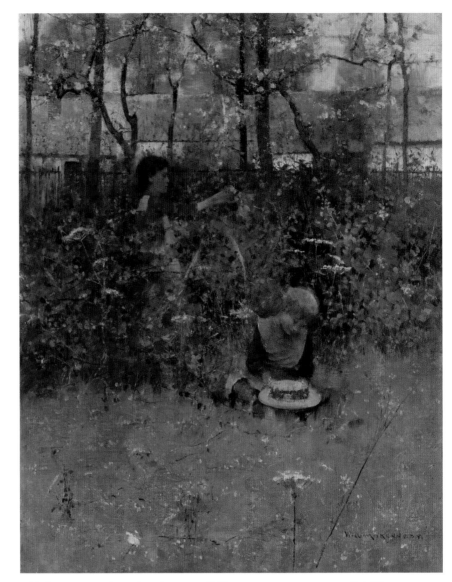

with her, even when they became ill.[5]

Artistically, Kennedy's picture owes much to the influence of the Boys' naturalist icon Jules Bastien-Lepage, particularly in the way in which he handles the space in his composition. Similar to the treatment of the teasels in Bastien-Lepage's *Joan of Arc Listening to the Voices* [Fig.10] which was shown at the Paris Salon of 1880, Kennedy uses the distinctive flower

Cat.40
Spring, 1884
William Kennedy
Oil on canvas
67.6 x 52cm
Paisley Museum,
Renfrewshire Council

Fig.10 *Joan of Arc Listening to the Voices*, 1879, Jules Bastien-Lepage, oil on canvas, 254 x 279.4cm, The Metropolitan Museum of Art, New York

Fig.11 *Pea Pickers at Auvers sur Oise*, 1882, William Kennedy, pencil, 11 x 19.8cm, Glasgow Museums Resource Centre

Fig.12 Photograph of haymakers found in William Kennedy's sketchbook, Glasgow Museums Resource Centre

head of an umbellifer such as cow parsley or hogweed to establish the foreground of his garden setting. This plant and some other flowers, possibly yellow daisies and red clover, are finely painted rich spots of colour. Spindly tree trunks, denser foliage, a rickety fence and pink cherry blossom are painted in a less precise manner and define the middle distance, almost encompassing the children. The steeply roofed village houses and the outlines of some trees against the sky can be seen in the far distance. The two paintings are also similar in their handling of tones and colours. Soft muted tones of greys and greens are enlivened by touches of yellow and red. Even the motif of the girl's outstretched arm as she picks the blossom from the tree finds an echo in the pose of Bastien-Lepage's *Joan of Arc*.

Naturalist painters were often criticized for their photo-realist techniques. In contrast to the Pre-Raphaelites' methods earlier in the nineteenth century of paying equal attention to every surface detail, Naturalist painters identified the focus of the camera lens as the most modern way of viewing a subject. Imitating the eye of a camera, they would focus on certain details such as a person's face or foreground foliage, while surrounding areas would appear slightly blurred or out of focus. As we know from Kennedy's sketchbooks, drawing was still an important part of his working method [Fig.11], but it is likely, again from evidence found in one of his sketchbooks, that he was also interested in contemporary photography [Fig.12].[6]

Bastien-Lepage was aware of the criticism of his 'lack of perspective', and as early as 1876 defended himself:

'It is the criticism of men who have never looked at a landscape, except when they are sitting down. Then you see more of the sky, and trees and houses or living beings stand out sharply, and the effect of greater distance and wider atmosphere is naturally given. But this is not the ordinary way in which we look at the landscape. We see it when we are on our feet, and then objects both animate and inanimate, instead of standing out of the sky, are seen in profile against the trees, or the fields, and mingle with the background, which seems to come forward. The fact is, we must renew the training of the eye by looking at things as they are in nature.'[7]

Kennedy appears to have used his time at Grez to *'renew the training of the eye'*. In subsequent pictures on his return to Scotland he continued a faithful analysis of his contemporary environment, depicting soldiers in their camps around Stirling Castle, crowds at Stirling train station and fashionable middle-class ladies at leisure.

NOTES

[1] Because both hotel gardens had a vegetable plot and faced onto the river, it is sometimes difficult to judge from the paintings whether the Chevillon or the Laurent is being depicted. Another factor making identification difficult is the proximity of the two hotels on the same riverbank.

[2] Lavery, J (1940).*The Life of a Painter*. London, Cassell, p.53.

[3] Ernestine was born on 8 August 1859 and Berthe Virginie on 5 May 1866, so they would have been 25 and 18 respectively in 1884 when Kennedy painted this picture. Could they be the two ladies featured in Lavery's *Sewing in the Shade* (1884)?

[4] MB Wright in her *Bohemian Days* describes the Hotel Chevillon and its owners in 1878 and recalls that many local children tried to be models and get a few coins, *Scribner's Monthly*, 16:1, May 1878, p.125.

[5] *'La Mère Chevillon était la bonne mere; elle accueillait les artistes comme ses enfants, leur préparait des tisanes s'ils étaient malades; elle a laissé à tous le meilleur souvenir....'*(Mother Chevillon was like a mother to us, she welcomed the artists as if they were her children, preparing tisanes for them if they were ill, leaving everyone with good memories). Fernande Sadler, *L'Hôtel Chevillon et les Artistes de Gres-sur-Loing*, Contribution to *l'Histoire regionale*. (1938). L'Informateur de Seine-et-Marne, p.5.

[6] Included in one of Kennedy's sketchbooks held by Glasgow Museums is a group of photographs of rural labourers including one of haymakers.

[7] Cartwright, J (1894). *Jules Bastien-Lepage*. London, Macmillan and Co., p.63, quoting Jules Bastien-Lepage's letter to André Theuriet, August 15, 1876.

On The Bridge at Grez

One of Lavery's closest friends at Grez was fellow Irish artist, Frank O'Meara, and he is the artist depicted in this unusual and striking composition.[1] Three years older than Lavery, he was regarded affectionately by the American artist Will Low as typifying a *'pure type of Celt'* noted for *'the capricious moodiness of his race, the alternate sunshine and rain of his emerald isle'* but to this he added *'an exquisitely sensitive temperament as an artist....'*[2]

Isobel Osbourne, the 17-year-old daughter of Fanny Osbourne who later married Robert Louis Stevenson, immediately fell in love with him,

'Frank O'Meara, an Irish boy of twenty, was the next arrival at the Hotel Chevillon. He too praised Louis to the skies. This handsome youth in his rough country tweeds, knitted stockings, and stout brogues, with a blue beret on his curly head and a blackthorn shillelagh in his hand, distracted me somewhat from the talk about a stranger's arrival. Added to his fine figure and Irish blue eyes, he had a voice that melted the heart...'.[3] This description of O'Meara's typical apparel is very similar to how he appears in Will Low's group photograph. Third from the right with his pipe in his mouth, he wears knee breeches, and his distinctive beret, and leans nonchalantly on his wooden walking stick [Fig.13].

For Lavery, O'Meara provided the artistic link between two generations of British and American artists, those who had come to Grez from Carolus Duran's studio in the 1870s with those from the Académie Julian in the 1880s. In pictures such as *Twilight,* 1883 (Hugh Lane Municipal Gallery of Modern Art, Dublin), *Evening in the Gatinais*, c.1883 (untraced) and *Towards Night and Winter* [Fig.15], which were all exhibited at the Glasgow Institute, O'Meara's work combined the two artistic styles that were hotly debated by art students in nineteenth-century France – the rural naturalism of Bastien-Lepage's 'peasant' subjects and the development of symbolism in the work of Jean-Charles Cazin and Puvis de Chavannes. Alexander Roche, who was often present at the artistic debates that raged amongst the Boys studying in Paris, recalled that 'ardour and tobacco were burned freely before the shrines of Puvis de Chavannes and Jules Bastien-Lepage'.[4] O'Meara absorbed both these influences, and his work was of vital importance in introducing these ideas to the young Glasgow Boys. While Lavery and Kennedy responded to his naturalism, other artists like Dow and Roche recognized a kindred spirit in his mystical and atmospheric approach to landscape painting. Their debt to O'Meara was acknowledged by Lavery,

'The Swedish and American contingent were stronger than the English. Carl Larson (sic) was perhaps the most interesting Swede, Harrison the American, Stott the English, and O'Meara the Irish, have much influenced me, above all the last during the three or four seasons that I spent at Grez'.[5]

In *On the Bridge at Grez*, Lavery borrows the same compositional format as O'Meara's *Autumnal Sorrows* [Fig.14] and the untraced work *Evening in the Gatinais*, but takes the novel approach of painting on the bridge itself rather than giving us a view of it from below.

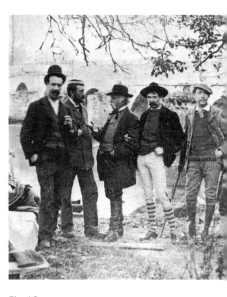

Fig.13
A group of artists at Grez in the garden of Hotel Chevillon, 1877 RAM Stevenson (in the striped socks) and Frank O'Meara on his right.

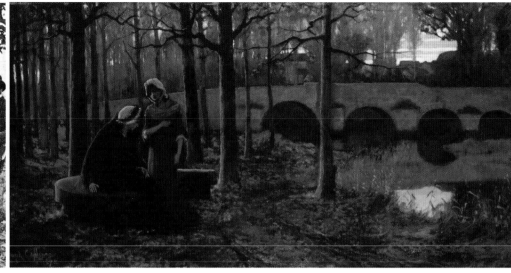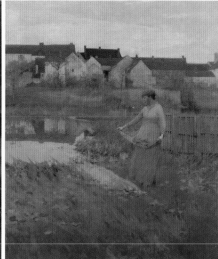

Above from left to right:

Fig.14
Autumnal Sorrows, 1878
Frank O'Meara
Oil on canvas
48.3 x 99.7cm
Ulster Museum, Belfast

Fig.15
Towards Night and Winter,
1885
Frank O'Meara
Oil on canvas
150 x 125cm
Hugh Lane Municipal Gallery
of Modern Art, Dublin

Fig.16
Sir James King Bt in Lavery's
studio at 248 West George
Street in 1888–89,
(photograph from plate owned
by Glasgow Art Club)

The same grey-green-brown tones so characteristic of O'Meara's pictures are prevalent here.[6] As already noted, Lavery was one of the few artists at Grez to record encounters between the villagers and their summer residents. Two village women lean over the parapet of the bridge to watch something on the river, while the artist leans lazily against the wall, his painting materials at his side. Gazing in their direction, he is perhaps wondering if the women will pose for him. Lavery's confident rendition of the figures and his crisp brushwork give elegance to the painting. The rough stonework of the bridge and the cobbled path in the immediate foreground are captured using the large, 'square' brushstrokes favoured by Bastien-Lepage. By contrast, the reflections in the water, the riverbank, the trees and houses in the background are painted in a less defined manner, making it softer and more atmospheric.

While Lavery was working on this picture and his *Under the Cherry Tree* [Fig.8], O'Meara was working on his quintessential *plein-air* painting *Towards Night and Winter* [Fig.15].[7] The similarities in style and motifs between each artist's work at this time is further evidence of their close relationship. It was probably Lavery who encouraged O'Meara to exhibit his pictures at the Glasgow Institute and at the Glasgow International Exhibition of 1888. More proof of their friendship can be found in a contemporary photograph [Fig.16] of Sir James King Bt, Lord Provost of Glasgow, posing in Lavery's Glasgow studio for his state visit of Queen Victoria picture. In this we can see that Lavery's *On the Bridge at Grez* (Cat.42) took pride of place above his fireplace. Next to it, further along the wall, is O'Meara's painting *The Widow*, 1882 (Hugh Lane Municipal Gallery of Modern Art, Dublin), suggesting that Lavery must have kept it after it was exhibited at the Paris Salon in 1882. It is also likely that Lavery helped to promote O'Meara's work with private collectors in Scotland – a true 'chronicle of friendships'![8]

NOTES

[1] Kenneth McConkey was first to identify this picture as *On the Bridge at Grez* and the artist as O'Meara in a catalogue entry in 1986 – see *Irish Renascence*. (1986). London, Pyms Gallery, p.25.

[2] Low, W (1908). *A Chronicle of Friendships* 1873–1900. New York, Charles Scribners Sons, p.67.

[3] Field, I (1937). *This Life I've Loved*. London, Longman/Green, pp.103–4.

[4] Shaw-Sparrow, W (1911). *John Lavery and His Work*. London, K. Paul, Trench, Trübner and Co., pp.40–1.

[5] Letter from Lavery to Fernande Sadler and quoted in her *L'Hôtel Chevillon et les Artistes de Gres-sur-Loing*, Contribution to *l'Histoire regionale*. (1938). L'Informateur de Seine-et-Marne, p.14.

[6] Several writers comment on how the artists who worked at Grez preferred to paint overcast skies, and to use a subdued grey and grey-green palette emulating their hero, Bastien-Lepage. Isobel Osborne recalled, *'The painters scorned sunlight, and endless time was wasted waiting for a grey day. Then we would be off: O'Meara and I in one direction, my mother in another, with Louis carrying her painting outfit....'*. Field, I (1937). *This Life I've Loved*. London, Longman/Green, pp.105–6.

[7] O'Meara was a notoriously slow worker so he probably began his painting in the autumn of 1884 but did not complete it early 1885.

[8] A letter written by O'Meara to Lavery on 8 December 1887 states, *'My dear Lavery, I am seriously conceiving the idea that you wear wings. With very little more kindness on your part I should certainly see an aureole around your head. I am only too pleased to get the price your goodness has procured me. Rest assured of my very grateful recognisance of the leuner has come in more than usefully. I am still further in your debt in the trouble old Davidson must have given you and know not how to thank you sufficiently...'*, Lavery Correspondence Tate Gallery Archives. O'Meara's picture *Evening in the Gatinais*, 1884, current whereabouts unknown, was bought by James Gardiner, a Glasgow ship-owner and cousin of James Guthrie in 1884.

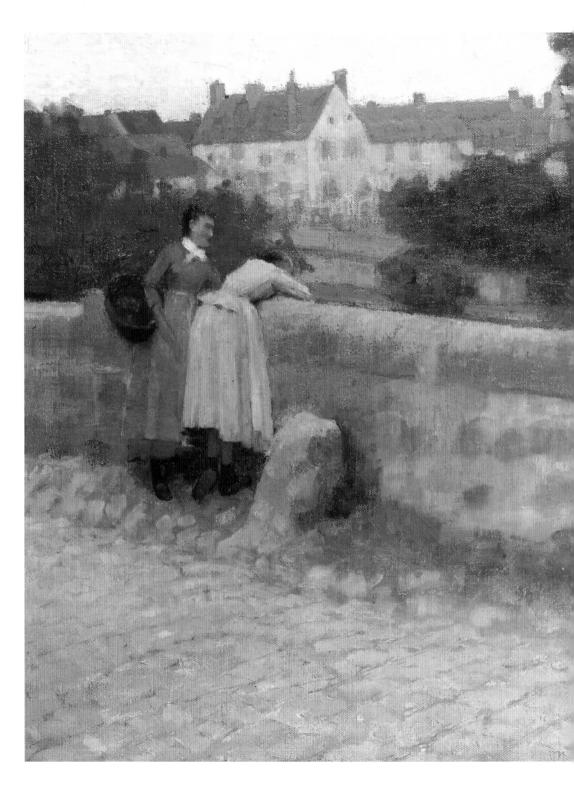

Cat.42
On the Bridge at Grez, 1884
John Lavery
Oil on canvas
49 x 100.5cm
National Gallery of Ireland, Dublin

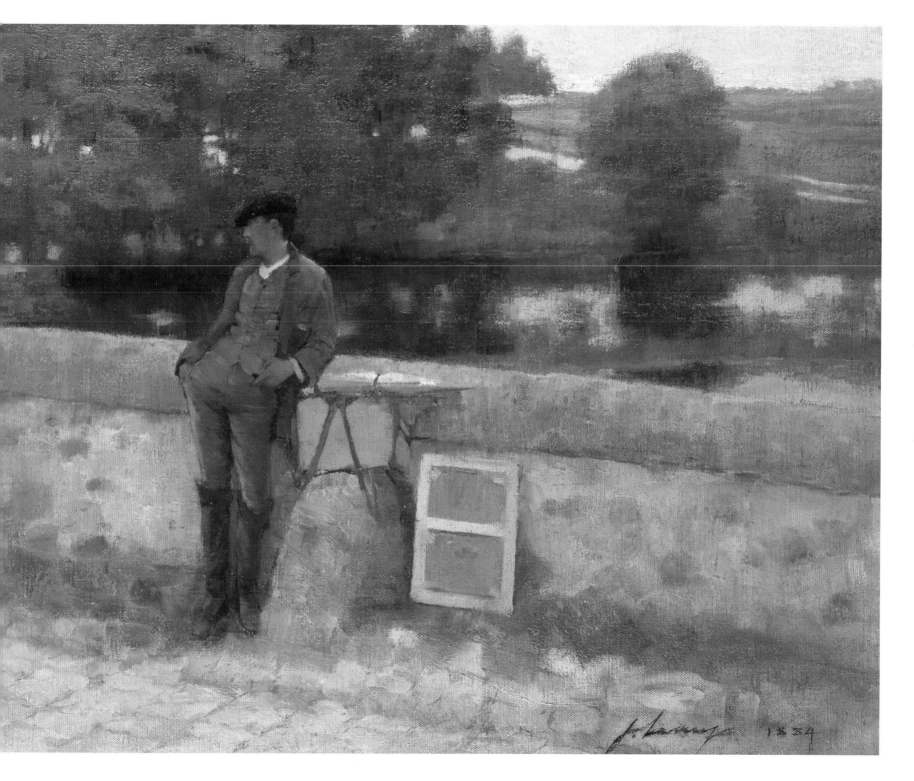

Jean Walsh

A Reed Shaken by The Wind:

From Kirkcudbright to Japan

The small town of Kirkcudbright in Dumfries and Galloway and the surrounding countryside provided a great source of inspiration for the Glasgow Boys in the mid 1880s and early 1890s. Not only do the town's distinctive Tolbooth and eighteenth-century houses feature in the backgrounds of several of the Glasgow Boys' canvases, but local people such as Old Willie were brilliantly captured for posterity. However, the most enduring and intriguing imagery of this period involves the undulating hills and fields with their cattle, woods with their streams and dense undergrowth of foliage, and the changing colours of the trees and vegetation with the seasons. Artist EA Taylor, writing about Kirkcudbright's popularity with artists, mentions the town's unique beauty but adds, *'It is the nearness of unspoilt Nature that makes it the artist's paradise that it is...not many steps from your doorway the river, the sea, pastoral lands, woodland, rugged hills, moorlands and glens are all within easy reach.'*[1]

For the Boys, another factor that made this part of the world so important was the close friendship between two of them, George Henry and EA Hornel. We do not know when they met initially, but they had certainly made contact by 1885 as by then Henry and Guthrie had made their first visit to Hornel in his native Kirkcudbright, and been inspired by what they saw. The friendship between Henry and Hornel lasted about ten years (until a disagreement upon their return from Japan) and is documented by their use of the same models and motifs in their paintings, two known collaborative paintings *The Druids – Bringing in the Mistletoe* (Cat.58) and *The Star In the East* (Kelvingrove Art Gallery and Museum), and in a series of over 100 letters written to Hornel by Henry.[2] It was this

friendship that led to a new decorative, or symbolist, phase in the Boys' work, bringing about some of the most original and controversial pictures ever painted by them. As Bill Smith has recognized, *'The close friendship of Henry and Hornel provided both men with encouragement, stimulus, assistance and constructive criticism. It fostered mutual experimentation and development.'*[3] Without this cross-fertilization of ideas, it is doubtful whether the later masterpieces of the Boys would have been painted.

The reason for the younger Boys' move towards a more decorative or symbolic aesthetic in the later 1880s was their increasing exposure to new artistic influences. By 1887, the older members of the group had each painted his masterpiece in the naturalist vein championed by Bastien-Lepage – Guthrie's *To Pastures New* (Cat.13) in 1883, Lavery's *The Tennis Party* (Cat.66) in 1885, and in the same year Walton's *A Daydream* (Cat.34). It was time for the Boys to take a new direction, and the fresh sources that impressed them included Frank O'Meara's Grez pictures, Whistler, Monticelli and Japanese woodblock prints. All these stimuli were readily available in Glasgow, either through loan pictures seen at the 1888 International Exhibition, the annual Glasgow Institute exhibitions or shows mounted by Glasgow art dealer Alexander Reid at his own gallery La Societé des Beaux-Arts.[4]

For Henry, Hornel and some of the other Boys such as Dow, Roche and Gauld, the desire to evoke or suggest something other than what is actually there became a key aim. To do this they had to find a new aesthetic to convey this to the viewer, and they were in the vanguard of what was to become an international pursuit. Where the early naturalist pictures of the Boys used predominantly soft tonal colours of brown, green and blue, those made following the symbolist creed

used stronger, brighter hues, mainly greens, turquoises and reds and sometimes gold. The arrangement of their compositions became more complex, so that viewers were often confronted with a compressed or enclosed space with little or no sense of distance. Figures were painted using the same brushstrokes as their background compared with detailed figures and broader handling for backgrounds in naturalist pictures, and therefore tended to merge into it as if part of an exquisite pattern. This made viewers more aware of the overall design of a composition, and how elements balanced or complemented each other. The artists drew inspiration from both the natural and occasionally the supernatural world (for example, Hornel's *The Brownie of Blednoch,* 1889 (Kelvingrove Art Gallery and Museum) or from societies remote in time, Celtic Britain (Henry was very interested in Scottish archaeology and folklore), Early Christianity or the Middle Ages (for example Henry and Hornel's *The Druids – Bringing in the Mistletoe*, (Cat.58); Gauld's *Saint Agnes*, (Cat.57); Roche's *Good King Wenceslas* [Fig.20]), or from distant lands such as Japan. Even the titles of their paintings reflected this deeper spirituality or otherworldliness – often just a few words (*A Galloway Idyll*, *Music, The Brook*) or the name of the season the picture evoked (*Autumn, Summer* [Figs 17 and 18], *The Dance of Spring*).

Japan

The influence of Japan had reached Scotland and the Boys by a variety of roots. In the late 1880s Whistler was an important hero for the Boys, and his *Ten o'Clock Lecture*, published in 1888, extolled the virtues of Japanese art. Japanese artefacts could be found in the Corporation Art Galleries as a result of a cultural exchange with the Japanese government in 1878. Several of the Boys owned Japanese prints and other

Fig.17
Autumn, 1889
George Henry
Oil on canvas
45.7 x 38.1cm
Kelvingrove Art Gallery
and Museum

artefacts, as can be glimpsed in the background of their pictures or adorning the walls of their studios.[5] And the citizens of Glasgow themselves were interested in buying Japanese artefacts as evidenced by the large number of retail outlets, such as the City Oriental Warehouse, selling Japanese goods. Further afield, over 200 Japanese pictures from the Anderson Collection were displayed in a gallery in the newly built east wing of the British Museum, London, in March 1888. Later, in November 1890, the same number of pictures by Hokusai was shown at The Fine Art Society.[6]

Henry and Hornel regarded Japan as the model society, one whose people embodied an enviable honesty, simplicity and spirituality, completely at one with their natural surroundings. The Boys admired what they saw as the external manifestation of this

Above from left to right:

Fig.18
Summer, 1891
EA Hornel
Oil on canvas
127 x 101.5cm
Walker Art Gallery, National
Museums Liverpool

Fig.19
Beauty After the Bath,
mid-19th century
Utagawa Sadakage
Woodcut surimono print
20 x 18.5cm
Kelvingrove Art Gallery
and Museum

Fig.20
Good King Wenceslas, 1887
Alexander Roche
Oil on canvas
45.8 x 76.2cm
Private Collection

inner beauty and harmony in Japanese art. Elements of Japanese art, particularly the Japanese print, can be found in Hornel's *Summer* [Fig.18] in its flattened perspective, high horizon line, the curving pose of the figure on the right and in the decoration of the clothes she is wearing [Fig.19].[7]

Hornel was so attracted by Japanese art and culture that he felt the need to see it for himself. As he explained, *'A reed shaken by the wind; for to those acquainted even slightly with Japanese art the words express the spirit and motif of its dainty achievements. Japanese art, rivalling in splendour the greatest art in Europe, the influence of which is now fortunately being felt in all the new movements in Europe, engenders the desire to see and study the environment out of which this great art sprung, to become personally in touch with the people, to live their life, and discover the source of their inspiration.*[8]

In retrospect, it seems the natural apogee of the artistic collaboration between Henry and Hornel, started at Kirkcudbright in the mid 1880s, that it should conclude almost ten years later with a trip in 1893–94 to the *'land of the Mikado'*.

NOTES
[1] As quoted in Bourne, P (Ed.) (2000). *Kirkcudbright: 100 Years of an Artists' Colony*. Edinburgh, Atelier Books, p.11.
[2] The letters from Henry to Hornel are held by The National Trust for Scotland at Broughton House, Kirkcudbright.
[3] Smith, B, in Bourne, P (Ed.) ((2000). *Kirkcudbright: 100 Years of an Artists' Colony*. Edinburgh, Atelier Books, p.34.
[4] Frank O'Meara's *Twilight*, 1883, *Evening in the Gatinais*, 1883, *Towards Night and Winter*, 1885, *October*, 1887 were all exhibited at the annual Glasgow Institute exhibitions during the period 1884–87. In 1888, two of Monticelli's paintings were shown at the International Exhibition in Glasgow, and a retrospective exhibition of 75 works was held at Dowdeswell Gallery in London the same year. Local collectors such as William Burrell regularly lent works by him to the annual Glasgow Institute exhibitions. In 1889 Alexander Reid held an exhibition of Japanese prints, including 'numerous examples of Hokusai and his pupils', at his Glasgow gallery in West George Street.
[5] Japanese prints can be seen in the background of William Kennedy's *A Fur Boa*, c.1890–91 (Kelvingrove Art Gallery and Museum, Glasgow). A Japanese fan and a screen can be seen respectively in the background of Lavery's *A Quiet Day in the Studio* (Cat.113) and *A Visitor* (1885, National Gallery of Ireland, Dublin).
[6] *Glasgow Herald*, 2 and 5 March 1888; 24 November 1890.
[7] The picture caused a sensation when exhibited at the Walker Art Gallery in 1892, and controversy raged in the newspapers when Philip Rathbone recommended it for acquisition for the city's collection.
[8] Lecture written by Hornel and delivered by John Keppie in the Corporation Art Galleries, Glasgow on Saturday 9 February 1895.

Early Kirkcudbright Works

Graduating from art school in Antwerp in 1885, Hornel was eager to embark on his artistic career and would have been receptive to the progressive naturalist paintings of Guthrie, Henry and the other Boys. He had much to learn from them, and the time spent with Henry and Guthrie at Kirkcudbright must have been a revelation. The first evidence of this is *In the Town Crofts, Kirkcudbright* (Cat.47) which recalls the familiar subject matter of the cottage or cabbage garden treated earlier by Melville in *A Cabbage Garden* [Fig.21], Guthrie's *A Hind's Daughter* (Cat.28), Macgregor's *A Cottage Garden, Crail* (Cat.17) and Henry's *A Cottar's Garden* (Cat.23).[1]

Hornel's picture looks across the main allotments to the south of Kirkcudbright, and shows a woman working a plot with a large patch of kale, with two more figures working beyond. The autumnal colours and the single principal figure with a wooden fence to the right and the frieze of buildings in the background also echo O'Meara's *Towards Night and Winter* [Fig.15], which Hornel could have seen exhibited at the Glasgow Institute earlier that year.

The influence of Guthrie and Henry can be seen in Hornel's use of light colours and his awareness of tonal values. He adopted their technique of emphasizing details in the foreground, such as the kale lower right, the thickest pigment applied with a square brush, while treating the middle distance in a broader, less defined manner. His interest in capturing the effects of full sunlight on the scene can be seen in the flashes of light in the foreground vegetation and in the brilliant whitewashed, gable-ended houses in the townscape beyond.

The closeness of Guthrie, Henry and Hornel at this time can be seen in three paintings executed at Kirkcudbright in 1886. Guthrie's *Old Willie – the*

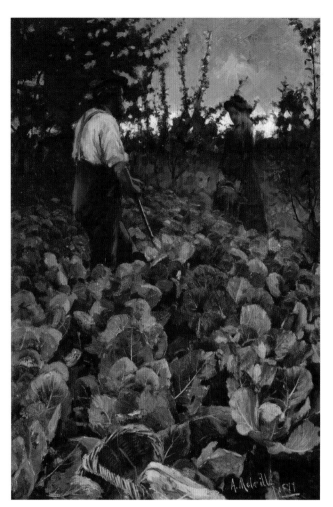

Fig.21
A Cabbage Garden, 1877
Arthur Melville
Oil on canvas
45 x 30.5cm
National Gallery of Scotland

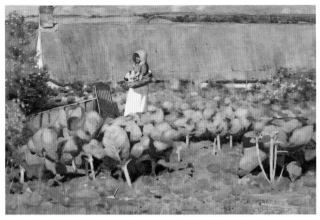

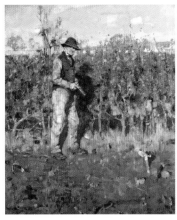

Above:
Cat.23
A Cottar's Garden, 1885
George Henry
Watercolour
29.3 x 44.5cm
The National Trust for Scotland:
Broughton House

Above right:
Cat.46
The Hedgecutter, 1885
George Henry
Oil on canvas
61 x 51cm
Private Collection, on loan to
the Hunterian Art Gallery and
Museum, University of Glasgow

Right:
Cat.50
Potato Planting, 1886
EA Hornel
Oil on canvas
114.2 x 71.1cm
Private Collection

Village Worthy (Cat.49), with its clear light and colour complements the natural dignity of the sitter. With his distinctive side-burns, large nose and weather-beaten cheeks, he may also be the same model who appears in Henry's *The Hedgecutter* (Cat.46) and Hornel's *Potato Planting* (Cat.50). But this masterful portrait was probably the last overtly naturalist picture in oil that Guthrie painted. In his *The Summer House, St Mary's Isle, Kirkcudbright* (Cat.69) he dabbled for a while with the emphasis on surface pattern and design being developed by Henry and Hornel but soon turned his attention to portrait commissions, and in the 1890s to a series of pastels of mainly middle-class subjects.

NOTES

[1] Hornel would have been very familiar with Henry's *A Cottar's Garden* as it was painted by the artist at Cockburnspath early in 1885 and given either to Hornel or a member of his family probably that summer.

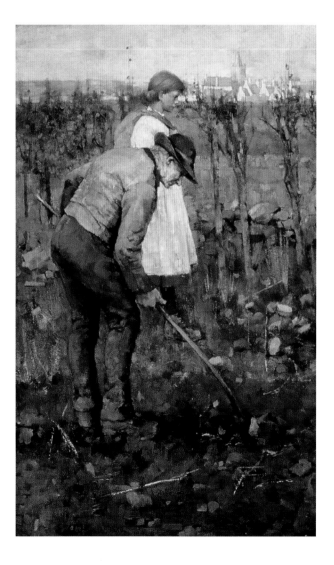

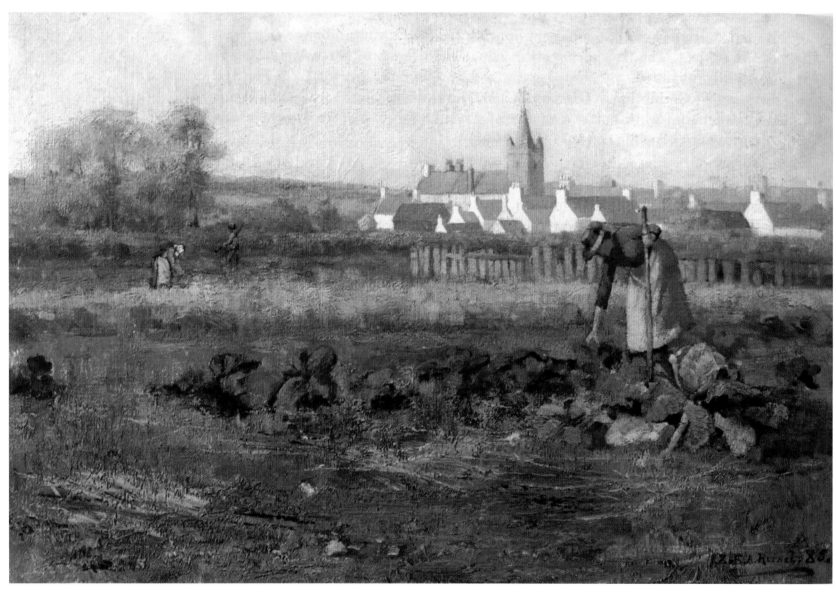

Cat.47
In the Town Crofts, Kirkcudbright, 1885
EA Hornel
Oil on canvas
40.6 x 61cm
Private Collection

Cat.49
Old Willie – the Village Worthy, 1886
James Guthrie
Oil on canvas
60.8 x 50.8cm
Kelvingrove Art Gallery and Museum

Resting

Towards the end of 1885, Henry wrote to Hornel praising two landscapes he had seen by Millie Dow, *'Dow has two landscapes, the most beautiful things I have ever seen. I don't know of any other fellow who has managed to make one feel on seeing those pictures so much of the spirituality of Nature.'*[1] Henry was probably referring to *The Hudson River* (Cat.52) and *At the Edge of the Wood*, 1886 (Private Collection). The appeal of these pictures for Henry and Hornel lay in Dow's unconventional viewpoint of the landscape he was depicting. In both instances, the delicacy and softness of his brushwork and the overall green and yellow tones give the scene a mystical, atmospheric quality. The sloping hillside with the winding curve of the Hudson River in the far distance in the former picture were motifs which Henry and Hornel were to experiment with later.[2]

Influenced by the atmosphere of these two works, in *Resting*, (Cat.48) Hornel's concern was to evoke the overall mood of the contemplative girl in her woodland setting. Although it has some similarities in compositional motifs and pose to Henry's *Noon*

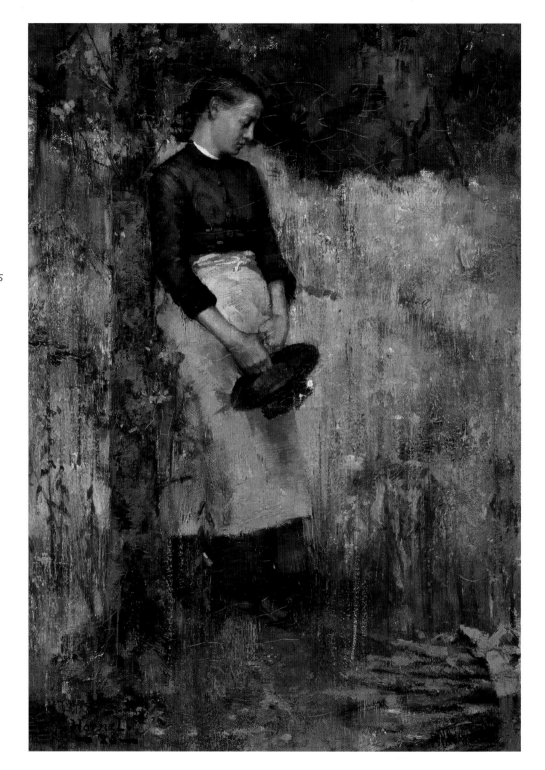

Cat.48
Resting, 1885
EA Hornel
Oil on canvas
38 x 28cm
Private Collection

Cat.52
The Hudson River,1884
Thomas Millie Dow
Oil on canvas, 123.2 x 97.8cm
Kelvingrove Art Gallery and
Museum

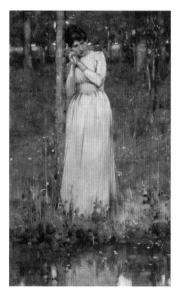

Fig.22
The Girl in White,1886
George Henry
Watercolour, 60.3 x 37cm
Kelvingrove Art Gallery and
Museum

(Cat.33), it is quite different in atmosphere. As she rests against the slender tree trunk, with her head bowed in reflection, the girl seems physically and spiritually surrounded by the woodland. She is lost in thought in a place where the outside world is excluded – only a few glimpses of sky can be seen through the trees. Hornel paints his figure quite delicately, but the rest of the composition is broadly handled with passages of impasto. As in Henry's *Noon*, we see a growing interest in compositional design and pattern with Hornel emphasizing the vertical and horizontal elements of the picture.

Resting was the first of many similar works depicting girls in woodland settings that Henry and Hornel produced. The following year Henry took up the theme in his watercolour *The Girl in White* [Fig.22] and in 1889 with his oil painting *Autumn*, 1886, (Kelvingrove Art Gallery and Museum). Hornel became even bolder with his picture of *Autumn* (Cat.53), where a solitary young girl is seen standing in a clearing in a wood staring up at the sky. Hornel's handling of the paint, even of the figure, is his broadest to date, the white impasto used to represent the vestiges of snow laid on with a palette knife. We are simultaneously aware of the very decorative nature of the composition and its strange, eerie quality. This patterned effect and laying on of blocks of rich colour may well have been inspired by Hornel's interest in the art of the French painter Adolphe Monticelli (1824–1886), whose pictures were widely available at Glasgow at this time [Fig.23].[3]

Left:
Cat.53
Autumn, 1888
EA Hornel
Oil on canvas
44.5 x 33cm
Private Collection

Fig.23
Fête Champêtre with White Horse, c.1863
Adolphe Monticelli, oil on wood, 39.8 x 59cm
Kelvingrove Art Gallery and Museum

NOTES
[1] Undated letter from Henry to Hornel, probably end of 1885, The Hornel Library, National Trust for Scotland: Broughton House, Kirkcudbright.
[2] Dow painted *The Hudson River* while staying with his friend, the American artist Abbott Thayer whom he had met in France in 1879. On 6 September 1883 he sailed on the *Devonia* from Glasgow to New York. From there he travelled on to Thayer's home at Cornwall-on-Hudson, where he stayed until the early summer of 1884. *The Hudson River* is probably a view of the river taken from Thayer's house.
[3] Alexander Reid strongly promoted the work of Monticelli, and is referred to as 'Monticelli Reid' in a letter from Henry to Hornel in 1892 dated 17 March, National Trust for Scotland, Broughton House, Kirkcudbright.

A Galloway Landscape

Henry's remarkable picture *A Galloway Landscape* (Cat.55) surpassed anything that had been painted by the Boys to date. With its emphasis on two dimensions and the sinuous rhythmic curving of the burn that dominates the canvas, it was the closest any Scottish artist in the nineteenth century had come to the Post-Impressionist work of Gauguin and the Pont Aven group, although it is unlikely that Henry had seen any pictures by these artists at this time. It is more logical to conclude that this picture was the culmination of Henry's and Hornel's experiments to find the new aesthetic that could convey a symbolic or underlying spiritual element in nature.

The steep profile of the hill, the trees and cattle placed against the hillside, the winding stream and the extreme flattening of the perspective all find an echo in Hornel's *Brownie of Blednoch* (Kelvingrove Art Gallery and Museum) painted in the spring of 1889. Another source of inspiration for these compositional motifs would have been found in Japanese prints depicting waterfalls, such as Hokusai's Washu *Yoshino Yoshitsune uma-arai no taki* [Fig.24] However, the intensity of Henry's colour is completely new – the deep blue for the burn, the slightly acidic green and yellow tones for the field, and the vibrant oranges for the trees bring an otherworldly quality to the scene. The distinctive black and white dairy cattle of the Galloway region appear rooted to the scene, almost as if part of a rich natural tapestry.

The artist AS Hartrick claimed to know the spot that inspired Henry, *'I have seen the spot where it was painted, a very ordinary field with a hill in it; but Henry introduced a blue burn, painted with a palette knife, around it; then put a stain over all, …'*[1] Hartrick's insistence that Henry invented the burn is borne out by a letter from Henry to Hornel asking, *'Could you do me a sketch of a bit of winding burn, also some shrubs and twisted trees or blossom. Do them in pencil, don't trouble however if you are busy at anything.'*[2] It did not matter to Henry that the burn was not there in reality, as his artistic aim was twofold – to use it as a compositional motif that linked the upper and lower parts of his picture, but also to convey the spirit of the place, a symbol of life in Galloway itself. His intention was to evoke the natural beauty and idyllic atmosphere of Galloway as a whole, not just an accurate representation of a particular spot.

When *A Galloway Landscape* was shown at the Glasgow Institute in 1890, most critics found the picture's lack of perspective extremely puzzling. Only the art critic of the Glasgow weekly *Quiz* appreciated the pioneering nature of the work and wrote,

'Among the examples of our local artists which have been prominently placed here, the pictures by Mr. George Henry and Mr. E. A. Hornel at once arrest attention, from their unlikeness to any other works in the exhibition. In whatever light these pictures are regarded, there can be no denying their originality of style, the peculiarly personal nature of their artistic aim, and method of expression. They certainly do not record impressions of nature which occur to the ordinary observer, but seem to be efforts to realise emotions and ideas suggested to highly imaginative minds by peculiar aspects and conditions of light, colour, and atmospheric effects in nature, in such a way as to produce artistic

Fig.24
Washu Yoshino Yoshitsune uma-arai no taki c.1830
Katsushika Hokusai
Woodcut print
The British Museum

Cat.55
A Galloway Landscape, 1889
George Henry
Oil on canvas
121.9 x 152.4cm
Kelvingrove Art Gallery
and Museum

harmonies of tone, subtle combinations of sensuous colour and quaint design. The artists appear to be searching for some new form of expressing their sense of the beautiful by means of painting, in which the details and facts of nature will merely form a basis upon which the artist can construct the artistic creations of his own imagination and fancy. The work of Monticelli is an example of art expression somewhat akin to what these two young artists are attempting...' [3]

NOTES

[1] Hartrick, AS (1939). *A Painter's Pilgrimage Through Fifty Years.* Cambridge, Cambridge University Press, p.61.
[2] Undated letter from Henry to Hornel, National Trust for Scotland: Broughton House, Kirkcudbright.
[3] *Quiz,* 14 February 1890.

The Druids – Bringing
in the Mistletoe

The close friendship that had developed between Henry and Hornel and their quest to evolve an aesthetic beyond naturalism finally led to artistic collaboration in 1890. In a venture not often seen in western art since the seventeenth-century collaborations of Flemish artists, they painted at least two pictures together.[1] It is almost impossible to discern which artist was responsible for which elements of the composition, but *The Druids – Bringing in the Mistletoe* (Cat.58) ranks as one of the most important works ever executed by the Glasgow Boys. Hornel probably suggested the subject matter as he was deeply interested in Scottish archaeology and folklore,[2] but for both artists it was crucial to convey as authentically as possible the true spirit of Scotland's Celtic past.

According to Robert Macaulay Stevenson, they examined skulls which were reputed to belong to Druids to determine their likely physical features, and visited the Duke of Hamilton's ancient herd of white cattle.[3] Hornel also scoured the local landscape for evidence of cup-and-ring markings cut into rocks, as Galloway is one of two regions in Scotland where these are found. AS Hartrick recalled *'On one such occasion [Hornel] took me and another friend with him to visit a local character named Sinclair, who was reputed to have some special knowledge of them.....'* After having been shown some markings on the rocks near Sinclair's cottage, *'...we returned to the cottage, when going into his bedroom, he took from a shelf a small china bowl in which was a small bluish stone like a bean. Holding this in his hand, in a few minutes he seemed to go off in a sort of trance, and then began to describe, like a radio announcer of today, a vision of a procession of priests with sacred instruments and cattle which somehow were connected with the cup-and-ring markings.'*[4]

True to the vision, this painting does indeed show a group of Celtic priests or Druids in richly decorated ceremonial robes and insignia proceeding down a steep wooded hillside. The leader of the procession holds an item clearly inspired by *lunulae* [Fig.25], although it could also represent the golden sickle used to cut down the sacred harvest from the oak tree. Traditionally this ceremony took place at the time of the winter solstice, when the mistletoe bears fruit, and most particularly on the sixth day of the moon, when it is waxing, which we can see here at the top of the canvas. Two white wild cattle, with their distinctive black noses, ears and black-tipped horns, carry the mistletoe, revered by the Druids for its magical as well as medicinal properties.

As John Morrison has pointed out, the designs on the robes and insignia worn by the Druids are derived from Pictish carved stones. For example, the serpent on the cloak and golden breastplate of the first Druid can be found on a carved stone in Glamis, Angus, while the red comb symbol on the Druid carrying the banner can be seen in the Dunnichen Stone, also found in Angus.[5] But significantly, Henry and Hornel also drew on British Celtic sources, including famous examples probably on display in the British Museum in London the 1890s, notably the decorative patterns that appear on the Aylesford Bucket (found in Kent in 1886) [Fig.26], and the Battersea Shield (found in 1855) [Fig.27], which can be seen repeated in the cloak worn by the second figure in the procession, and the Mold Gold Cape (found in 1833) [Fig.28]. The raised decoration of ridges, separating rows of dots, rectangles and lozenges on this last object seem very similar to that on the gold collar worn by the bearded Druid.

The emphasis on rich colour and pattern

Fig.25 **Gold lunula** with embossed decoration
The British Museum

Fig.26 **The Aylesford Bucket**,
Iron Age
Copper alloy
The British Museum

Cat.58
The Druids – Bringing in the Mistletoe, 1890
George Henry and EA Hornel
Oil on canvas
152.5 x 152.5cm
Kelvingrove Art Gallery and Museum

throughout the composition is breathtaking. The group itself forms an almost two-dimensional pyramid. The half-sphere of the moon finds its echo in the curve of the hillside and the spiral patterns of the Druids' costumes. This extends to the Celtic shapes and motifs on the picture's frame, also designed by the artists. The high horizon line and elimination of traditional perspective in the picture increase the feeling of flatness and confined space. It is almost as if the group will march off the canvas to meet us. The use of gold leaf, laid on top of the paint layer, adds to the drama of the occasion. When the picture was exhibited at the Grosvenor Gallery in London in 1890, it attracted somewhat grudging praise from the critics who found the picture *'startling, and at first sight very ridiculous....It is extraordinary, but it would be useless to deny that it is effective.'*[6] Of greater importance was the visit of Adolphe Paulus, who was responsible for the foreign section of the Munich Art Society exhibition in the Glaspalast, Munich; he was so impressed by the work of the Boys that he immediately invited them to exhibit in Munich later that year. There the radical nature of *The Druids – Bringing in the Mistletoe* caused a storm. Progressive Munich artists were just beginning to search for an escape from the confines of naturalism and had never seen anything like it, *'... a glow of colour that even in these surroundings puts all others in the shade...The two artists have even used gilding in the picture, and its effect is splendid, just because the work is so great and peculiar in its naivete [sic], so naïve a means can be applied with excellent effect.'*[7]

Fig.27
The Battersea Shield
350BC–50BC
Bronze
The British Museum

Fig.28
The Mold Gold Cape
2200BC–1400BC
Embossed gold
The British Museum

NOTES

[1] Their second known collaboration was the picture *The Star in the East*, 1881, Kelvingrove Art Gallery and Museum.
[2] Hornel acted for a time as the Secretary of the Kirkcudbrightshire Field Naturalist and Antiquarian Society. In 1923 he was elected a Fellow of The Society of Antiquaries of Scotland.
[3] Macaulay Stevenson manuscript notes as quoted in Smith, B (1996). *Hornel: The Life and Work of Edward Atkinson Hornel*. Edinburgh, Atelier Books, p.59.
[4] Hartrick, AS (1939). *A Painter's Pilgrimage Through Fifty Years*. Cambridge, Cambridge University Press, pp.60–1.
[5] Morrison, J (2003). *Painting the Nation. Identity and Nationalism in Scottish Painting, 1800–1900*. Edinburgh, Edinburgh University Press, pp.194–7.
[6] *The Saturday Review*, 10 May 1890, p.565.
[7] 'Scottish Pictures: What the Germans Think of Them, No 2', *The Weekly News*, 27 September 1890 (translation of an article by Fritz von Ostini in *Munchener Neuste Nachrichten*).

Japanese Lady with a Fan

In 1893, Henry and Hornel decided to visit Japan and see at first hand the art and culture that had already influenced many of their pictures. Their reasons for undertaking the trip have already been outlined (see p.68) but crucially they regarded Japan as a culture in harmony with its natural environment. They wanted to emulate this phenomenon, so it seemed a logical step in their artistic development to visit the country that had inspired this approach. For a *Glasgow Herald* critic, this step did not seem so advisable,

'Why Mr Hornel should seek inspiration in Yokahama or its neighbourhood we are at a loss to understand. It seems to us that he has already studied Japanese art to some purpose, and that a visit to Italy, a week or two in the churches of Venice and its Academy, would not have been amiss…Such an experience would have satisfied him, if he does not already know, that there were great colourists in the past who were influenced by beauty of line and form.'[1]

Henry and Hornel's trip to Japan was financed by art dealer Alexander Reid and Glasgow ship-owner and collector William Burrell. In February 1893 they sailed by steamship from Liverpool to Suez, stopping off at Cairo for a few days before travelling on to Nagasaki, arriving in April. Spring was, as Hornel recalled, the perfect time to arrive in Japan, as this was the season when *'nature-worship reigns supreme.…Nature to them is*

symbolism itself, and associated with traditions handed down from remote periods'.[4] Government restrictions meant that they had to stay within the confines of the 'Concessions', a special area reserved for Europeans. A way round this was to find employment with a Japanese national. They worked as house agents for a few months, showing people round houses for rent in order to get unrestricted access to the everyday lives of Japanese people and their culture. They spent some time apart, which may account for the quite different subjects they chose to depict and their style of painting these.

Hornel painted a wide variety of subjects, documented in the review of his Japanese pictures exhibition at Reid's gallery in 1895,
'Though lust of the eye is his first and last consideration he has deigned to be more intelligible in form, and incident than ever before; and to most people, we fancy, those scenes of a sunny and apparently happy land of tearooms, gardens, cherry blossoms, gentle mousmes, dancing girls, samisens, and junks will have even a literary appeal. For the romance indescribable, that mystic effluence that is in the best of all pictorial art, and that gives the infinite variety of suggestion to prevent it staling, let them look at the shipping scenes, at the high pooped junks, riding like survivals of the Spanish Main, on blue harbours with water really wet, salt and swinging. For pastoral joyousness more Greek than Oriental, let them look at the girls in their quaint and beautiful costumes playing at the game of battledore or shuttle-cock in laughter and irrestraint; for a rare and delicious sympathy with the careless joy of child-like let them see the children, flushed and eager, fishing over a pool or flying kites; for an austerity and fervour almost as striking as an Italian altar piece, let them witness the Lotus Garden. We mention these … to show how versatile the artist is and how responsive

Cat.80
A Music Party, 1894
EA Hornel
Oil on canvas mounted
on board
76 x 35.6cm
Aberdeen Art Gallery &
Museum Collections

Cat.77
The Balcony, Yokohama,
1894, EA Hornel
Oil on canvas on panel
40.6 x 50.2cm
Yale Center for British Art

Cat.75
Japanese Lady with a Fan,
1894
George Henry
Oil on canvas
61 x 40.6cm
Kelvingrove Art Gallery
and Museum

 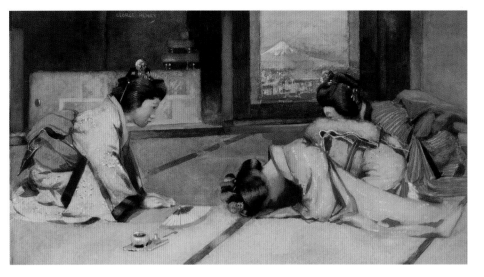

is his genius to many emotions. And, indeed, there is not in the collection a single picture commonplace or feeble. They are all without exception strong, original, impressive, balanced, and complete.'[5] As can be seen in such compositions as *A Music Party* (Cat.80) or *The Balcony, Yokohama* (Cat.77) Hornel's Japanese pictures were characterized by an even greater emphasis on surface texture and rich colours perfectly suited to the patterned fabrics worn by his models or the brightly coloured gardens in which they play.

By contrast, Henry's Japanese pictures are far more intimate, often concentrating on single figures selling pottery in the street, carrying a goldfish bowl, or playing a musical instrument (such as *The Koto Player, Tokyo*, Cat.76). There are seldom more than three figures in his pictures and in these group scenes his models are usually depicted taking part in a traditional Japanese ritual such as making tea, dressing their hair or bowing during a formal visit as in *Salutations* or *An At-home in Japan* (Cat.74). The interior scenes in particular are perfectly balanced, harmonious arrangements with a strong emphasis on line and design, revealing Henry's

understanding of Japanese pictorial space.

In his single figure subjects, such as *Japanese Lady with a Fan*, it is possible that he was deliberately reworking one of the traditional themes of Japanese art – the *okubie* of *ukiyo-e*, the type of print depicting actors, beautiful women or courtesans in half-length. This reached its peak in works by such masters as Utamaro, Kunisada and Eisho [Fig.29]. Henry also had a genuine awareness of Japanese colour, *'In Tokio and Yokohama, and throughout the north generally, it is not good taste to dress in colours. Dark blue, unrelieved by any variety, is the ordinary walking dress of the native ladies, and women in lower stations adopt this custom. The Southern blood of the Kioto ladies makes them go in for more vivid colours.'*[6] As we can see in this work Henry adopted the dark refined colour favoured in Tokyo. The elaborate treatment of the woman's hair and its ornamental pins, her pale cheek and neck and her dark eyelash are exquisitely drawn. In contrast, her kimono, the fan and the background of the picture with its stylized blossom branches are loosely but delicately painted and owe much to Japanese art.

Above from left to right:

Cat.76
The Koto Player, Tokyo, 1894
George Henry
Watercolour
71 x 40.3cm
Kelvingrove Art Gallery
and Museum

Cat.74
An At-home in Japan or
Salutations, 1894
George Henry
Watercolour
30.5 x 56cm
Kelvingrove Art Gallery
and Museum

Fig.29
The Courtesan Yosooi,
late 1790s
Chokosai Eisho
Woodcut print
38 x 25.5cm
Victoria and Albert Museum

Fig.30
Woman seen from behind,
Photographer unknown
Late 19th century
Albumen print
27.9 x 20.8cm
The Hornel Library, National
Trust for Scotland: Broughton
House, Kirkcudbright

As Ayako Ono has pointed out, Henry had another source of inspiration for his model's pose.[7] In Hornel's library at Broughton House, Kirkcudbright, there is a collection of around 300 photographs of a type now called *Yokohama Shashin*, produced as souvenirs for foreign visitors in the late nineteenth century. One photograph shows the rear view of a Japanese lady in three-quarter profile in a very similar pose to the lady in the painting [Fig.30]. There are even squared-up pencil lines to suggest that Henry may have used the photograph at some stage in his work, although in the painting the image is reversed. This too is intriguing, as Henry discovered a few days after his return to Glasgow that almost all of his Japanese oil paintings had been ruined. His distress is apparent in a letter he wrote to Hornel,

'I am undone… I have just got my canvases unrolled, and Oh Heavens what a result – I feel very sick. With a few exceptions, they are simply one mass of cracks, and the full length portrait of the wee Kanazawa Geisha which I rolled up rather carefully with a clean piece of canvas facing is utterly destroyed, and at present quite wet. I do not exaggerate when I say that really I don't know whether to start and finish the impression on the fresh canvas, or work on the old one as I have exactly two pictures, the one the reverse of the other of course.[8]

So it is possible that the original position of *Japanese Lady with a Fan* (Cat.75) was the same as the one in the photograph but Henry had to work up a new one in Glasgow showing her in the reversed position looking towards the right.

Japan was the highpoint of Henry and Hornel's artistic journey together. Soon they and the rest of the Boys went their separate ways, the lure of London and commissions for portraits filling their sights. However, building on Guthrie, Lavery and Walton's lead, Henry and Hornel had taken Scottish painting and put it at the forefront of progressive art in Europe, blazing a trail for future generations of Scottish artists to follow.

NOTES
[1] *Glasgow Herald*, 25 February 1893.
[2] Lecture written by Hornel and delivered by John Keppie in the Corporation Art Galleries, Glasgow on Saturday 9 February 1895.
[3] *Glasgow Evening News*, 25 April 1895.
[4] *Two Glasgow Artists in Japan – An Interview with Mr George Henry*, in the *Kirkcudbrightshire Advertiser*, 20 July 1894.
[5] Ayako Ono, *George Henry and EA Hornel's Visit to Japan and Yokohama Shashin. The influence of Japanese photography,* in *Apollo*, November 1999, pp.11–18.
[6] Letter from George Henry to Hornel dated 13 July 1894 (The Hornel Library, National Trust for Scotland: Broughton House, Kirkcudbright).

Hugh Stevenson

Modern Life

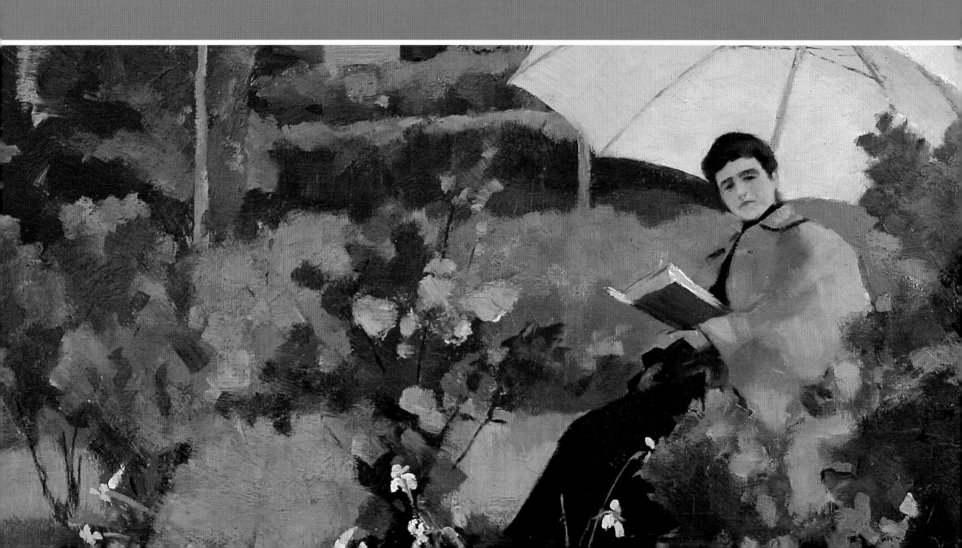

Although the Boys made their reputation with their essays in rustic realism, some of their number, particularly Melville and Lavery, had produced scenes of modern, middle-class life from an early stage. Guthrie, Walton, Kennedy and Roche were the more prominent among those who were to join them in the search for new subject matter calculated to appeal to their British patrons. They were following the example of successful British and French artists such as James Tissot, but eschewed the risqué nightspots and scenes of decadence favoured by some of the Impressionists in their paintings. Melville, however, dared to show the theatre in his exhibition pastel *After the Play* (Cat.128), a respectable development from his exceptional lightning sketches of Paris's Moulin Rouge dancers.

These new subjects generally reflected the prosperous milieu in which the Boys moved, as they sought out clients and supporters who would help them on the road to prosperity. Lavery was famously adept at courting enlightened and well-off business people, such as the great Paisley thread mill owners, the Coats, the Fultons and the Clarks, and depicted them enjoying leisure pursuits, lounging under parasols, or as they sat for their portraits.

Helensburgh, on the Firth of Clyde, was a pleasant middle-class town, comfortably removed from wealth-producing industrial Glasgow, where the fortunes of its inhabitants were made. It became an important urban locus for some of the Boys, in contrast to the rural areas they had favoured earlier. Dentist and amateur painter John G Whyte gave Guthrie the use of his studio for his large paintings, and after his death in 1888 Whyte's home became the setting of Guthrie's intimate pastel interiors featuring the Whyte daughters.

Cat.73
Ebbing Tide, c.1896, James Whitelaw Hamilton, oil on canvas, 45.7 x 61cm, Yale Center for British Art

Whitelaw Hamilton, whose importance is somewhat neglected, was the son of a Glasgow industrialist who lived at Thornton Lodge in Helensburgh. His home became a meeting place for the Boys, and the garden was to be the setting for Guthrie's *Midsummer*, 1890 (Royal Scottish Academy, Edinburgh). Hamilton painted many scenes around Helensburgh (such as *Ebbing Tide*) and his sister Maggie, also a painter, sat for Guthrie. Glasgow 'Girls', such as the Hamiltons and Waltons, were no doubt an added draw for the Boys in Helensburgh, as they were still in their twenties and interested in mixing with prospective partners.

There was a new sense of freedom in the 1880s, brought about by sports and pastimes such as croquet, tennis, boating, rowing and cycling, which provided the better-off with opportunities for social mixing, not to mention flirtation. Lavery's *A Tennis Party* (Cat.66) was painted at Cathcart on the south side of Glasgow, in the garden of solicitor James MacBride, where the more sporting Boys were wont to gather for a game. Lavery's studio was decked with tennis racquets as well

as half-finished canvases and props. *Croquet,* exhibited in 1890 (Private Collection), effectively a family group portrait of the Clarks in their sea-view garden at Largs, was Lavery's only serious attempt to repeat the triumph of his *Tennis Party.*

Travel and transport were another aspect of modern life that interested some of the Boys. Walton evidently liked horse-drawn carriages, as seen in his Helensburgh watercolours and his later London streets. Kennedy, whose *The Last Days of the Tuileries* (Cat.61) is an eerie Parisian twilight scene of people rushing home, went on to immortalize the railway in his *Stirling Station* (Cat.71). The streets and waterways of Glasgow, spiritual home of the Boys, however, feature scarcely at all, an exception being James Nairn's long-lost *West Regent Street,* 1884, a view no doubt from a studio window. Henry's enigmatic *Sundown* (Cat.70) is a moody Whistlerian view of the riverside, presumably the Clyde, at dusk, the huge globe of the sun recalling that of Monet's *Impression, Sunrise,* 1873 (Musée Marmottan Monet, Paris).

Lavery's response to Glasgow was to paint 50 scenes of the exotic buildings, displays and merry crowds of the International Exhibition at Kelvingrove in 1888, an exercise in escapism from the industry that made the city great. Once more he was responding to the taste of the time.

What are we to make of Kennedy and Crawhall and their portrayals of modern life, one with his obsession for soldiery, the other for horse riding? They are examples, like so many of the Glasgow Boys, of artists moving away from a shared aesthetic ideal into areas where their feelings took them. The move eventually took them away from Scotland altogether, to the south and north of England and to Morocco.

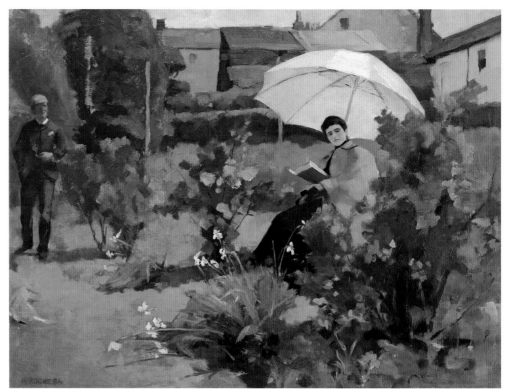

Cat.63
An Interruption, 1884
Alexander Roche
Oil on canvas
47 x 61cm
Private Collection

The Tennis Party

Painted only 25 years after the invention of the game of lawn tennis and 15 after its introduction into Scotland, Lavery's composition is the tennis painting par excellence, one of the most memorable works by the Boys.

It depicts the court on the lawn of Cartbank, a Georgian mansion in Cathcart on the south side of Glasgow. Solicitor James MacBride, his wife Jessie and other family members and friends are watching a game between their son Alexander and daughter Elizabeth and partners.[1] Alexander, 25 years old and at the start of a successful career as a watercolour painter, was friends with Lavery, Melville, Guthrie and Walton. The Boys enjoyed fun and good company, and the game of tennis afforded an excellent opportunity for young people of both sexes to mix. Lavery was inspired to paint at least seven pictures at Cartbank in 1885.

A small oil sketch of this scene was the starting point, the strongly horizontal format, essential to show the whole court, chosen to portray all the action in a game of mixed doubles. When adjusting the composition for the full-size painting, with the addition of extra figures, Lavery received much advice from Melville, Guthrie and Walton, so this is perhaps not a solo effort. The careful balance of the figures and the evening shadows echo the picture-making practices of Whistler, although Lavery introduces elements of detail and action that are essential to telling the story.

A companion composition exists both as an oil sketch *Played!*, 1885 (Private Collection) and an exhibition watercolour *A Rally* (Cat.65). It shows Elizabeth and Alex involved in a game seen from the opposite end of the court and in full sunlight. The latter is Lavery's best watercolour, one of his rare essays in this medium. The choice of medium could be explained by the presence of Melville and Walton, both outstanding

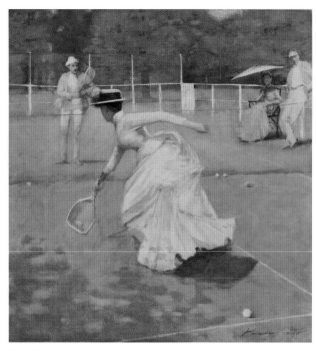

Cat.65
A Rally, 1885
John Lavery
Watercolour
65.9 x 63.4cm
Kelvingrove Art Gallery and Museum

practitioners, who may have given advice, as well as Alex, a budding member of the Scottish Society of Water Colour Painters, and his sister, whom Lavery may have wished to impress with his skill.

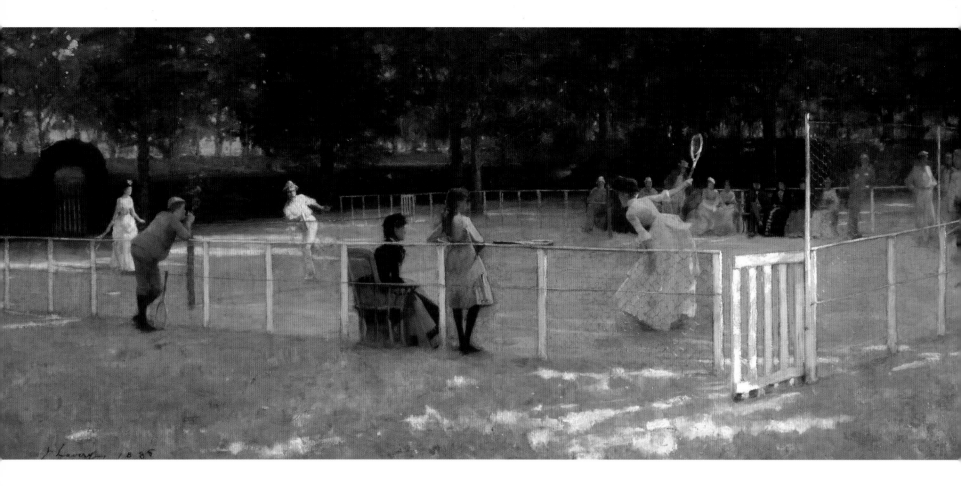

Lavery's other outstanding watercolour of this time, *Lady on a Safety Tricycle* (Cat.64), shows the gate and lodge of Cartbank on Netherlee Road. The lady with black hat and yellow flower seems to have come from *The Tennis Party.* The craze for cycling, like tennis, was about to take off in a major way, and Crawhall would depict one of his sisters on a bicycle about ten years later. Lavery was evidently so fascinated by the tricycle, an expensive contraption suitable to be used by ladies in long skirts, that he had to record the phenomenon.

The remaining two Cartbank paintings recall Lavery's early career as a painter of conversation pieces. *The Tennis Match*, 1885 (Private Collection), whose title surely has a romantic connotation, shows a young swell (Alex) idling with a lady in white (Elizabeth), while the third member of the love triangle, a lady in black, sits coyly at the end of the bench, separated by an unmoved Scottie dog. *Beg Sir!* (untraced), a trivial subject remarkable chiefly for its extreme vertical format, takes place at the same tennis court. The Scottie dog – the cheeky ball thief, and star of the picture – is too cute to be taken seriously; and it is little wonder that the painting may not have survived.

The Tennis Party was widely exhibited. At the Royal Academy of 1886, it received passing mention, perhaps because of its lack of finish, as 'a lively work

Cat.66
The Tennis Party, 1885
John Lavery
Oil on canvas
76.2 x 183cm
Aberdeen Art Gallery &
Museums Collections

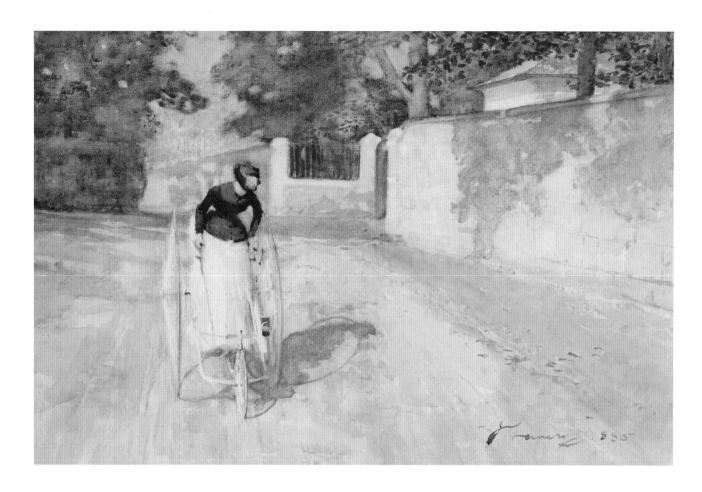

Cat.64
Lady on a Safety Tricycle,
1885
John Lavery
Watercolour
35 x 52cm
Government Art Collection

of the impressionist school'. But in 1888, as *Une partie de tennis,* it earned Lavery a Paris Salon medal, the first ever to come to Scotland. It was part of the Boys' triumphant contribution to the Munich Glaspalast exhibition of 1890, and was bought by the Bavarian Government for display in the Neue Pinakothek, their first Scottish painting in an enlightened programme of international collecting. At the Munich Sezession of 1901 it received a gold medal. Then after the Great War it was sold, much to the chagrin of later curators. Sir James Murray bought it on the London market and presented it to Aberdeen Art Gallery in 1926, bringing it home to Scotland.

NOTES

[1] A letter from Alex MacBride, dated 18 December 1943, to Aberdeen Art Gallery, describes the locus and personnel involved. Further detail was drawn from searches in Glasgow Post Office Street Directories and the online Census return for 1871.

Stirling Station

The choice of a railway subject is surprising for Kennedy, as his preference when he stayed at Stirling, in central Scotland, was to paint the soldiers based at the Castle and camped round about. A group of Glasgow Boys, including Walton, gathered in the 1880s at nearby Cambuskenneth, where they found the rural subjects that appealed to them. Kennedy joined them, attracted by the country setting, the exploits of the military [Fig.31] and the presence of his wife-to-be, Lena Scott, herself an artist, close by at Craigmill.

Quite why Kennedy selected this subject is unexplained. Although Turner, Monet and Frith are renowned for painting different aspects of rail travel, *Stirling Station* (Cat.71) owes no debt to them. A more immediate precedent was Sydney Starr's *Paddington Station*, 1886 (Durban Art Gallery), but his was a painting given over to incidental activity, where detail provided the main focus of the composition.

The admiration the Boys felt for Whistler is abundantly clear in this evening scene, with its overtones of the nocturnes painted by their hero. However, Whistler himself would never have painted like this. There is too much movement and incident, as the throng makes its way to or from the expected or departed train. What Kennedy introduces to contrast with the areas of delicate greys, touched by the evening sun and the glow of the locomotives' fires, is the interest in modern life.

The only apparent precedent, though hardly comparable, is Kennedy's *The Last Days of the Tuileries* (Cat.61), painted from on-the-spot pencil sketches done while he was attending classes at the Atelier Julian in Paris.[1] It too is an evening scene with a measure of big city bustle, a contrast to the artist's preferred rustic

Fig.31
Mid-day Rest, c.1892–93
William Kennedy
Oil on canvas
61.3 x 91.7cm
Kelvingrove Art Gallery
and Museum

Cat.61
Les Derniers Jours des Tuileries (The Last Days of the Tuileries), 1883
William Kennedy
Oil on canvas
29.1 x 55cm
Private Collection

genre subjects of this period. The restrained greyish palette and reflected lights again point to Whistler and his aesthetic of arrangements and harmonies. The dark silhouette of the ruined Tuileries, last vestige of the old order, gives the painting its title, but does not really feature as central to the point of the composition. The strangely gauche figures add to the impression that this was an experimental picture outside Kennedy's usual field of activity.

NOTES

[1] Sketchbooks from Kennedy's Paris years and later contain several quick pencil impressions relating to this painting. Glasgow Museums Resource Centre

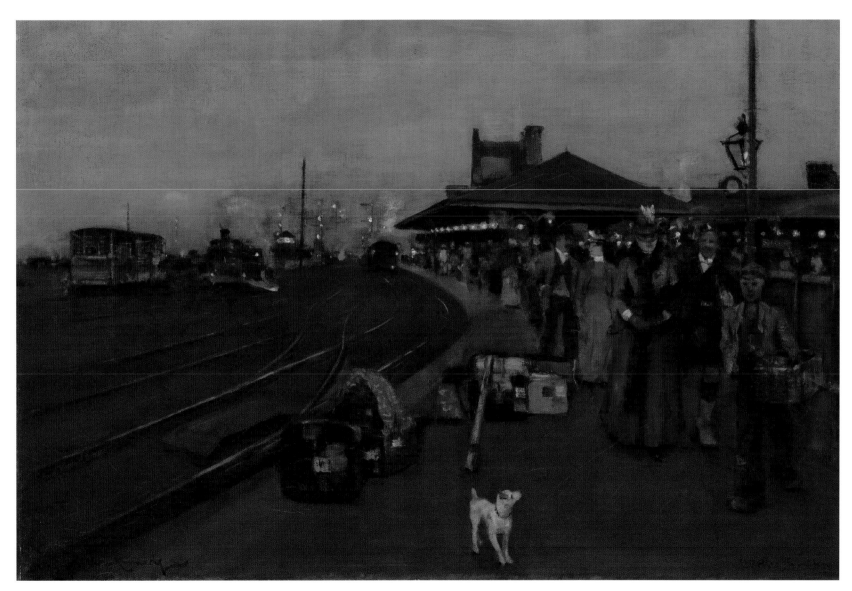

Cat.71
Stirling Station, 1887
William Kennedy
Oil on canvas
54 x 81.6cm
Kelvingrove Art Gallery and Museum

Lavery's 1888 Exhibition Paintings

The Glasgow International Exhibition of 1888 was held with the aim of raising funds for a much needed new art gallery and museum at Kelvingrove, in the city's west end (completed and celebrated by a second international exhibition in 1901). As well as a celebration of British (mainly Scottish), industry there was a significant element of art to which the Glasgow Boys contributed, although not as a coherent group. Commissions for allegorical figures in the corners supporting the dome of the main building were awarded to Guthrie (Art), Henry (Industry), Walton (Agriculture) and Lavery (Science), while Roche and Hornel were among those who painted other murals, all now lost.

The most memorable legacy of the exhibition, however, was provided by Lavery. Responding to the fantastic ambience created by the chief architect James Sellars, whose Moorish confection was dubbed 'Bagdad [sic] by Kelvinside', he painted a series of 50 small lively oils of generally high quality and delightful spontaneity. Lavery revelled in recording the display of modern life seen in the fashionable crowds and the daily entertainments, with the exotic touch provided in the Indian pavilions. The Kelvingrove exhibition provided a welcome oasis from grimy industrial Glasgow, whose face the Boys showed little inclination to portray in their paintings.

Lavery exhibited his 50 paintings in Craibe Angus's Glasgow gallery in October 1888,[1] and 30 were shown in Van Baerle Bros' gallery in Glasgow

in 1890. Lavery adopted a truly Whistlerian mood in some of these pictures; for example, the twilight view known simply as *The Glasgow International Exhibition* (Cat.102), which may be that originally titled *Fairy Lights*. The River Kelvin became *A View from the Canal* (Cat.107) because of the still nature of the water and

Cat.101
The Dutch Cocoa House, 1888
John Lavery
Oil on canvas
45.8 x 35.7cm
National Gallery of Scotland

the presence of the Venetian gondola. Van Houten's Cocoa House, sometimes referred to as *The Dutch Coffee House* (Cat.101), provided the interior setting for one of the most successful scenes. Lavery exercised his versatility with the brush in recording an array of different activities, times of day and light effects. The surprising angles and off-centre viewpoints of some of these compositions have led writers to propose that he used photography as an aid to his work, in the manner adopted by some of the Impressionists.

There is now firm evidence that photographs were the basis of his largest painting, *The State Visit of HRH Queen Victoria to the Glasgow Exhibition*, which the Executive Council commissioned from him and was completed in 1890. Lavery made a lively sketch of the scene (Cat.105) on 22 August 1888, the short time allowed him – barely 20 minutes – sufficient to make only a few colour notes of the temporary dais and canopy with surrounding crowd for future reference. The sketch therefore exhibits in parts the character of an abstract painting. A series of photographs of the event by official photographer and friend of Lavery, James Craig Annan[2] enabled the artist accurately to record the scene, and to depict all 253 official guests in the final enormous (256.5 x 406.4cm) painting (Kelvingrove Art Gallery and Museum). Individuals then posed for separate sketches by Lavery, mainly in his Glasgow studio, while he also took his own black and white photographs for added accuracy. These give a fascinating insight into his studio at 248 West George Street, with Japanese fans and tennis racquets decorating the walls and a number of the unsold exhibition scenes in their gold frames stacked against each other.[3]

The completed commission was well reviewed, though it may appear stuffy today without its impressive

William Leiper frame, a wartime casualty. More importantly, it was the stepping-stone for Lavery's future career as a portrait painter. Not only did Queen Victoria grant him a sitting at Windsor, as did some members of the European royal houses elsewhere, but he gained an entrée into the world of the industrial, social and artistic elite of the United Kingdom.

NOTES

[1] No catalogue has been traced. Titles of some surviving pictures appear to have been improvised or changed over the years.
[2] Glass negatives, found in Glasgow Art Club from 1984, were published in McQuade, BT (2006). *Sir John Lavery and his use of Photography at the Glasgow International Exhibition of 1888.* Glasgow, THAM van Asperen.
[3] McQuade, *op. cit.*

Right:
Cat.102
The Glasgow International Exhibition, 1888
John Lavery
Oil on canvas
61 x 45.7cm
Kelvingrove Art Gallery
and Museum

Helensburgh Watercolours

Helensburgh was of great importance to some of the Boys. At nearby Rosneath, Guthrie and Walton, joined by Crawhall, had found a secluded spot for one of their early artists' colonies, while affluent, fashionable Helensburgh provided the location for some of their most memorable depictions of modern life.

When Walton returned from Cockburnspath in autumn 1883, one of the first watercolours he painted was *Victoria Road, Helensburgh* (Cat.62), a view of one of the few curved streets in the grid-pattern town. The strategically placed Brougham coach, approaching horse, red-haired girl and nun-like lady, provided the essential compositional interest on a drab day. The handling is fluid, with a touch of the blottesque in the trees and grass, a lesson perhaps learned from Melville at Cockburnspath, but this is still quite a traditional watercolour, recalling the work of the ever-popular Sam Bough.

Walton went on to develop his own recognizable watercolour style, confident and mature, best exemplified by the picture now known as *En Plein Air* (Cat.68). Under the title *An Afternoon Walk*, it was one of a record total of nine pictures shown by him at the Scottish Society of Water Colour Painters exhibition of 1885, the year Walton was elected to membership, and which he recorded in tiny pencil drawings in Guthrie's sketchbook (National Gallery of Scotland).[1] The view up the slope of Sinclair Street, the main south–north

Cat.62
Victoria Road, Helensburgh,
1883
EA Walton
Watercolour
33.6 x 53.5cm
Private Collection

artery of Helensburgh's grid, is just outside Whitelaw Hamilton's home at Thornton Lodge, off to the left, location of Guthrie's memorable *Midsummer*, 1890 (Royal Scottish Academy, Edinburgh). The two ladies crossing the road, relatives of Walton, and the fast moving cab provide the compositional emphasis in what would otherwise be a featureless street. Fancy, fashionable clothing now makes an entry into Walton's work. The parasol, which became a *leitmotif* of many of the Boys' plein-air paintings of modern life, is also present, and Walton makes a play on short, dark shadows to indicate high summer. The expanse of the road is enlivened by a 'dry brush' technique that he seems to have taught himself, to create a variety of effects. In this case it is combined with the grain of the paper to give an impression of the gravel on the road.

Cat.68
En Plein Air or **An Afternoon Walk**, 1885
EA Walton
Watercolour
44.5 x 59.7cm
Private Collection

In a further display of skill, he has indicated carriage tracks on the surface by the method of wiping out.

Limited in palette, and with almost half of its area dominated by grey, this watercolour points to Walton's admiration of Whistler through its carefully balanced composition and restrained detail. Whereas a recorder of the modern scene such as James Tissot would have concentrated on incident, social custom and the fashions of the day, all precisely rendered, Walton goes for an overall balanced effect. Walton was, along with Guthrie, the prime mover behind the successful campaign for the purchase by Glasgow Corporation of Whistler's portrait of Thomas Carlyle, the first painting by the Boys' hero to enter a public collection.

NOTES

1. See MacSporran, F (1987). *Edward Arthur Walton 1860–1922*. Glasgow, Foulis Archive Press, pp.28–30. A sketch of Walton's oil *The Daydream* is also present on the page; it is debatable whether these are preliminary sketches or hastily done records of exhibited works.

Lavery's Studio or Parlour

A series of pictures by Lavery of models in the studio or parlour, painted either in France or in Glasgow in the 1880s, provide another aspect of modern life, as well as showing the artist's working environment. He uses his own paintings, finished or unfinished, as props to provide a background arrangement in a manner that owes a clear debt to Whistler, a device adopted also by Clausen, as in *La Pensee* (Kelvingrove Art Gallery and Museum). Thus in Lavery's *A Visit to the Studio,* 1885 (Private Collection), we see on the easel his half-completed *The Return from Market* (Cat.45). In *Between the Sittings*, c.1882 (Private Collection) he has propped against the wall his costume genre piece *A Conquest (or A Heart for a Rose)*, (Kelvingrove Art Gallery and Museum). *A Quiet Day in the Studio* (Cat.113), a more spartan interior, includes, complete with frame, a painting that could even pass for a Whistler, along with a few accoutrements hinting at the taste of the time, such as a Japanese fan and jars on the mantelpiece. The carefully worked chalk exhibition piece *Her Portrait* (Cat.111) explores this aspect further, showing a young woman admiring a picture on the easel, one of the contents of a portfolio in her hand, with a typical group of studio props carefully arranged on the side table.

Woman in Japanese Dress (Cat.115), the model for which may be the same as the woman in *A Quiet Day*, takes the interest in Japonisme a stage further. The enigmatic dedication 'To Miss Wagrez' may be the name of the lady, or perhaps a reference to someone he met while at Grez.

These interior scenes all breathe respectability. Lavery's studios are far tidier than the reality seen in the photographs of his Glasgow 1888 portrait sketches.[1] The ladies, be they professional models or not, are beautifully clothed. Perhaps the pinnacle of the parlour pictures is reached in two paintings of 1885. *The Finale* (Private Collection) exudes class in the luxurious décor, piano and the lady's blue dress. *A Visitor* (Cat.67) depicts a lady worthy of Tissot in the grandeur of her black dress, cape and accessories, posed against a Japanese lacquer§ed screen, further proof of the Boys' and Whistler's interest in oriental art.

Cat.67
A Visitor, 1885
John Lavery
Oil on canvas
46 x 46cm
National Gallery of Ireland, Dublin

NOTES

[1] See photograph on p.53.

Opposite:
Cat.115
Woman in Japanese Dress,
1883
John Lavery
Oil on wood
27.9 x 21cm
Yale Center for British Art

Roger Billcliffe

Hugh Stevenson

Away from the Easel:

Watercolours and Pastels

O il was the primary medium for most of the Glasgow Boys, with even the most prolific watercolourist, Joseph Crawhall, using oil paint in his early career. All of them worked on paper to produce drawings and sketches on the spot to use later in working up exhibition paintings, but about ten of them also produced exhibition paintings in watercolour.

Of these ten, Joseph Crawhall and Arthur Melville showed real brilliance, and their watercolours hold their own in comparison with work from any period. Among the other Boys, the most consistent and talented users of the medium were James Paterson and EA Walton. In the 1880s in particular, they extended the naturalist aesthetic of the Boys into watercolour, and were recognized for their skills and individuality of technique by their early election to the Scottish Society of Water Colour Painters (which received its royal charter in 1886).

Gauld, Lavery and Henry also made watercolours, but these did not form a high percentage of their output. Guthrie rarely ventured into the medium, but for three or four years from 1886 he experimented with pastel, becoming the most adept of the Boys in this demanding medium.

This chapter focuses on the key works Crawhall, Melville and Guthrie produced in these mediums.

Joseph Crawhall's Watercolours

Walton's portrait of Crawhall (Cat.117) shows him standing against two large canvases, with an inscription which originally read 'Joe Crawhall/The Impressionist/ By EA Walton/The Realist/Madrid 84'. Walton later painted out the subtitles and the word 'Madrid', which we have no record of his having visited. This action is evidence of how scornful the Boys were of the critics' attempts to categorize them. The term 'impressionist'

Detail from *The Aviary, Clifton* (Cat.139)

was commonly used at that time to denote painting that was free, sketchy, lacking in high finish, or simply modern, but Crawhall's mature style is unique, defying such definitions.

Crawhall turned early to watercolour painting. It is assumed that Melville influenced his technique at the outset, but there are echoes of Bastien-Lepage's square brush style in his Scottish and North African subjects of the 1880s. One characteristic shared with Melville and Walton was his depiction of intense, almost blinding light and deep, dark shadows. This is seen to advantage in views of Tangier (such as *Donkey, Tangier,* 1887 Cat.138), which he visited from 1884, and in the remarkable *The Forge,* (Cat.25).

Another outstanding composition using a fairly orthodox, but brilliant, technique on paper is *The Aviary, Clifton,* (Cat.139), which is acknowledged as having established Crawhall's reputation. The unusual viewpoint, leading to a startling reduction in scale of the two curious ladies, is something he may have learned through his penchant for Chinese and Japanese graphic art.

Cat.95
The White Drake, c.1895
Joseph Crawhall
Gouache on linen
40.7 x 57.1cm
National Gallery of Scotland

It was shortly after this that Crawhall started working in his hallmark technique of gouache on holland, a buff-coloured linen. It has not proved possible to establish a precise chronology,[1] but *The Race Course* (Cat.143) has been seen as an experimental example because of a lack of finish, although this could also be seen as a successful attempt to recreate the hubbub before or after the race.[2] Despite the artist's lifelong obsession with horses, this is the only one showing an actual course and stands – Kempton Park – that Crawhall exhibited.[3]

The White Drake (Cat.95) is usually held to be Crawhall's masterpiece. It epitomizes his classic technique, in which he built up the white areas layer by layer – a reversal of the approach in a standard watercolour – while one or two applications sufficed for the darker background areas. It is often said that Crawhall created these perfect gouaches from memory, following careful observation and analysis of the animal or bird in question. This assertion is borne out, perhaps, by the absence of related preparatory sketches and by reports that he frequently destroyed pictures that had gone wrong or with which he was dissatisfied.

In contrast to *The White Drake*, *A Black Rabbit*

Right:
Cat.117
Portrait of Joseph Crawhall,
1884
EA Walton
Oil on canvas
74.3 x 36.8cm
Scottish National Portrait Gallery

Far right:
Cat.25
The Forge, 1887
Joseph Crawhall
Watercolour
63.5 x 55.5cm
Private Collection

(Cat.141) casts its spell by a series of thinly applied semi-transparent black washes. *Horse and Cart with Lady* (Cat.142), which may be identifiable with *The Dog Cart*,[4] shows how contrasting thin and thick layers of dark and light can combine to make a harmonious arrangement. The composition, with half the cart and lady cut off at the left, and a daringly flat pattern formed by the kerbed flowerbeds, recalls Whistler, oriental art and even Degas.

NOTES

[1] Apart from two exhibitions, Glasgow 1894 and London 1912, Crawhall rarely showed his work or dated it after 1890.
[2] Similar technique, albeit in an orthodox watercolour on paper, is seen in *The Bullfight* (Cat.140).
[3] First shown at the Crawhall exhibition, La Société des Beaux Arts, Glasgow, 1894 (then Cat.29).
[4] Shown at the Crawhall exhibition, Paterson's Gallery, London, 1912 (Cat.39); the lady in *Horse and Cart* is thought to be Crawhall's sister Beatrice, with the head of the family dachshund partially visible at her feet. The 'cart' is strictly speaking a 'rally car', a model derived from the dog cart, particularly favoured by women.

Arthur Melville's Watercolours

Cat.132
The Sapphire Sea, Passages, 1892
Arthur Melville
Watercolour, 78 x 50.5cm, by permission of the Scottish
Gallery, Edinburgh and Ewan Mundy Fine Art, Glasgow

Arthur Melville stands out as one of the finest
watercolour painters of all time. He mastered the
medium in his own recognizable way, whether working
with an earthy palette, in the rustic realist manner of the
Boys, or with the intense colour and saturated light of his
Spanish, North African and Middle Eastern subjects.

Watercolour obviously suited his genius. It is hard
to point to any teacher or influence that shaped his
style, although the artistic excitement of Paris in the late
1870s and the example of Hague School watercolour
painters have been cited.

Fired, no doubt, by French and British Orientalist
painters such as Jean-Léon Gérôme and John Frederick
Lewis, Melville journeyed to Egypt, the Persian Gulf
and what is now Iraq in 1880–82. The intense heat
and light, the exotic, if at times grubby surroundings,
not to mention being attacked and left for dead by
robbers, had a profound effect on his artistic output.
He continually returned to sketches and memories of
this journey to create some of his most memorable
compositions. Some critics query whether their style and
subject matter fit rightly into the oeuvre of the Glasgow
Boys, but there is no doubt that Melville continued to
associate with the Boys and frequently adopted their
painting methods.

The technique he evolved has been described thus:

'…he was to work in water-colour on prepared paper.
This paper was impregnated with Chinese white, with

Cat.127
Awaiting an Audience with the Pasha, 1887
Arthur Melville
Watercolour, 66 x 100cm
Private Collection

which it was saturated again and again, and then finally rinsed, leaving a prepared surface… Then he applied his colour very wet with vigorous brush strokes sponging out any superfluous detail, and again ran in these clear blues and reds in rich transparent tones which he became expert in producing. Often he would put in his background on damp paper, sometimes very wet, according to the effect wanted, using umber to obtain his tone, and when this was nearly dry he would add the full bright patches of colour so characteristic of his painting.[1]

He applied this technique even in his sober-toned British landscape subjects, such as those done on his trip to Orkney with Guthrie in 1885. He used it more spectacularly when painting his Scottish autumnal scenes of 1893, *Brig o'Turk* (Cat.134) and *Autumn – Loch Lomond* (Kelvingrove Art Gallery and Museum). Here we can admire Melville's mastery of the blottesque, the practice of flooding large areas of the paper with fluid colours, which mixed together on the surface to create brilliant effects.

Awaiting an Audience with the Pasha (Cat.127) and *A Captured Spy*, 1895 (Kelvingrove Art Gallery and Museum) are the most dramatic of his Orientalist set pieces. In the former, praised as '*in the best contemporary French manner*',[2] Melville revels in the detail of the Ottoman setting, his skilful placing of the participants heightening the tension of the impending action. The latter picture, with its courtyard walls saturated by blinding light, reducing the figures to evanescent blobs, is equally effective.

The six visits Melville made to Spain between 1890 and 1899 inspired some of his most glorious watercolours. *The Sapphire Sea, Passages* (Cat.132) was described as '*one of the most remarkable works in the exhibition*' in which '*strong and deep colour is almost unequalled*'.[3] This view of the Basque port of Passages was one of several painted by Melville, including two known for many years under the titles *A Mediterranean*

Cat.133
The Little Bullfight: 'Bravo Toro', c.1892
Arthur Melville
Watercolour
56 x 78.8m
Victoria and Albert Museum

Port (Cat.131) and *Passages (Pasajes de San Juan)* (Cat.130). His travelling companion Frank Brangwyn also painted the subject. In *The Sapphire Sea, Passages* and the Glasgow painting, Melville uses the covering power of ultramarine to create a stunning velvety depth, as opposed to the translucency of conventional watercolour. This is a perfect foil for the dazzling white walls and busy little figures, some achieved by the skilful use of blank paper, some by the application of 'Chinese' (zinc) white.

The Little Bullfight: 'Bravo Toro' (Cat.133) is the star of Melville's bullfighting paintings, successfully capturing the atmosphere of blinding light, heat, dust and activity of the ring. The eye moves around the heaving crowd before alighting on the more sharply delineated group of matadors around the bull.

Melville was one of the few Boys who seemed destined to continue developing in an exciting way, until cut short by his comparatively early death at the age of 49. His remarkable on the spot watercolour *Dancers at the Moulin Rouge*, 1889–90 (National Gallery of Scotland), seems to presage the abstract paintings by Mark Rothko of 70 years later.

NOTES
[1] Mackay, AE (1951). *Arthur Melville, Scottish Impressionist 1855–1904*. Leigh-on-Sea, F Lewis, p.26; the passage was apparently written from personal reminiscence.
[2]*Glasgow Herald* review of the Royal Watercolour Society, London exhibition, 28 April 1888.
[3] *Glasgow Herald* review of first Grosvenor Gallery exhibition, 19 February 1893.

Opposite:
Cat.134
Brig o'Turk, 1893
Arthur Melville
Watercolour
60.8 x 86.4cm
The Robertson Collection, Orkney

James Guthrie's Pastels

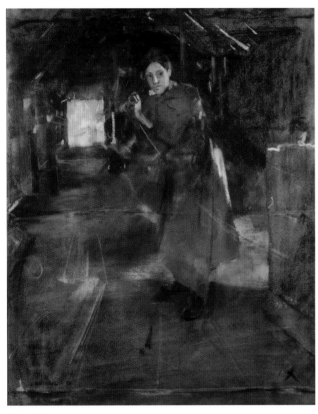

Cat.120
The Ropewalk, 1888
James Guthrie
Pastel
63 x 49.5cm
Private Collection

Once the Glasgow Institute of the Fine Arts acquired its own building (designed by JJ Burnet and opened in 1880), it needed to find exhibitions to ensure its year-round use. Many of these were of works on paper, which attracted the natural watercolourists among the Boys – Crawhall, Henry, Melville, Paterson, and Walton. Guthrie was not a regular exhibitor in these shows, and rarely seems to have made watercolours, although he produced many pencil, ink and chalk studies in sketchbooks related to his large oil compositions. Pastel drawings made increasingly frequent appearances at these small Institute exhibitions, the artists no doubt encouraged by the growing fashion for the medium in London, where the Grosvenor Gallery organized exhibitions devoted to it in 1888 and 1889. Guthrie's first recorded exhibits in pastel were at the Glasgow Art Club in 1888. They received favourable criticism, commentators suggesting that they were perhaps the start of something new for Guthrie. Certainly, at this time, Guthrie's commissions for portraits were building up and he rarely seemed to have time for the sort of figurative work in oil he had produced at Cockburnspath and Kirkcudbright a few years earlier.

Guthrie produced his first pastels at Cambuskenneth, near Stirling, where both Kennedy and Walton had studios. Their subjects are taken from the life of the village and its surrounding countryside – scenes of harvesting, views of the River Forth and

Top right:
Cat.123
The Morning Paper, 1890
James Guthrie
Pastel
48.2 x 61cm
Private Collection

of Stirling, and a group centred on the rope works at Cambuskenneth. *The Ropewalk* (Cat.120) is the most substantial of these, a return to the simplicity of composition of *A Hind's Daughter* (Cat.28). It was shown perhaps at the New English Art Club in London, then in the Glasgow Institute's Black and White exhibition in the autumn of 1889, and later at the first Glaspalast exhibition in Munich in 1890.

A second series of pastels centred on life in Helensburgh, where Guthrie had lived in the 1880s. This series contains views of the town, the shore, the farms around it, navvies working on the new West Highland Railway and also a group of studies of middle-class Helensburgh life (including *Firelight Reflections*, Cat.122, *Tennis*, Cat.124, *Causerie*, Cat.125, *The Morning Paper*, Cat.123, and *Candlelight*, Cat.121), similar to the watercolours that Walton had been producing there for some years. Young ladies taking tea, reading, making music, playing tennis are the main subjects here. The complete series was exhibited at Dowdeswell's in London in 1890. Presented rather enigmatically without titles they attracted critical approval but no sales. When the exhibition was repeated later at Lawrie's Gallery in Glasgow every picture sold.

Bottom right:
Cat.121
Candlelight,
1890
James Guthrie
Pastel
42.5 x 51.5cm
Private Collection

Kenneth McConkey

The Glasgow Boys
in the 1890s

No group's more free of unpictorial claim —
Pictorial magic is its only aim.
The men are young, the best is yet to be,
What is to come not even they foresee.
Tis where a new convention may arise
To gladden more than Caledonian eyes …[1]

Cat.87
Miss Wilson, 1890, James Guthrie
Oil on canvas, 105.5 x 108cm
Private Collection

An odd and uncomfortable event occurred in May 1893 when two Scotsmen visited a studio in Paris. They went there with the dissolute, bohemian Charles Conder, to meet Louis Anquetin, an artist with a bubble reputation, glowing briefly in the penumbrae of Paul Gauguin, Emile Bernard and Toulouse-Lautrec. Dressed in sweater and corduroys, the cool Anquetin, we are told, looked like an athletic hidalgo. His radicalism had now turned to crude recaps of earlier work and more conventional landscapes of the Seine valley. Of the two Scots, the younger, Dugald Sutherland MacColl, may have hoped for more from his friend James Guthrie, since as sons of the kirk, they had much in common. But Guthrie sat 'prim and natty' by the door, and of Anquetin's *pastiches et mélanges*, all he would say was – 'Not central, not central'.

Of course, he was probably right; yet this awkward encounter revealed someone loathe to 'come out of his shell', and while he talked more freely in private with MacColl about the recent successes of the Glasgow Boys, he must also have realized that a chasm had opened between his older, more bourgeois artists' circle and those who were currently slumming it in the ateliers.[2] Not that Guthrie could empathize completely. His Paris experience, regarded as essential by most of his contemporaries in the west of Scotland, had been brief. He had been hailed for arriving early at a thorough-going rural naturalism, without ever painting in the French countryside, and by the late 1880s, had slipped into the comfortable regime of portrait painting, which he maintained for the rest of his career. At first this was no retreat – portraiture was the most hotly contested genre of the day – and with young MacColl, he exchanged opinions on John Singer Sargent in those Parisian summer conversations.

The drift away from painting *en plein air* was already happening when in 1887, the Boys discussed forming a 'brotherhood', exerting more influence in the forthcoming Glasgow International Exhibition and asserting themselves forcefully in annual Institute of the Fine Arts exhibitions.[3] Within a year Guthrie's stern, solid painting, reminiscent of Bastien-Lepage, had given way to a light, lyrical touch when he painted the portrait of the 'blossoming' 16-year-old, Constance Wilson, daughter of Glasgow retailer Walter Wilson (Cat.87). The 'elusive charm' of his subject was revealed in what were regarded as 'profound and moving harmonies'.[4]

Suave, well-read and 'with a clear melodious voice', Guthrie was already prime material for the Royal Scottish Academy, and with his acceptance of an Associateship in November 1888, the group immediately risked compromise with the Edinburgh establishment.[5] Arguments to this effect were ongoing and they remained unresolved in the summer of 1893. For his part, MacColl, art correspondent of *The Spectator*, may well have recognized reluctantly the importance of Henry, Hornel, Guthrie, Kennedy, Lavery, Melville, Roche and Walton, but he later confessed finding it difficult to be 'completely fair' to them, questioning their ability to develop as a group.[6]

The Grosvenor Gallery

No doubt Guthrie reminded MacColl about the reputation his fellows had already gained at home and abroad, recalling for instance that Lavery, awarded a 'wooden spoon' for *The Tennis Party* (Cat.66) at the Royal Academy in 1886, had won a gold medal with the same unaltered picture in the Paris Salon two years later.[7] Supported by dealers such as Craibe Angus, Thomas Lawrie and the most avant-garde of

all, Alexander Reid, the painters collectively realized, as they looked up from Kelvinside to the opulent terraces of Park Circus, that Glasgow's 'merchant princes' with their adventurous purchases of French and Dutch art, were ripe for the challenge of home-grown talent.[8] The way to open this market was to achieve recognition at home and abroad through collective action. The brotherhood idea was fortunately never formalized under William Kennedy's leadership.[9] As one writer later observed, they escaped the 'dullness' that 'creeps in with the purchase of a minute book'.[10] The series of migrations between town and country studios continued as Kennedy was established at Stirling, EA Walton worked nearby at Cambuskenneth, and Henry and Hornel decamped to Galloway – with Glasgow as the hub. Recognition gradually came when compilers of 'Art Extras', supplements to local illustrated papers, extracted their works from the throng of exhibits at the annual Glasgow Institute shows and began to illustrate them side by side [Fig.32].[11] Following the success of their showing at the Glasgow International Exhibition, the social buzz of the Glasgow Art Club, the launch of *The Scottish Art Review*, and the club's great costume ball in 1889, they were finally offered, in 1890, what became known as the 'Impressionist' room at the Glasgow Institute of the Fine Arts.[12] Here they showcased their own work, with that of New English Art Club (NEAC) allies from south of the border, Theodore Roussel, Walter Sickert and others, and it was obvious from works like Henry's *Galloway Landscape* that the 'Scottish Impressionists … have never sold themselves to the devils of Pink and Purple' like their southern counterparts.[13]

A meteoric rise was triggered. George Clausen, one of the original NEAC rebels, suggested to Sir Coutts and Lady Lindsay, proprietors of the Grosvenor Gallery

Fig.32
Quiz Art Extras, Pictures at the Glasgow Institute of the Fine Arts, No 1, supplement to *Quiz*, 10 February 1888

Fig.33
The Grosvenor Gallery of Fine Art, New Bond Street, from the *Illustrated London News*, 5 May 1877

in New Bond Street [Fig.33] that the Glasgow group be invited to submit work to their forthcoming summer exhibition and despite the ruinous state of their finances in this, their final year as gallery owners, the Lindsays concurred.[14] Thus, in high spirits Guthrie, Lavery, Corsan Morton and Harrington Mann met at Glasgow's Central Station on 1 May 1890 to catch the train to London for the opening of their first group exhibition outside Scotland.[15]

The journey south was both real and symbolic – every train whistle through the English countryside reinforced the collective identity. With its canonical sequence of pictures, including Melville's *Audrey and her Goats* [Fig.34], Henry and Hornel's *The Druids – Bringing in the Mistletoe* (Cat.58), Roche's *Garden of Girls* (untraced) and Lavery's *Dawn after Langside* (Private Collection), the Grosvenor exhibition quickly assumed folkloric status. Of these the first was by far the most talked about. 'But if we have neither Shakespeare's Audrey nor Nature's grass', wrote one reporter, 'we have at least a novel and original specimen of impressionistic art'. Another interpreted Melville's large canvas as 'a militant protest' and 'the newest *pronunciamento* from the impressionist camp', while a third regarded its foreground texture as the artistic equivalent of 'the spotted horse in the toyshop'.[16]

The term 'impressionist', by this time common in art parlance, would come back to haunt the entire group. More thoughtful writers craned their necks to see Henry and Hornel's *The Druids – Bringing in the Mistletoe*, which had been 'skied' by the hangers. Some of these recognized its promise, while puzzling over its shamanistic content.[17] Here was a stern riposte to the limp legends of the Burne-Jones followers who were multiplying in the rival New Gallery.[18]

Eccentric or not, the homogeneity of new Scottish painting was obvious to the London audience in its strong colours, bold handling and decorative intensity.[19] The Glasgow School quickly became the Grosvenor swan song – an event quoted as a watershed in emerging accounts of contemporary British painting. Some might quibble over the use of the terms 'school' or 'movement', but there was no mistaking 'the similarity of motive and common elements of strength that lurked behind the vigorous diversity of the Glasgow men'.[20] There was consternation that a place like Glasgow, with its grimy working-class wynds and closes, should produce anything other than the hackneyed 'Highlandism', sanctioned by the Academy in Edinburgh.[21] Looking back over five years it seemed to one energetic supporter that having lost some of their best Pre-Raphaelite painters to other exhibitions, the Lindsays had held their 'best trumps in reserve'. This was after all, the same 'greenery-yallery' gallery of Whistler and Oscar Wilde which opened back in 1877, established the reputations of artists as diverse as Burne-Jones and Bastien-Lepage, and had, in one final flourish, conceded most of its wall space to young, risky Scots painters, who, in the opinion of one observer, 'cast [other exhibitors] hopelessly into the background'.[22] The Scots proposed a robust, richly textured alternative to both Sickert's weak and confusing exhibition of 'London Impressionists' and to the grey tonalities of the Newlyn School, bringing 'freshness and importance to the show' and adding, in the words of one reviewer, 'that element of novelty which we have seen to be wanting at the Royal Academy and at the New Gallery'.[23]

Munich

The Grosvenor Gallery show reaped a whirlwind of plaudits abroad and hostility at home. Two selectors for the forthcoming International Exhibition in the Munich

Left:
Fig.34 *Audrey and her Goats*,
1884–9
Arthur Melville
Oil on canvas
204.5 x 213.5cm
Tate

Right:
Fig.35 *Summer*, 1891
EA Hornel
Oil on canvas
127 x 101.5cm
Walker Art Gallery, National
Museums Liverpool

Glaspalast were so impressed by it that they imported the Glasgow pictures en masse and devoted three rooms to them.[24] The effect was immediate: a lengthy encomium written by Fritz von Ostini mythologizing the group was published in the German papers and translated for Scottish readers. Elsewhere it was reported that 'critics and painters come to study it [Glasgow School painting] from the remotest corners of the Fatherland. To study it? They come to adore it, like the Magi in the New Testament'.[25] Recalling the display, the German art historian, Richard Muther repeated what by 1896 had become the mantra – Glasgow, a grim industrial city, had unexpectedly produced 'a style of painting which took its origin from decorative harmony, and the rhythm of forms and masses of colour … [which were] full, swelling, deep and rotund, like the sound of an organ surging through the church at the close of a service'. Such was the enthusiasm that the painters were invited back the following year with portraits and landscapes 'which cast into the background almost everything by the English'.[26] The effect, Richard Muther contended, was to bring a more 'sonorous harmony' to German and French painting.[27] From now on, Glasgow artists were welcomed at the Paris Salons and German Secessions.

Liverpool

By contrast, anywhere in Britain, outside Glasgow, was a good deal more contentious. This was abundantly illustrated in the autumn of 1892 when the Boys' work was to be given a separate room in the annual Liverpool Autumn Exhibition at the city's Walker Art Gallery. By convention, key pictures from the London spring shows were circulated to northern cities after the closure of the Royal Academy, and from there unsold

works went to a further round of annual shows in Dublin, Glasgow or Edinburgh. A specially arranged display of Glasgow School paintings was, in some senses, a departure from this general practice, although in the previous year, Whistler had been similarly featured in Liverpool.[28] Benign curiosity congealed into open hostility when the Arts and Exhibitions Sub-Committee of Liverpool Council proposed the acquisition of Hornel's *Summer* [Fig.35]. The local papers had described the picture as 'an old woman's patchwork quilt' or 'landscape sampler such as our great grandmothers were wont to work in their long winter evenings'.[29] Such is its degree of abstraction and spatial flattening that comparison with Walton's *A Daydream* (Cat.34) is instructive. Where Walton's children and cattle in a wooded glade take on the naturalism of Bastien-Lepage, Hornel's emerge

in decorative cadences that reveal an artist playing, in MacColl's opinion, 'as a musician with notes'.[30] Amidst cries of derision, the City Council asked its sub-committee to think again, but when its radical Deputy Chairman, Philip Rathbone, threatened to resign, it caved in and agreed to the purchase. In the midst of the furore, George Moore penned an amusing philippic on 'The Alderman in Art', recounting the discussion in the Liverpool chamber when Hornel's 'daub' was discussed. The Glasgow school had yet to be 'recognized by the public', a councillor proclaimed, and as aldermen 'we are here to supply the public with what it wants'. To shrieks of laughter another councillor, a certain Dr Cummins, compared the acquisition of pictures to that of 'cattle in the parish pound'. 'The corporations of Manchester and Liverpool', Moore ruefully concluded, 'do not seem to have grasped the fact that there is no real analogy between a picture gallery and a dressmaker's shop'.[31]

There is no shrinking from the fact that exhibition pieces by individual members within the group played up different qualities and characteristics. None of the archaising details inserted in *Summer* are found in Guthrie's contemporary *Midsummer*, 1892 [Fig.36] and Roche's *Idyll*, 1892 [Fig.37]. While not lacking in charm, Guthrie's women in the shady bower at Helensburgh are resolutely of the present. For Moore they provided 'a delicate and yet a full sensation of the beauty of modern life from which all grossness has been omitted …', in striking contrast to Roche's ambitious attempt to enlarge the scope of intimate, familial conversation.[32] Indeed Roche was trying to do everything expected of a modern painter. Puvis de Chavannes had painted classical idylls on the great themes of nature, cultivation, and maternal nurture, but not *en plein air*; at the same time, around 1892, Salon naturalism, a byword for plein-air effects in painting, was mutating partly as a result of the growing consciousness of Impressionist methods. All of these things were coming together.

Fig.36
Midsummer, 1892
James Guthrie
Oil on canvas
99 x 124.5cm
Royal Scottish Academy,
Edinburgh

Fig.37
Above left:
Idyll, 1892
Alexander Roche
Oil on canvas
1841 x 1590cm
Mackelvie Trust Collection,
Auckland Art Gallery
Toi o Tamaki

In the teeth of external acclaim and domestic dissent the old enmity between Glasgow and Edinburgh resurfaced with a vengeance. The former may boast itself as the Second City of the Empire, but the latter was Scotland's capital. The Royal Scottish Academy vacillated between grudging acceptance and open hostility to its western neighbour. At the prize giving for students at the Glasgow School of Art in February 1892, Sir George Reid, the RSA's frustrated new president alluded to the latest 'isms' and to the 'devoted band' of impressionist 'followers' in the city, but shied away from more overt criticism. The tone of voice was enough. Hackles rose, and for the next seven days the letters' columns were filled with outrage.[33] How dare he come from Edinburgh with these insinuations? Circumspection ruled however, for almost a year until, in an interview in *The Westminster Gazette*, Reid returned to his ruminations on 'West of Scotland Impressionism', stating boldly, 'I dislike young artists going in for that sort of thing'.[34] Even as Walton and Lavery were being adopted by the Academy, the flames of anger were rekindled. Sensing good copy, the editor of *The Art Journal* appropriated the dispute and canvassed the opinions of sympathetic painters south of the border. Although some considered withdrawing from the RSA in protest, the Boys wisely kept their counsel, sensing perhaps, that London, the next battleground, with its art world orthodoxies and breakaway sects, was much more problematic. Unable to draw the painters themselves, the journal commissioned the young James Lewis Caw to write about the current 'phase of Scottish Art', but this did not appear until early in 1894. 'Because of its greater complexity of artistic motive', new Scottish painting has, Caw believed, ' … been least understood and most misrepresented'. He was no doubt thinking of Reid and his supporters while attempting to steer a path between these and the firebrands, Henry and Hornel, who typified the group at its most extreme.[35]

The Grafton Gallery

London remained a formidable challenge. The Glasgow painters had resigned en bloc from the New English Art Club in 1892, when its jury rejected one of their works in favour of those of untried Slade students.[36] Regarded as the most sympathetic venue for the avant-garde, the club's internal politics, not least rumbling disputes over the terms 'new' and 'English', were fraught.[37] The Royal Academy, while appearing more tolerant than its Edinburgh equivalent, gradually retrenched in the 1890s, losing all of the Boys by 1898.[38] London was nevertheless dynamic: the formation of the Society of Portrait Painters in 1891, for instance, created new opportunities for the likes of Guthrie and Lavery and these two painters had already stepped out of the group to stage solo exhibitions in 1890 and 1891.[39] When the eagerly awaited Grafton Gallery opened with its First Exhibition Consisting of Paintings and Sculpture by British and Foreign Artists of the Present Day on 18 February 1893, the Glasgow painters again were out in force – to such an extent that they outnumbered other British contributors.[40] Widely tipped as the Grosvenor's replacement, this resplendent new venue courted the work of DY Cameron, Crawhall, Millie Dow, Gauld, Guthrie, Lavery, Melville, Roche and Walton within an impressive roster of prominent French, German, Swedish, Italian and American exhibitors.[41] Once again it must have seemed that Glasgow sought to dominate all potential British rivals, and the comments this time were generally favourable.[42] MacColl struck the one significant discordant note, launching into the 'stupid hanging' that placed a 'yellow' Orchardson beside a

'purple' Lavery.[43] The Octagon Room where Gauld's *June* and Guthrie's *Miss Wilson* jostled with Whistler's *Arrangement in Black*, *Lady Meux*, 1881–2, Emile Claus's *Soleil d'Arrière Saison*, Jean-François Raffaelli's *Clemenceau Addressing His Montmartre Constituents*, 1885, and a Spanish study (unidentified) by the American, William Turner Dannat, was too densely packed [Fig.38]. Yet, while conceding that the Boys had 'pictorial ideas', MacColl noted that Henry and Hornel's colour was 'Japanese in intensity but not in coherence' – a prescient remark, given their imminent departure for Japan on a trip that would last 19 months.[44]

If there were good passages in Roche, Walton and Guthrie, they were not sufficient to satisfy MacColl.[45] In the light of these recent utterances, Guthrie's reserve was understandable when they met a few months later in Paris. In any case MacColl's reservations had been exceptional. Roche, 'modern of the moderns', was praised for *Idyll*, while Hornel's *Summer*, that controversial Liverpool acquisition, was equally applauded.[46] Both pictures were fantasies of an ideal world of sensual delight conceived in the most vibrant colours and there was little European art on display to match them – with the sole exception, in a very different idiom, of Degas' much earlier manifesto of urban naturalism, *L'Absinthe* [Fig.39]. The furore that gradually emerged around this painting may well have prompted Henry's brief return to city street subject matter in works such as *The Milliner's Window* [Fig.40] and *The Fruiterer*, c.1894 (Private Collection).[47] Keen observers might have noted that the marquetry of pavement slabs in the foreground of *The Milliner's Shop* echoes the zig-zag of table tops in *L'Absinthe* – but they did not.

The overall cohesion of Glasgow School painting that had been assumed up to this point was becoming less and less obvious. Surveying the scene, Caw noted that with 'customary exaggeration' Henry

Fig.38 The Octagon Room at the Grafton Gallery, 1893, from *The Sketch*, 1 March 1893, p.277

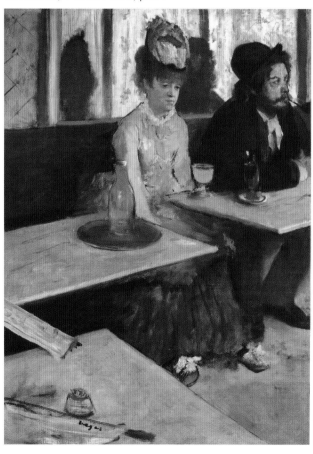

Left:
Fig.39 *Dans un Café: L'Absinthe*, 1876, Edgar Degas oil on canvas, 92 x 68cm Musée d'Orsay, Paris

Fig.40
The Milliner's Window, c.1894, George Henry Oil on canvas, 89 x 54cm Private Collection, photo courtesy, Sotheby's

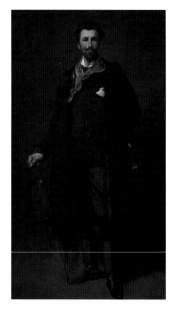
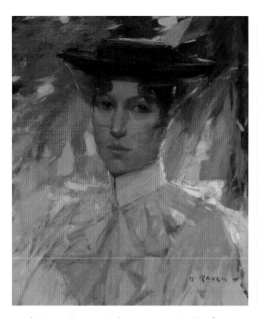
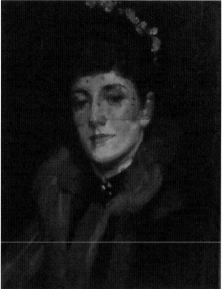
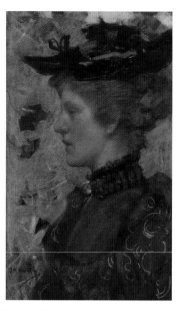

Above from left to right:
Cat.91
RB Cunninghame Graham,
1893, John Lavery,
Oil on canvas, 203.2 x 108.2cm
Kelvingrove Art Gallery
and Museum

Cat.93
Portrait, c.1893–4
David Gauld
oil on canvas, 51 x 40.5cm
Private Collection

Fig.41
The Face Veil, 1892
John Lavery
oil on canvas, 46 x 35.5cm
Private Collection

Cat.88
Miss Elizabeth Reid or *Auburn*,
c.1893, EA Walton
Pastel, 67 x 37cm
Kelvingrove Art Gallery
and Museum

and Hornel were taken as 'typical' of a group that contained the 'impressionist' and 'contemporary' in Guthrie and Lavery.[48] Indeed, looking at the latter's *RB Cunninghame Graham* [Cat.91] at the Salon in that year, one would be forgiven for thinking it recherché. Lavery was locked in the complex visual dialogues of contemporary portraiture that spun around hispagnolisme. He, Mann and Melville had recently paced the long first floor gallery of the Prado exchanging glances with the court clowns and dwarfs of Velázquez and the effects were obvious. The Spanish master's subtle syntax of colour and tone, his suave brushwork, his hermetic 'impressionism' winningly described by RAM Stevenson, led off in a different direction – one with which Cunninghame Graham's 'hidalgo' appearance seemed to concur.[49]

Nowhere is this clearer than in the small 'fair women' head studies of Gauld, Kennedy, Lavery, Roche and Walton in the early nineties (Cat.88, 93) [Fig.41].[50] Each of these is more than a portrait. In an age when provincial face painters would labour over photographic

likenesses, these works often deliberately obscured the features with millinery, fur and veils, giving a profound sense that we, the observers, are being observed from behind a protective screen. In their animation, the pictures often simulate a moment of encounter. Here were fleeting 'infantas' to rival any by Manet, Whistler and Sargent.

Discerning visitors to the Grafton could also see that Glasgow painting was having a deeper effect among the rising stars of British painting. Frank Brangwyn, exhibiting *The Buccaneers* [Fig.42] had completely abandoned comforting Cornish greys in favour of bright emblazoned colours. In the previous summer he had travelled by train, mule and barge through Northern Spain in the company of Arthur Melville, and observing Melville's extraordinary ability with blocks of bright colour at close quarters was a revelation.[51] Melville's principal objective was *The Contrabandista* (Cat.90), a scorched landscape punctuated by a distant mule train, its empty foreground segmented by the blue shadows of unseen poplars.[52] Monet's motif is beyond the frame of a picture that is

more accurately Post-Impressionist than Impressionist.

The cumulative effect of the Glasgow School was 'stunning', and in such glittering international company Elizabeth Robins Pennell could confidently conclude that the Boys' show of strength at the Grafton threatened 'to cut the ground from under our London Impressionists' and 'emphasises the mistake of the New English Art Club in losing them as exhibitors'.[53] Two years later, she returned to her hobbyhorse, arguing that while the New English was perceived as the home of the 'accomplished student and disciple' and,

'… it is from Glasgow … and not from the Scottish Academy and the schools of London, that modern British art has received its strongest impetus; it is to Glasgow one now looks for that art's most brilliant achievement'.[54]

America

Caw's article in *The Art Journal*, a long anonymous piece in *Blackwood's Edinburgh Magazine* and Pennell's *Harper's New Monthly* essay effectively reinforced the Boys' importance at home and introduced them to a wider audience in the United States. Pennell's publication coincided with the entrepreneurial activities of Charles M Kurtz, art selector for the St Louis Exposition and Music Hall Association. In the spring of 1895 Kurtz arrived in Glasgow, toured the studios and with Alexander Reid's assistance, scooped 125 canvases for his forthcoming exhibition which was scheduled to tour to the Art Institute of Chicago, the Cincinnati Art Museum and the Pennsylvania Academy of Fine Arts, ending in Klackner's, a dealer's gallery on West Twenty-eighth Street in New York.[55] His arrival, just when Hornel was about to open his exhibition of Japanese pictures at Reid's gallery, was also significant. Among the recent works packed for the States, two were Japanese Hornels (including *The Balcony, Yokohama*) (Cat.77) along with *Alice* by Walton [Fig.43], *Edith* by Gauld,

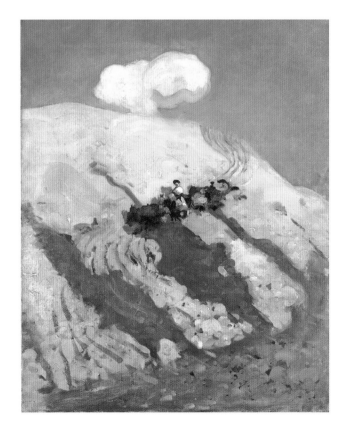

Fig.42
The Buccaneers,
1892–3
Frank Brangwyn
Oil on canvas
205.7x 231.1cm

Cat.90
The Contrabandista,
1892
Arthur Melville
Oil on canvas
101.5 x 56cm
Collection Miss Flure Grossart

Cat.77
The Balcony, Yokohama,
1894
EA Hornel
Oil on canvas on panel
40.6 x 50.5cm
Yale Centre for British Art

c.1894 (untraced), and enchanted woods and spring idylls by Macaulay Stevenson, Millie Dow and Roche. Henry and Lavery were not represented, and Guthrie only by older works.[56] Of the 116 paintings in the final catalogue, that which best typifies the school was Walton's *Alice*, a picture that exudes the confidence, ease and spontaneity of his best work. Walton's subject was classic. When in London, his country child with her straw hat would be sacrificed for the vague symbolism of *The White Flower*, (Cat.96), but at this moment, fleeting effects, instantly rendered, the flash of youth, the *jeune fille en fleurs*, essayed by Walton's compatriots – Gauld, Guthrie, Henry, Hornel, Kennedy, Lavery and Roche – epitomized the School.

Glasgow painters were immediately taken up in annual international exhibitions in Philadelphia and Pittsburgh from 1896 onwards, and group members were invited to act as jurors.[57] Having acquired his own

Fig.43
Alice, 1894
EA Walton
Oil on canvas
86.2 x 72.4cm
Private Collection
Photograph courtesy
Sotheby's

collection of their work, Kurtz tended the flame, and in 1905, after his appointment as the founding director of the Albright Gallery in Buffalo, toured a further exhibition of the Boys' work.[58]

New Wave Followers

In the studios of St Vincent Street, Bath Street and West Regent Street, and the well-heeled suburbs of Pollokshields and the West End, Pennell's eulogy is likely to have been received as the movement's first hagiolatry. It was now rapidly expanding, with artists such as William Mouncey, John Reid Murray, WHP Nicholson, George Pirie and Grosvenor Thomas being added to the selection for North America. Even the Royal Scottish Academy could no longer refuse to heed the call when it was noted in 1895 that 'what distinction the Edinburgh exhibition enjoys is mainly due to the contributions from Glasgow'.[59] Young Scots painters of the mid-nineties, those from the eastern industrial cities of Dundee and Aberdeen, such as William James Yule, Robert Brough, and David Muirhead, were seen in the reflected light of the Boys, and treated as new wave followers.[60] At the same time, with talented 'Glasgow Girls' such as Bessie MacNicol, Lena Kennedy and Stansmore Dean emerging, the basis of the Glasgow movement was broadening to encompass almost every ambitious young Scottish painter.[61] Virtually all of these artists painted colourful Roche-style idylls, and in this self-confident atmosphere the perceptive young JD Fergusson could easily differentiate between 'paint that expressed the envelopment of things in light, low tone or bright …' and the more hackneyed styles of many contemporaries south of the border. And in general, he noted, 'their own people backed them'.[62]

This new painting was not only supported by Clydeside's merchant princes; after the *Harper's* article, it also spawned its own literature and widely disseminated illustrations – the radical literary magazine *The Yellow Book*, for instance, devoted all its plates to Glasgow painters in January 1896. A story was unfolding that rapidly risked hyperbole. With the appearance of David Martin's monograph the following year, a status equivalent to that of the Flemish, Venetian and Dutch schools of the sixteenth and seventeenth centuries was claimed for the movement by no less an authority than Francis Newbery, Director of the Glasgow School of Art.[63] This seemed almost sacrilegious to some. The anonymous critic of *The Saturday Review* contended that the book was 'the hardest reading we have done for many a day' and marred by 'fatuous exultation and unintelligibility'.[64] The invective may well have been stoked by the knowledge that following Melville in 1889, Walton, Lavery and Guthrie had all purchased houses in Kensington and Chelsea and, dissatisfied with their reception in the capital, were planning a 'long-waited' artist-led rival exhibition to both the Academy and the NEAC.[65]

The International Society

Informal meetings had been taking place for two years, but by 23 December 1897, with Lavery in the chair, the time was right. Whistler, now living in Paris and in his mid-sixties, was adopted as President of what would be grandly named the International Society of Sculptors, Painters and Gravers.[66] He immediately tested the diplomatic skills of the organizers by insisting on exceptions to rules he had previously approved, and by being pernickety on the display of his pictures and the look of the exhibition as a whole [Fig.44].

Lavery, with whom he communicated by letter,

was often left to pick up the pieces – almost literally on the occasion when British packers smashed Rodin's plaster sculptures, fitting them into their cases.[67] Nevertheless, from the start members of the Glasgow School dominated the International Society. Five of its 14-strong executive committee and 40 of the 200 artists included in the first exhibition were Scots. Vague symbolism was represented in Millie Dow's *Herald of Winter* [Fig.45] and Paterson's *In Arcady*, c.1897 (untraced); landscapes were provided by MacGregor and Gauld; portraits included Walton's *Mrs James Mylne*, c.1897 (untraced) and Guthrie's *Miss Jessie Martin* [Fig.46]. Crawhall showed three works, *The Black Cock, Pigeon*, both c.1894 (the Burrell Collection) and *Huntsman*, c.1894 (National Gallery of Scotland, now known as *The Whip*) which describe their subjects accurately, while Henry's *Goldfish* and *Spring*, both c.1897 (untraced) were in fact 'aesthetic' pictures of young women caught in moments of reverie.

Lavery showed three pictures at the first International – *A Garden in France* (Cat.97) *Mrs Plowden* and *Humphrey*, 1897 (untraced) and *Portrait Group* (*Père et Fille*) [Fig.47] – the first depicting a scene at Marlotte in the previous summer where, under the trees close to the river, he caught sight of two women and a child at a garden table, enveloped in foliage. An empty bench, on the left, is carefully studied, while the woman and child with their backs to the viewer are almost obscured by hollyhocks. It was to be one of Lavery's most overtly impressionistic pictures.[68]

With these pictures the Boys had seized the moment.[69] When it opened in May 1898, the exhibition was hailed a critical success.[70] 'The most interesting exhibition … now to be seen in the capital', was how one paper described it.[71] If you thought that the first exhibition was representative of artistic trends

Left:
Fig.44 The International Society of Sculptors Painters and Gravers, The Whistler Wall, 1898, from *The Art Journal*, 1898, p.249

Below:
Fig.45 *The Herald of Winter*, 1895, Thomas Millie Dow, oil on canvas, Dundee Art Galleries and Museums, Dundee City Council

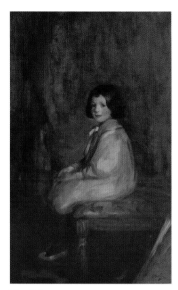

Fig.46
Miss Jessie Martin, 1896–7
James Guthrie
Oil on canvas
142.3 x 94cm
Private Collection, photograph
courtesy of Bonhams

in Europe, you would also be likely to conclude that new Scottish painting must be leading the way. While further comparisons were made with the New English Art Club, now in the grip of Slade School orthodoxy, with MacGregor as the only leading Scots exhibitor, the Glasgow Boys had effectively introduced a British equivalent of the new Salon and the European secessions, such that when its third exhibition was staged in 1901, a critic wrote,

If we look at Paris, Berlin, Vienna, Munich, Dusseldorf, or St Petersburg, we see 'Secessionist' written in bold characters – ie the artist who has voluntarily withdrawn himself from academic association. The term implies the acknowledged right of perfect personal freedom … To mark the freemasonry which unites them … the International Society was called into life.[72]

Some discord greeted this general approval. MacColl broke cover to express doubts about the project to create the 'same sort of international exhibition' as the Venice Biennale. With Whistler so centrally involved in the enterprise, it was difficult to be dismissive, however there was 'too much Glasgow painting' and too many return favours to 'the foreigners who have shown [the painters] hospitality at the Champ de Mars and Munich'.[73] Tackling Lavery's *Père et Fille* [Fig.47] in particular, he declared that Glasgow School painting as a whole revealed the lack of 'an adequate system of drawing'. True to the rigour of Slade and Westminster School of Art draughtsmanship that was now becoming almost a religion, MacColl really spoke on behalf of the New English. At this point, the club no longer represented the broad modernist church, and even he felt obliged to concede 'a large part of Europe disagrees with me'.[74] Europe did indeed disagree: within two years, after some reworking, *Père et Fille* was

purchased for the Musée du Luxembourg – a further confirmation of the importance of the Glasgow School.[75]

Having secured a regular London presence, Glasgow painters were accorded designated space in further British provincial exhibitions. The Manchester Autumn Exhibition, for instance, allocated a room to the Scots in 1899, observing that while 'no longer as united as it was,' this was 'a welcome sign of growth, not of failure'. '*Indeed the abundance of fresh, interesting work that comes out of Scotland attests the importance of that movement in the artistic life of our day*'.[76]

Henceforth, clusters of Scottish pictures – often

Fig.47 ***Père et Fille***, 1898–1900, John Lavery
Oil on canvas, Musée d'Orsay, Paris

including works by Mouat Loudan, Whitelaw Hamilton, David Gauld, Bessie MacNicol, Austen Brown, Reid Murray, AK Brown, Coutts Michie, and William Mouncey gave the school a presence in exhibitions at home, in the colonies and abroad.[77] Guthrie, Henry, Hornel, Lavery, Roche and Walton were international names – Guthrie becoming President of the Royal Scottish Academy in 1902 and Lavery, leading the International Society through Whistler's final years of illness, and through the subsequent presidency of Auguste Rodin. Such was its fame that the Boys did not need to write to the editor of *The Glasgow Herald* to emphasize their place in the scheme of things for the Glasgow International Exhibition of 1901. A prudent selection placed their work in the context of the city's distinguished collections.[78] Nevertheless, William Kennedy chose to memorialize the exhibition with a large resplendent panoramic view of the exterior of the exhibition building at Kelvingrove [Fig.48], and the painters were openly acknowledged as having overhauled the city's reputation as a great cultural centre.[79]

Extolling its role as a 'gate and pillar' of the Empire – with its cotton kings, sugar and tobacco barons, and its builders of a large percentage of the world's ships and steam trains – a writer in Pearson's Magazine gave due prominence to the 'Glasgow School', 'though the gentlemen themselves who paint these wonderful pictures prefer to speak of "The Glasgow movement in art"'. Guthrie, interviewed by the reporter, acknowledged the great collections 'found in the private galleries in the great houses of the west of Scotland' and their influence on 'the new departure in Scottish art'. The 'making of a new kind of pictures' was 'a new industry' comparable to the others, but it was 'bold, confident and original' at the same time.[80]

In 1901 it was only necessary to visit the City

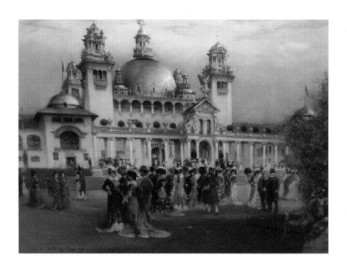

Fig.48
The International Exhibition, Glasgow, 1901
William Kennedy
Oil on canvas
Private Collection

Chambers and view the recently completed Banqueting Hall decorations to see evidence of this. Having abandoned a plan to commission murals for the interior of St Andrew's Halls, the city fathers asked Henry, Lavery, Roche and Walton to portray scenes from its illustrious past which would show Glasgow's place in the 'general history of human culture from the dawn of intelligence in the naked savage … to the modern epoch of the development of the higher arts …'.[81]

Exhibitions, newspaper criticism, medals and prizes were ephemeral; Glasgow needed a great permanent statement of its achievement. Roche's St Mungo, miraculously pulling Queen Langueth's lost ring from the mouth of a salmon [Fig.49], established the ancient settlement of Strathclyde as a spiritual centre, just as the clanging steel and crackling furnaces of the modern, murky Clyde [Fig.50] in Lavery's mural brought prosperity to its latter day merchant princes, and glory to the great engine of the British Empire.[82] Ancient myth was matched with modern industry, fable with fact. Lavery's nameless workers from the wynds and closes were just as heroic as Roche's bards, only the gold they pulled from the Clyde, in this instance, ironically,

Fig.49
St Mungo's Recovery of the Ring, 1900
Alexander Roche
Banqueting Hall, Glasgow
City Chambers

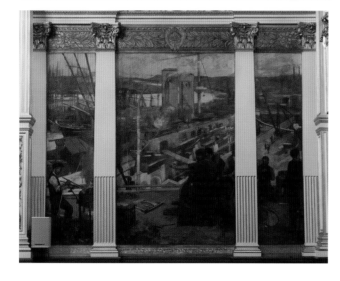

Fig.50
Shipbuilding on the Clyde,
1889–1901
John Lavery
Banqueting Hall, Glasgow
City Chambers

was Japanese bullion. In this dazzling sight, a warship of the Imperial Japanese Navy under construction, Glasgow's modernity led the world – and its success was led by its painters.

NOTES

[1] Ford, S (1901). Writing on the Glasgow School in *The Art of Folly*, 1901 (Boston, Small Maynard and Co), pp.80–1. Ford's doggerel describes pictures shown at the Paris Salon of 1891. I am grateful to Professor Ronald Pickvance for drawing this passage to my attention.
[2] Caw, J (1932). *Sir James Guthrie*, PRSA, LL.D. London, Macmillan and Co, p.68.
[3] Guthrie wrote two letters to *The Glasgow Herald*, (3 September 1887, p.4 and 10 September 1887, p.10) calling attention to the achievements of the group and advocating their inclusion as advisors on the art section of the Glasgow International Exhibition. Between these two letters there was a lively correspondence for and against, provoking responses from other members of what Guthrie described as the 'body of sincere art workers', such as Harrington Mann, James Paterson and Corsan Morton. By 30 September *Quiz*, Glasgow's own serio-comic journal, was reporting (p.40) that the art committee of the International had 'done the right thing' and invited five artists to join. They included Guthrie, AK Brown and P Macgregor Wilson. The membership of the local body of 'art workers' was somewhat loosely defined. For a consideration of these issues see Buchanan, W ed. (1968). *The Glasgow Boys*, 1968 and 1971 (2 vol., exhibition catalogue, Scottish Arts Council) and Billcliffe, R (2008). *The Glasgow Boys*. London, Frances Lincoln.
[4] Caw (1932), p.79; see also Robins Pennell, E. 'Art in Glasgow', *Harper's New Monthly Magazine*, vol.90, no. 537, February 1895, p.418; *The Graphic*, 25 February 1893, p.183.
[5] Aikman, G. 'The New President of the Royal Scottish Academy', *The Art Journal*, 1903, pp.26–7; Caw (1932), p.47; see also Hartrick, AS (1939). *A Painter's Pilgrimage through Fifty Years*. Cambridge, Cambridge University Press, p.56.
[6] DSM, 'The International Exhibition of Art at Knightsbridge', *The Saturday Review*, 21 May 1898, pp.681–2.
[7] Lavery's 'wooden spoon' was voted by the readers of *The Pall Mall Gazette*, see *Freeman's Journal*, 8 December 1887, p.6; his gold medal was reported as the first awarded to a Scottish painter in the Salon, *Glasgow Herald*, 5 June 1888, p.6. See also Billcliffe (2008), pp.258–62; and McConkey, K (2010). *John Lavery, A Painter and His World*. Edinburgh, Atelier Books, pp.31–6.
[8] For a useful survey of dealerships and collectors see Fowle, F (2008) *Impressionism and Scotland*. Exhibition catalogue, National Galleries of Scotland.
[9] Living at Stirling from 1887, Kennedy was voted president of the group, but he was not an ideal candidate for this role. As a painter of military scenes, he was jokingly referred to as 'the Kurnal' in Henry's letters to Hornel (The Hornel Library, National Trust for Scotland: Broughton House, Kirkcudbright); Billcliffe (2008), pp.155–83.
[10] Anon, 'The Glasgow School of Painting. Art XI – 1. *Glasgow International Exhibition*, 1901. *Catalogue of the Fine Arts*. 2. *The Glasgow School of Painting*. By David Martin with an Introduction by Francis H Newbery …', *Edinburgh Review*, vol.cccxcviii, October 1901, pp.495.
[11] The first 'Art Extra' in *Quiz* (10 February 1888) for instance, includes work by Coventry, Millie Dow, Guthrie, Whitelaw Hamilton, Henry, Hornel, Kennedy, Lavery, Mann, Morton, Nairn, Paterson,

Roche and Walton.

[12] Anon, 'Institute of Fine Arts – Twenty-Ninth Exhibition', *The Glasgow Herald*, 1 February 1890, p.4, noted that 'the hanging committee, with a spirit of boldness for which we give them credit' had placed pictures of a radical kind in the Fourth gallery. This enables 'one to compare the differences which … exist in the styles of the impressionists'. Stott of Oldham's *A Nymph*, Roussel's *The Pub, Cheyne Walk* and Sickert's *Oxford Music Hall* were then singled out for notice. The room was hung by James Paterson.

[13] *The Scots Observer*, undated cutting, 1890, Hornel cuttings book, (Hornel Trust). Hartrick (1939), p.61, who claimed to have seen the inauspicious setting of *A Galloway Landscape*, described it as the 'spear head' of the Glasgow School and 'an ineffaceable memory for any artist who ever saw it'

[14] McConkey, K (1996). 'Rustic Naturalism at the Grosvenor Gallery', in Casteras, S and Denney, C, (eds.), *A Palace of Victorian Art*, *The Grosvenor Gallery*, (exhibition catalogue, Yale University Press), pp.142–5; see also Surtees, V (1993). *Coutts Lindsay 1824–1913*. Michael Russell, p.178. The Lindsays closed the gallery with an overdraft of £111,000.

[15] Sir John Lavery; unpublished diary entries, 1–5 May 1890.

[16] *Daily News*, 14 May 1890, p.2; *The Glasgow Herald*, 3 May 1890, p.9; *Birmingham Daily Post*, 3 May 1890, p.6. *Audrey and her Goats*, as *The Times*, 5 May 1890, p.5, reminded readers, was a long time in the making. It had started life in 1884, Billcliffe (2008), p.269, as a scene from *As You Like It*.

[17] *The Magazine of Art*, 1890, p.326.

[18] Billcliffe (2008), pp.218–9; Buchanan ed. (1968), vol.2, pp.55–6; Later writers (e.g. Morrison, J (2003). *Painting the Nation, Identity and Nationalism in Scottish Painting, 1800–1920*. Edinburgh, Edinburgh University Press, pp.192–198) have stressed the Celtic sources of the costumes and breastplates in this work and pointed to Hornel's antiquarian interests. In forming the features of their Druids it is not impossible that Henry and Hornel looked to contemporary sources for images of native Americans, in illustrations of the surrender of Geronimo (1886) and the Buffalo Bill Wild West Show Jubilee tour (1887).

[19] *The Times*, 5 May 1890, p.5, quoted in Buchanan (ed.) (1968), vol 2, p.58. The sense of cohesion was only evident elsewhere in the work of the Newlyn School.

[20] Anon, 'The Scottish School of Painting', *Blackwood's Edinburgh Magazine*, vol.158, no.953, March 1895, pp.335–50; Anon, 'Glasgow Art in the Scottish Exhibitions', *The Manchester Guardian*, 15 April 1895, p.8.

[21] For a fuller discussion of the Highlands as a metaphor for nationhood see Morrison, (2003).

[22] Pennell, (1895), p.417. For Pennell's importance as a critic, see Clarke, M (2005). *Critical Voices, Women and Art Criticism in Britain 1880–1905*. Aldershot, Ashgate, pp.115–53.

[23] Anon, 'The Grosvenor Gallery, (First Notice)', *The Saturday Review*, 10 May 1890, pp.565–6. See also Anon, 'The Grosvenor Gallery', *The Times*, 5 May 1890, p.10 which comments upon the 'decidedly Scottish character' of the exhibition and concludes that this year's exhibition was, as a result, 'equal in interest' to that of the breakaway New Gallery.

[24] Pennell (1895) p.418; Baldwin Brown, G (1908). *The Glasgow School of Painters*. Glasgow, James MacLehose and Sons, pp.6–7; Caw (1932), pp.60–1.

[25] Rolleston, TW. 'The Gazette des Beaux Arts', *The Weekly Review*, 13 December 1890; 'Marie', 'Scottish Pictures. What Germans think of them. [Translation of an article by Herr Fritz v. Ostini]', *The Weekly News*, 20 September 1890. (Hornel Cuttings Book, Hornel Trust).

[26] Muther, R (1896). *The History of Modern Painting*, vol.3. London, Henry and Co, pp.687–99.

[27] Ibid.

[28] In the event, this did not occur, and although there was some concentration of Scots pictures in one particular room, the pictures were spread throughout the galleries. Hornel, who gathered the works from Reid's gallery for the exhibition, was told by George Henry that Stanhope Forbes, leader of the Newlyn painters, and a member of the hanging committee, 'cussing us as hard as he can', placed Kennedy's work above the line. Letter from George Henry, 9 September 1892, (Hornel Trust), quoted by Smith, B (1997). Hornel, *The Life and Work of Edward Atkinson Hornel*. Edinburgh, Atelier Books, p.73.

[29] Ibid; quoting *The Liverpool Echo*, 5 September 1892.

[30] Ibid; quoting *The Spectator*, 22 October 1892. Both pictures nevertheless contain girls, seated with their boots jutting forward, in emulation of Bastien-Lepage's peasant woman in *Les Foins*, 1878 (Musée d'Orsay, Paris).

[31] Moore, G (1893). 'The Alderman in Art', in *Modern Painting*. London: Walter Scott Ltd, p.165.

[32] Ibid, p.206.

[33] Sir George's speech was reported in *The Glasgow Herald*, 23 February 1892, p.4. The views of ARTIST, indignantly pointing out that the Glasgow School had achieved more recognition than Reid's 'chartered Academy' (25 February 1892, p.10) are typical. Tensions between the Royal Scottish Academy suffering, according to William McTaggart from 'exclusiveness in the conduct of its affairs' and the Glasgow Institute of Fine Arts perceived as 'broadly sympathetic and public spirited', since 1888; see *Quiz*, 10 February 188, p.226.

[34] *The Glasgow Herald*, 6 February 1893 p.6. *The Art Journal* failed to receive comments from any of the Boys – Walton and Lavery were going through the process of election as RSA associates – but Clausen, Fred Brown and Edward Stott submitted supportive letters which were quoted. See McConkey, K (1989). *British Impressionism*. London: Phaidon Press, pp.100–1.

[35] Caw, J (1894). 'A Phase of Scottish Art', in *The Art Journal*, p.75 ff; quoted from *Fifty Years of Art, The Art Journal, 1849–1899*, 1900, pp.324–7.

[36] When Roussel, a close friend of Melville's rose to object to the rejection of one of the Glasgow pictures, he was ruled out of order by the Fred Brown/Philip Wilson Steer clique. He promptly resigned, informed the members of the School and in what Frank Rutter described as an 'extraordinary example of Scottish clannishness' the entire group resigned, taking other sympathizers with them. See Rutter, F (c.1935). *Modern Masterpieces with an Outline of Art*, n.d., vol.1. London, George Newnes Ltd, p.56; also MacKay, AE

(1951). *Arthur Melville, Scottish Impressionist, 1855–1904*. (F Lewis Publishers), p.96.

[37] McConkey, *The New English, A History of the New English Art Club*, 2006. RA Publications, pp.57–63.

[38] Lavery, for instance, ceased submitting to the Royal Academy in 1897 when the portrait of Mrs Colquhoon Read was rejected. He only resumed in 1911 when offered an Associateship. For the New English rejection see McConkey (2006), pp.57–63.

[39] These 'dealer' shows, designed to open up new markets for sketches and smaller works were increasingly popular. While the Academy attracted large works designed for newly opened municipal galleries and the most opulent private collectors, smaller works in dealers' galleries addressed the new villas of the bourgeois suburbs – see for instance Moore, G (1889). 'Art for the Villa', *The Magazine of Art*, vol.12, pp.296–300. Guthrie had framed 51 of his recent pastels for Dowdeswell's in November 1890 and met the Newlyn painters head on in his London exhibition, since they occupied the main gallery with a rival show. Although aesthetically pleasing, none of his works sold and one of the Dowdeswell brothers declared 'The exhibition – well! The exhibition was an artistic success; but,' and he lowered his voice impressively, 'we can't afford to go on having artistic successes, you know!'; Caw (1931), p.57. Lavery, having recently returned from Tangier, exhibited his sketches of the kasbah and the souk at the Goupil Gallery, and fared slightly better. Press responses were, on the whole, favourable, and with his co-incidental display of the *State Visit of Queen Victoria to the International Exhibition, Glasgow, 1888*, 1890 (Kelvingrove Art Gallery and Museum), accompanied by a selection of the original sketches at MacLean's Gallery, he was more commercially successful. Both painters had follow-up exhibitions arranged in Lawrie's Gallery, in Glasgow.

[40] Backed by Lord Granby, Lord Baring and others, this commercial venture aimed to show the best European and American art. Apart from Watts, Boughton, Murray and Orchardson, there were no Academicians represented in the selection of its opening exhibition. So strong were the Glasgow pictures that *The Saturday Review*, 4 March 1893, pp.234–5, suggested that they should be given a separate section.

[41] Guthrie, Lavery and the manager, Mr Prange, travelled to the Low Countries together the following year, scouting for new work.

[42] Anon, 'The Grafton Galleries', *The Illustrated London News*, 25 February 1893, p.248, talked for instance, of the British camp divided into three groups – Glasgow, Newlyn and 'the Whistlerites' (London Impressionists).

[43] Lavery's *Mrs Ian Hamilton*, (untraced), although described by *The Glasgow Herald*, 17 February 1893, p.7, as a 'beautiful portrait' was repainted eight years later.

[44] William Buchanan, *Mr Henry and Mr Hornel visit Japan*, 1978 (exhibition catalogue, Scottish Arts Council); Smith 1997, pp.83–98. The trip was sponsored by William Burrell and Alexander Reid and the two painters spent 13 months in Japan. On their return it was discovered that most of Henry's work had been damaged in transit. Hornel however, staged a successful solo exhibition of 44 pictures at Reid's gallery in April 1895. Tensions between the pair bubbled to the surface when Hornel wrote and privately printed a lecture on his experiences in Japan without consulting his travelling companion.

[45] DSM, 'Art, The Grafton Gallery', *The Spectator*, 25 February 1893, pp.256–7.

[46] Anon, 'The Grafton Gallery', *The Times*, 20 February 1893, p.8.

[47] The inaugural exhibition was noteworthy for the angry arguments that gradually arose over Degas' *L'Absinthe*, despite the fact that it was passed over in many reviews; see Flint, K (ed.) (1984). *Impressionists in England, The Critical Response*. London, Routledge and Kegan Paul, pp.279–96. See also Gruetzner Robins, A and Thomson, R (2005). *Degas, Sickert and Toulouse-Lautrec, London and Paris, 1870–1910*, (exhibition catalogue, Tate Publishing).

[48] Caw (1894), (1900), pp.324–6.

[49] RAM Stevenson's classic *Velasquez*, (London, G Bell and Sons, 1898 ed.), was first published in 1895. For Melville's copy of *El Primo*, 1891 see Gale, I (1996). *Arthur Melville*. Edinburgh, Atelier Books, p.52. Lavery's copies, cited in his studio inventory at the time of his death, have subsequently disappeared; see McConkey, K (2005). 'The Theology of Painting, the Cult of Velázquez in British Art at the turn of the Twentieth Century', *Visual Culture in Britain*, vol.6, no.2, pp.189–205. Xanthe Brooke's, 'A Masterpiece in Waiting: The Response to *Las Meninas* in Nineteenth-Century Britain', in Suzanne L Stratton-Pruitt, *Velázquez's 'Las Meninas'*, 2003, pp.70–3, deals with Lavery's later canvas, *The Artist's Studio*, 1910–13 (National Gallery of Ireland). For Robert Bontine Cunninghame Graham (1852–1936), descended from the Earls of Glencairn and Menteith see Tschiffely, AF (1937). *Don Roberto, Being the account of the Life and Works of RB Cunninghame Graham, 1852–1936*. London and Toronto, William Heinemann. Graham's mother was half-Spanish and he spent much of his youth in the Americas, before a brief parliamentary career (1886–92). In addition to Lavery, his portrait was painted by George Percy Jacomb Hood, (1888), William Rothenstein (1895) and late in life by Ignacio Zuloaga (1935). Lavery's equestrian portrait of *Cunninghame Graham on 'Pampa'* 1898 is in the Museo de Bellas Artes, Buenos Aires.

[50] The phrase 'a dream of fair women', borrowed from Tennyson, was adopted as the title of Lavery's exhibition at Lawrie's Gallery in Glasgow in 1893. Following the more famous *Fair Women* exhibition at the New Gallery in 1894, the title was adopted by the International Society of Sculptors, Painters and Gravers for several shows in the early years of the twentieth century. See Sharp, W (1894). *Fair Women in Painting and Poetry*. Portfolio Monographs, Seeley and Co.

[51] Brangwyn, F (1893). 'Letters from Artists to Artists – Sketching Grounds No. 1 – Spain', *The Studio*, vol.I, no.1, p.12; McKay, 1951, pp.84–93. The Melville/Brangwyn manner was referred to as the 'stained glass palette', and *The Buccaneers* described as a 'war-cry of *fin-de-siècle* barbarism'.

[52] MacKay (1951), p.84. Melville noted 'long shadows, [of] cold blue thrown by poplar trees', and later in painterly terms recorded that, 'the hills bare, warm grey and scored with runnels of winter's streams. The nearest poplar trees showing dark against further hills'; quoted in McConkey, K (2009). 'Incongruous Impressions: Scottish Painters travels at the turn of the Twentieth Century', *Journal of the Scottish Society for Art History*, vol.14.

[53] AU [ER Pennell], 'The Grafton Gallery', *The Star*, 17 February 1892, p.2 quoted in Clarke (2005), p.136.

[54] Pennell (1895), p.412.

[55] Kurtz, CM (1905). 'The Glasgow School of Painting', *Academy Notes, Amorem Artis Promovere*, vol.1, nos 5, 6, 7 and 8, October 1905–January 1906, pp.82–88, 99–107, 115–123, 140–143, 154, 187. Kurtz's conversion occurred in Barcelona in 1894 where he saw his first Glasgow School paintings (p.82), thereafter he filled *Academy Notes* with a comprehensive and enthusiastic account of the Boys and their work, detailing acquisitions by the Albright Art Gallery and other American collections. For further reference see Pancza-Graham, A (1991). 'Charles Kurtz and the Glasgow School, an American critical response', *Archives of American Art Journal*, 1991, vol.31, no. 3, pp.14–25. Kurtz, as Pancza-Graham points out, (p.23) took it upon himself to correct some of Pennell's mistakes, noting for instance that, contrary to her assertion, David Gauld was not dead, while agreeing with her overall conclusions. I am grateful to Professor William H Gerdts for drawing this important article to my attention. For Kurtz' correspondence with Alexander Roche and Alexander Reid, see Archives of American Art, Smithsonian Institution. For a more general consideration of the impact of the Glasgow School see John Morrison, 'Scottish Art and the Post-Colonial Quest for Identity in the United States of America, 1895–1905', *Scotlands, The Interdisciplinary Journal of Scottish Culture*, 1995, vol.2, no.1, pp.44–60.

[56] Lavery's *The Bridge at Grez* joined the tour in Chicago. Following favourable reviews which praised Hornel's work, it appears that Kurtz wrote to the painter and attempted to act as his agent in the United States; see Smith 1997, p.102.

[57] Roche for instance, travelled on several occasions to the United States, painting the portraits of Mrs Andrew Carnegie and her daughter in 1902; see Haldane MacFall, 'The Art of Alexander Roche', *The Studio*, vol.37, April 1906, p.213.

[58] The 1905 exhibition travelled from Buffalo to the Art Institute of Chicago, the Museum of Fine Arts, St Louis, the Pennsylvania Academy of Fine Arts and the Toronto Art Museum, see Pancza-Graham, 1991, p.23.

[59] Anon, 'Glasgow Art in the Scottish Exhibitions', *The Manchester Guardian*, 15 April 1895, p.8.

[60] Anon, 'The Scottish School of Painting', *Blackwood's Edinburgh Magazine*, vol.158, no. 953, March 1895, p.340.

[61] For MacNicol see Burkhauser, J (ed.) (1990). *The Glasgow Girls, Women in Art and Design, 1880–1920*. Edinburgh, Canongate; also Tanner, A (1998). *Bessie MacNicol*. (Privately Published). The work of Kennedy (Mrs William Kennedy) remains to be researched.

[62] Fergusson, JD (1943). *Modern Scottish Painting*. (Glasgow, William MacLellan), p.31.

[63] *The Yellow Book, An Illustrated Quarterly*, vol.VIII, January 1896; cover and title page designs by DY Cameron plus 26 plates by members of the Glasgow School. This includes work by A Frew, D Martin, FH Newbery, George Pirie, Grosvenor Thomas, Kellock Brown, JE Christie and Stuart Park, as well as Kennedy, Mann, Paterson, Stevenson, Henry, Hornel, Crawhall, Walton, Guthrie, Lavery and Roche. Martin, D (1897). *The Glasgow School of Painting*. George Bell and Sons; Paul Harris Publishing reprint, 1976; Baldwin Brown, G (1908). *The Glasgow School of Painters*. Glasgow, James MacLehose and Sons.

[64] Anon, 'The Glasgow School of Painting …', *The Saturday Review*, 5 February 1898, pp.179–180. It is possible that the reviewer was MacColl and much of the fire was directed at Newbery's introduction which was carried away with comparing Glasgow painting with the great schools of Venice and Amsterdam. This text was omitted from the Paul Harris 1976 edition.

[65] *The Manchester Guardian*, 16 May 1898, p.6, began its review of the first exhibition by describing it as 'long-expected and much-discussed'.

[66] In essence, Whistler's acceptance of the role of President could be read as a return favour since the Boys had promoted the purchase of *Arrangement in Black no. 2, Thomas Carlyle*, by Glasgow Corporation seven years earlier and in the interim, Lavery had recommended sitters such as JJ Cowan to the master. It was common for critics like Richard Muther, throughout the nineties to see the Boys as Whistler's principal followers, even though in their handling and palette, they were very different. From Whistler's point of view, leadership of an 'International Society' greatly flattered his ego since its aims were simply 'to hold exhibitions of the finest art of the day', with the 'non-recognition of nationality in art' as an important confirmation of the commitment to quality; see Athill, P (1985). 'The International Society of Sculptors, Painters and Gravers', *The Burlington Magazine*, vol.127, no 982, pp.21–33.

[67] With Whistler's agreement Academicians and Associates should be excluded from the International. Lavery had the temerity to suggest Sickert as a possible exhibitor only to receive Whistler's rejection – 'My Walter, whom I put down for a moment and who ran off. Oh no, not Walter'; see Lavery, J (1940) *The Life of a Painter*. Cassell, p.108. Sargent and James Jebusa Shannon, now Academy stalwarts should be disqualified, however both were approached. Lavery later recalled 'Whistler's agreeing that we should have a Sargent at our first international exhibition and I was deputed to see him. I shall never forget my surprise. He was quite affable till I told him the object of my visit when he suddenly became inarticulate with rage – he spluttered and fumed – I gathered that he would see the International damned first including its Hon. Secretary and President'; see *Life*, 1940, p.114. George Clausen, now also an Associate of the Royal Academy, was included, no doubt in partial repayment for his early support for the Glasgow Boys. Whistler, exercising *droit de seigneur*, appointed Albert Ludovici, to the dismay of some members, as his agent liaising with dealers in Paris and a good deal of effort was expended in ensuring the support of prominent French painters like Lautrec, Puvis de Chavannes, Renoir, Monet and Degas. Only Degas posed problems. He was angry when he discovered that he was being represented without his permission and Lavery wrote desperately to William Rothenstein in an effort to get him to use his influence: 'I am sure he need only know that the thing is an affair of the artist and not of the dealer or middle man, to give his consent'. With characteristic truculence, Degas advised Rothenstein to have nothing to do with the project, telling him to show 'in colour shops, in restaurants – anywhere but at the brothels that picture shows are'; see Rothenstein, W (1931). *Men and Memories, 1872–1900*. London, Faber and Faber, p.336. Loans were secured through dealers like Vollard, Durand-Ruel and Georges Petit. Payment of carriage charges

became an issue with 'the Paris people', and was the subject of a brief letter dated 28 February 1898 from Lavery to Blake Wirgman. I am grateful to Patrick Brown for bringing 12 letters from Lavery to Wirgman, to my attention. Whistler's wry letter to Lavery on the question of Rodin's sculptures (Hyman Kreitman Archive, Tate, letter dated 5 February 1899), describes the destruction of his sculptures thus: 'Monsieur Rodin has promised to put in writing his experience of the management of the 'International' at Knightsbridge. It is a matter of public noteriety that all his casts came back broken to bits! - and that, in one case, the ingenuity of the British packer (for whom the executive is responsible) was so unrestrained in its joyous impulses and inspiration, that without a moment's hesitation, he summarily sawed off a *leg at the ankle!* and so brilliantly reduced the recalcitrant limb to immediate submission and *the fit of the box!* - so simple are the methods of genius! 'Ce sont les barbares!' said Monsieur Rodin. All comment would appear unnecessary'.

[68] Winning high praise at the International it was purchased by the Academy of Fine Arts in Philadelphia in January 1899.

[69] Reflecting on the second exhibition in 1899, CJ Holmes noted in *The Dome*, vol.III, 1899, p.176 that 'The Glasgow men have certainly chosen their time well, for since the death of Sir Edward Burne-Jones and the increasing age of Mr Watts robbed the New Gallery of its chief attractions, there has been no exhibition in London to which the lover of pictures could turn with certainty of finding at least one really good thing'.

[70] The Grafton Gallery was canvassed as a potential venue, before an unusual offer to stage the show at Prince's Skating Rink in Knightsbridge was accepted.

[71] *The Manchester Guardian*, 16 May 1898, p.6

[72] Kendall, B (1901). 'The Third Exhibition of the International Society of Sculptors, Painters and Gravers', *The Artist*, vol.xxxii, no 263, November 1901, pp.122–3. This venture, like any other, was the product of diplomacy, negotiation, compromise and substitution. The organizers were, in some instances as MacColl noted, returning previous favours. MacGregor was accepted by the New English probably because of his Slade pedigree under the tutelage of Alphonse Legros.

[73] DSM, 'The International Exhibition of Art at Knightsbridge', *The Saturday Review*, 21 May 1898, pp.681–2.

[74] Ibid.

[75] *Père et Fille* was shown in its unfinished state as *Portrait Group* in 1898. It and *A Garden in France* then travelled to the International Exhibition at Pittsburgh later that year, the latter being acquired by the Pennsylvania Academy of Fine Arts. *Père et Fille* was then reworked sometime during 1899. There is an implicit acknowledgement of its unfinished status as one reviewer commented that the painting was '… already proving to be one of the best of the painter's portrait pictures …' (*The Art Journal*, 1898, p.253). It is possible that Lavery was encouraged by Whistler to exhibit the work in its unfinished state, since the society's President had seen the canvas, set aside for repainting, in the studio. He apparently declared, 'at last my dear Lavery, you have done it. It is beautiful. It is complete', (Life, p.120). Initially the background contained part of Lavery's large Velazquez copy of *Marianna of Austria* (Prado) and a doll lying beside the wicker chair on which the child poses.

[76] Anon, 'The Manchester Autumn Exhibition', *The Manchester Guardian*, 9 October 1899, p.9.

[77] Charles M Kurtz for instance, renewed American interest with a touring exhibition, similar to that of 1895, in 1905–6, commencing at the newly opened Albright Art Gallery, Buffalo, to which he had been appointed Director.

[78] There were for instance 21 works by Corot, 11 by Monticelli, 18 by Jacob Maris and 19 by Josef Israels in the Glasgow International of 1901, while Guthrie had 5, Lavery 2, Walton 4, Henry, 5 and Hornel 1. Reasoning that the place for new work was the Institute, may well explain the relative weakness of the Glasgow School presence in the overall selection. Traditional values reasserted themselves in the 30 works by Cox and the 31 by Turner.

[79] Kennedy painted a large, celebratory picture of visitors, some of whom are identified, in the grounds of the exhibition building (Private Collection). Unlike Sellars' temporary structure in 1888, this was a permanent building, designed to be re-used as the city's art gallery.

[80] Machray, R (1896). 'Gates and Pillars of the Empire, no II, Glasgow Illustrated', *Pearson's Magazine*, vol.1, pp.487, 489–90.

[81] Baldwin Brown, G (1908). *The Glasgow School of Painters*. Glasgow, James MacLehose and Sons, p.42.

[82] The original commission was awarded in 1898. Roche's *St Mungo* mural was the first of the sequence to be completed; see *Glasgow Herald*, 19 October 1900, p.9. For reference to Lavery's *Modern Shipbuilding*, see McConkey (1984), p.50; Buchanan, W (2001). 'The Asahi Restored', *Journal of the Scottish Society for Art History*, vol.6, pp.77–80. For general reference see AP Willsdon, C (2000). *Mural Painting in Britain, 1840–1940, Image and Meaning*. Oxford, Oxford University Press, pp.184–5.

Artists' Biographies

Jules Bastien-Lepage

Born 1848, Damvillers, Meuse, France

Died 1884, Paris, France

Bastien-Lepage came from a farming family that lived in Damvillers, a village in north-east France. His parents favoured a career in the civil service for him, but his success as a part-time student of drawing led him to study full time at the studio of Cabanel in Paris. He exhibited regularly at the Paris Salon during the 1870s but his failure to win official approval led to his decision to return to his native village. There he painted his celebrated pictures of peasant life. He depicted his subjects as individuals in specific locations carrying out their daily rural tasks. His compositions were carefully designed with figures dominating the foreground and often silhouetted against a receding landscape. By painting out-of-doors he felt he could convey the true feel of nature and he developed a technique of painting with small, square brushstrokes, which also helped define the perspective in his paintings. He continued to exhibit his pictures at the Salon and elsewhere, including the Grosvenor Gallery in London (1880) and the Glasgow Institute of the Fine Arts (1883), and achieved international recognition. His work was very influential, particularly on the Glasgow Boys. By the time of his premature death in 1884 his influence had spread throughout Europe and North America, making him the most significant of all the later French naturalist artists.

Catalogue numbers 1, 2

Joseph Crawhall

Born 1861, Morpeth, Northumbria

Died 1913, South Kensington, London

Crawhall's natural skill as an artist was recognized by his father, who encouraged him to draw from memory. His connection with the Glasgow Boys came about as a result of his sister marrying EA Walton's brother. Crawhall, Walton and later James Guthrie realized they had much in common with regard to their artistic endeavours, and from 1879 onwards painted together in various locations in Scotland. Oil paintings by Crawhall are relatively rare, but those that survive show how influenced he was by Guthrie and the other Boys. His unique contribution to the group is his experimentation with water-based media, including gouache on linen. His brilliant depictions of animals and birds, breathtaking in their technical virtuosity, have often been compared to Oriental calligraphic art. Crawhall was one of the first Glasgow Boys to visit Tangier, between 1884 and 1893, and he was able to indulge his love of horses there. His later work reveals a move away from the Boys' naturalist principles, tending towards a style that was altogether unique.

Catalogue numbers 12, 19, 25, 95, 137, 138, 139, 140, 141, 142, 143, 144

Thomas Millie Dow RSW

Born 1848, Dysart, Fife

Died 1919, St Ives, Cornwall

Thomas Millie Dow was born in Dysart in Fife, the son of the town clerk. He studied painting in Edinburgh, and later in Paris with Gérôme at the Ecole des Beaux-Arts and at the studio of Carolus Duran. In Paris he met and was influenced by William Stott of

Oldham, whose work seen at the Glasgow Institute of the Fine Arts had impressed many of the Boys. After Dow's return to Scotland, he became closely involved with the new movement and his landscapes and flower paintings had a typically Glasgow Boys' feeling of atmosphere and strong design. From 1893 onwards he turned to more romantic, allegorical figural subjects. Millie Dow was among the first of the Glasgow painters to leave Scotland, settling part-time in St Ives in Cornwall in 1895. Able to travel extensively to Italy, Tangier, America and Canada, by 1897 he had returned to Glasgow and joined the New English Art Club. In later years his style moved away from that of the Boys, towards a more symbolist and less detailed manner of painting. Near the end of his life Dow's fondness for Cornwall is shown in his many works featuring St Ives harbour, though he also continued to paint large canvases of allegorical subjects.

Catalogue number 52

David Gauld RSA

Born 1865, Glasgow
Died 1936, Glasgow

As a young man, Gauld was apprenticed to successful lithographers Gilmour & Dean, a job which he combined with studying part-time at the Glasgow School of Art until 1885 and again in 1889. In between, he joined the staff of the *Glasgow Weekly Citizen*, illustrating the novels

which the newspaper serialized. In painting, he was noted for a series of elegant female portraits, his many pictures of cattle and his impressive landscapes of Grez-sur-Loing, south-east of Paris. His most remarkable pictures were of female figures, painted with rich colours and an emphasis on surface design. Because of their two-dimensionality some of Gauld's works were ideally suited to replication in stained glass, and so from the early 1890s he supplied designs to the Glasgow firm of J & W Guthrie. It was during that period that he shared a studio with Harrington Mann, who also worked for the firm. Gauld's most significant glass commission was for St Andrews Church in Buenos Aires (1900–10). In 1935, near the end of his life, he was appointed director of Design Studies at the Glasgow School of Art.

Catalogue numbers 54, 57, 93

Sir James Guthrie HRA, PRSA, RP, RSW

Born 1859, Greenock, Renfrewshire
Died 1930, Rhu, Argyll and Bute

Guthrie was mainly self-taught, but studied for a while in London in the studio of John Pettie, a Scottish artist who was well known for his large figurative compositions. The influence of Jules Bastien-Lepage came to the fore in Guthrie's work after a short visit to Paris in 1882, and he painted rustic scenes full of light and atmosphere. By 1884 Guthrie had settled at Cockburnspath, a farming village near the Berwickshire coast, and was joined there in successive years by other members of the group including Walton, Crawhall, Henry and Melville. Painting out-of-doors with Guthrie as their leader, they developed the strength of handling and freshness of tone and colour, which became characteristics of the early realist phase of the Glasgow Boys.

Guthrie moved on to establish his reputation as a society portraitist, consolidated with an order book which was very rarely empty. So busy was he with orders and his role as President of the Royal Scottish Academy that in the intervening three decades until his death he rarely created any other type of work.

Catalogue numbers 9, 11, 13, 28, 31, 32, 49, 69, 87, 98, 110, 112, 119, 120, 121, 122, 123, 124, 125

James Whitelaw Hamilton RSA, RSW

Born 1860, Glasgow
Died 1932, Helensburgh, Argyll and Bute

Hamilton spent his early days as a businessman, but painted as an amateur artist with Guthrie, Walton and Crawhall at Cockburnspath in 1883 and 1884. Around 1887 he took up painting professionally and travelled to Paris to study in the studios of Dagnan-Bouveret and Aimé Morot, most likely

on the suggestion of his artist friends. He continued his friendship with Crawhall who was there at the same time. On his return to Scotland, he painted naturalistic landscapes of fishing villages and the countryside in Berwickshire and near his home in Helensburgh, which became a favourite meeting place for the Boys. He also painted several nocturnes on the Clyde in a style reminiscent of Whistler. His mature style was linked to that of the Boys, and is typically evident in his landscape works through the vigorous handling of paint and strength of colour.

Catalogue number 73

George Henry RA, RSA, RP, RSW

Born 1858, Irvine, North Ayrshire
Died 1943, London

Henry trained part-time at the Glasgow School of Art while working as a clerk but probably his most formative period artistically was spent with fellow Glasgow Boys, James Guthrie and EA Walton, at Brig o'Turk, Rosneath and Cockburnspath. There he painted rural scenes in fresh, natural colours using square brushstrokes favoured by their mentor, Jules Bastien-Lepage. After meeting EA Hornel in 1885, a change took place in Henry's art. More concerned with brighter colours and decorative pattern, in 1889 he painted *A Galloway Landscape*, one of the masterpieces of the group in this new style. He then collaborated with Hornel on another major picture, *The Druids – Bringing in the Mistletoe*, which took Europe by storm. Together they developed a powerful symbolist style, based on colour, pattern and surface. Both artists visited Japan in 1893–94 and this resulted in a remarkable series of pictures. Elected to the Royal Academy in 1902, Henry moved to London in the first decade of the twentieth century, tempted by the promise of lucrative portrait commissions, and his work turned to focus on more conventional subjects.

Catalogue numbers 10, 16, 23, 29, 33, 46, 55, 58, 70, 74, 75, 76, 94

Edward Atkinson Hornel

Born 1864, Bacchus Marsh, Australia
Died 1933, Kirkcudbright, Dumfries and Galloway

Although born in Australia, Hornel was raised in Kirkcudbright, in south-west Scotland. He studied at the

Trustees' Academy in Edinburgh and at the Art Academy in Antwerp, Belgium, for two years. On his return in 1885 he met George Henry, and they formed a friendship that was to influence them both for the rest of their lives. Together they travelled to Japan in 1893–94, and were responsible for the later phase of the Glasgow Boys' activity, during which there was a progression from a realist to a more symbolist style. This ornamental style of painting reached its zenith in their joint canvases of 1890 and 1891 – the large and unique *The Druids – Bringing in the Mistletoe* and *The Star in the East*. Hornel subsequently journeyed to Ceylon (Sri Lanka) and Burma but neither visit proved as inspirational as the original trip with Henry, though he did make a return voyage to Japan in the 1920s. When in Scotland, he preferred to remain at his home in Kirkcudbright, where he concentrated on shaping his Japanese garden.

Catalogue numbers 47, 48, 50, 53, 56, 58, 59, 60, 77, 78, 79, 80, 81, 82, 83

William Kennedy

Born 1859, Glasgow
Died 1918, Tangier, Morocco

A student at Paisley School of Art, Kennedy later travelled to Paris, where one of his teachers was the hero of the Glasgow Boys, Jules Bastien-Lepage. His early work reveals his influence in its rustic realism and broad, open brushwork. Later Kennedy adopted a more measured approach to composition, with flatter areas of colour and occasionally a hint of Japanese influence. This stems from the example of that other icon of the Boys, Whistler. Kennedy is best known for his pictures of army life, but while working with Guthrie, Walton and Henry at Cambuskenneth, he painted some charming rural scenes. Well respected by the Boys, they elected him their president when they formed themselves into a short-lived society in 1887. Beginning in 1900, he began to visit Berkshire, where he found

inspiration in its rural character and charm. He later moved to Tangier, where he sought respite from ill-health.

Catalogue numbers 39, 40, 61, 71

Sir John Lavery RA, RSA, RHA, PRP

Born 1856, Belfast, Ulster

Died 1941, County Kilkenny, Eire

Raised in Ulster on a farm, Lavery moved to Glasgow to work as a railway clerk and studied art in Glasgow and London before going to France in the early 1880s. He became an ardent admirer of Jules Bastien-Lepage, and working out of doors at Grez-sur-Loing, south of Paris, he painted some of his most beautiful rural scenes. On his return to Glasgow in 1885, Lavery modified his style and subject to suit his middle-class patrons, with pictures such as *The Tennis Party*, his most famous picture. By 1888 he was so highly regarded that he

was commissioned to paint the official record of the state visit of Queen Victoria to the Glasgow International Exhibition. The resulting work was to provide the foundation for his career as one of the most fashionable society portrait painters of his generation. Moving to London in the early 1890s, he built up a highly successful practice.

Catalogue numbers 24, 38, 41, 42, 43, 44, 45, 64, 65, 66, 67, 91, 92, 97, 100, 101, 102, 103, 104, 105, 106, 107, 111, 113, 114, 115, 116

J Pittendrigh Macgillivray RSA

Born 1856, Inverurie, Aberdeenshire

Died 1938, Edinburgh

As a teenager Macgillivray studied sculpture under William Brodie in Edinburgh, before moving to Glasgow to work with John Mossman on the sculptural adornment of the city's buildings. He was the only sculptor member of the Glasgow Boys and painted very few

pictures. A skilled graphic artist, amateur musician and poet, his interests stretched to Scottish national history and politics, as well as art. His writing was well received, particularly his diatribes against the academics, published in *The Scottish Art Review* and *The Evergreen*. In 1890 he helped found the Edinburgh College of Art. His work in bronze is marked by its bravura. He executed many portrait busts and several public commissions, the most important of which was the Gladstone memorial, of 1912, in Edinburgh, in which can be seen the influence of Alfred Stevens and of Art Nouveau. In 1921 he was appointed King's Sculptor in Ordinary for Scotland, a position which he held until his death.

Catalogue numbers 108, 109

William York Macgregor RSA, RSW

Born 1855, Finnart, Argyll and Bute

Died 1923, Bridge of Allan, Stirling

Born into privilege as the son of a Glasgow shipbuilder,

Macgregor studied under Alphonse Legros at the Slade School in London. On his return to Scotland he set out with James Paterson for the east coast, painting at Nairn, Stonehaven and St Andrews. During the winter months the Boys tended to congregate in Macgregor's Glasgow studio. He advised them to avoid following any school, as 'there are no schools in art' and instead to 'hack the subject out as you would were you using an axe, and try to realize it; get its bigness'. His masterpiece, *The Vegetable Stall* 1884, epitomizes his realist approach to art. Chronic asthma, exacerbated by the smoky, polluted atmosphere of Glasgow at that time, proved to be detrimental to his health. In 1886 Macgregor was forced to leave due to illness and his influence as 'father of the school' waned. His later landscapes have an intriguing austere quality.

Catalogue numbers 8, 15, 17

Bessie MacNicol

Born 1869, Glasgow

Died 1904, Glasgow

Although equally talented in music, MacNicol decided to study painting and at the age of 18 she enrolled at the Glasgow School of Art where her teacher was the charismatic Fra Newbery. She continued her studies in Paris in 1892, attending art classes at the Académie Colarossi. On her return to this country she exhibited her work at the Royal

Academy in London (1893) and at the Glasgow Institute of the Fine Arts (from 1895 onwards). In 1896 she acquired a studio in Glasgow's St Vincent Street and paid regular visits to Kirkcudbright, where she became friends with EA Hornel and George Henry. At that time she was particularly influenced by the former's work and the colours in her own paintings lightened and brightened. MacNicol also studied the artists admired by the Boys such as Bastien-Lepage and Whistler, but she developed her own style, rich in paint textures, in which strong decorative design combined with great delicacy of feeling. Later MacNicol began painting on a larger scale but just when her work was gaining full recognition and reaching maturity she died, aged just 34, in childbirth.

Catalogue number 118

Alexander Mann

Born 1853, Glasgow
Died 1908, London

From an early age, Mann's talent for drawing was encouraged and he received art lessons from Robert Greenlees. He continued his studies in Paris in 1877 and enrolled first at the Académie Julian, but later moved to the studio of Carolus-Duran. He settled in Paris and for the next 15 years travelled back and forth between there and Scotland. The pictures he exhibited at the Glasgow Institute of the Fine Arts and the Paris Salon during this period revealed the influence of the Barbizon painters, such as Jean-François Millet, and also Bastien-Lepage and the Hague School. His picture *A Bead Stringer, Venice* gained an honourable mention at the Salon of 1885, the first Glasgow picture to receive such an award. As well as figure subjects, Mann also painted several naturalistic landscapes of salmon fishermen at Findhorn, near Forres in north-east Scotland. These pictures have the characteristic hallmarks of the

Boys in their feeling for light and atmosphere and subtle colour harmonies. Although Mann was a longstanding friend of Dow and exhibited with Lavery at the New English Art Club, he remained slightly detached from the group and spent the latter years of his life with his family in Berkshire and pursuing his lifelong passion for foreign travel.

Catalogue number 14

Arthur Melville ARSA, RSW, RWS

Born 1855, Loanhead of Guthrie, Angus
Died 1904, Whitley, Surrey

Melville trained at the Trustees' Academy in Edinburgh before going to Paris in 1878 to study the work of the French Impressionists at first hand and he was also inspired by visits to Grez-sur-Loing, south of Paris. Melville experimented with the transparent qualities of watercolour paint. He was thus a well-established artist before he met any of the Boys, and was a strong influence on Guthrie and Crawhall, (who,

like Melville, was primarily, a watercolourist). Melville never lived in Glasgow, but visited the Boys from Edinburgh and joined them on their summer painting excursions to Cockburnspath to see Guthrie. In the later 1880s and early 1890s he travelled to Spain and North Africa, painting unforgettable images which were bold in colour and dramatic in composition. In 1899, shortly after his marriage, he moved to Whitley in Surrey. He caught typhoid and died during a trip to Spain five years later.

Catalogue numbers 4, 5, 6, 7, 36, 84, 90, 126, 127, 128, 129, 130, 131, 132, 133, 134, 135, 136

Jean-François Millet

Born 1814, Gruchy, France
Died 1875, Barbizon, France

The son of a peasant farmer, Millet's artistic talent was recognized at an early age, and he went to Paris in 1838 to study at the Ecole des Beaux-Arts. He painted some fine portraits during this period, but memories of his early life on the farm soon became his greatest source of inspiration. Around 1849 he moved to Barbizon, a small village in the Forest of Fontainebleau, near Paris, and decided to concentrate on the rural peasant scenes for which he became famous. Ordinary people labouring in the fields became his usual subjects and he painted them in a matter of fact manner without making them sentimental or picturesque. Instead he gave

them a powerful dignity and often portrayed them against a bare, neutral background. This kind of painting greatly appealed to the young Glasgow Boys. Scottish collectors such as James Duncan, James Donald and John McGavin bought Millet's work. They in turn lent their pictures to the Glasgow Institute of the Fine Arts from the early 1880s onwards so that artists such as the Boys had direct access to this type of painting. Millet enjoyed much critical and financial success in the latter years of his life. However ill health meant that he was unable to complete some important commissions and his final years were marred by the upheaval of the Franco-Prussian war, which forced him to flee Barbizon with his family.

Catalogue number 3

James Nairn

Born 1859, Lenzie, Glasgow
Died 1904, Wellington, New Zealand

After having worked for five years in an architect's office in Glasgow, Nairn decided to pursue a career as an artist and enrolled at the Glasgow School of Art. He also studied in Paris at the Académie Julian. During the 1880s Nairn exhibited at the Glasgow Institute of the Fine Arts and the Royal Scottish Academy a series of atmospheric landscapes and fishing scenes. Many of these were painted out-of-doors in the typical Glasgow Boys' style using subtle, restrained tonal colours and vigorous brushwork. Ill health prompted Nairn's decision to emigrate to New Zealand in 1890. After a period in Dunedin he settled in Wellington and in 1891 was appointed as an art instructor at the Wellington Technical School where he became a very influential teacher. In 1892 he set up the Wellington Art Club, in order to provide artists with an informal alternative to the New Zealand Academy of Fine Arts, of which he was a member and served on the council. He encouraged his followers to paint *en plein air*, advocating individual artistic expression.

Catalogue number 26

James Stuart Park

Born 1862, Kidderminster, Worcestershire
Died 1933, Kilmarnock, Ayrshire

The son of an Ayrshire carpet-designer, not much is known about Park's early life, except that he studied at the Glasgow School of Art and in Paris under Lefebre, Boulanger and

Cormon. Almost his entire output took the form of flower paintings, particularly roses, pansies or violets shown against a dark background. Many of these works were exhibited annually at the Glasgow Institute of the Fine Arts. When a strong sense of design became a hallmark of the Boys' style from the late 1880s onwards, Park's still-lifes echoed that trend, linking him with the new style developed by Henry, Hornel and Gauld. From 1889–92, he painted a series of delicate flower pieces, or more elaborate studies of girls' heads surrounded by flowers. These enigmatic pictures, with their emphasis on decorative pattern and design, transformed still-life painting in Scotland, and became very popular commercially in the West of Scotland.

Catalogue number 86

James Paterson RSA, PRSW, RWS

Born 1854, Glasgow
Died 1932, Edinburgh

Born to a successful cotton manufacturer, Paterson worked in business for four years while attending classes at the Glasgow School of Art. He then spent six years in Paris where he saw pictures by Camille Corot and Jules Bastien-Lepage. He was impressed by their broad technique, realist approach and earthy palette. On his return to Scotland Paterson painted with fellow Glasgow Boy, WY Macgregor, on the east coast. Then Paterson 'discovered' a place that really inspired him – the Dumfriesshire village of Moniaive. He was so taken with it that he settled there with his wife in 1884 and immersed himself in the country life of south-west Scotland. There he painted his most memorable atmospheric landscapes of Moniaive and the surrounding countryside, but he did not forget his roots in Glasgow,

helping to establish the *Scottish Art Review*. He served as President, Librarian and finally Secretary of the Royal Scottish Academy until shortly before his death.

Catalogue numbers 22, 51, 85, 99

Alexander Roche RSA, RP

Born 1861, Glasgow
Died 1921, Slateford, Midlothian

Roche started to train as an architect, but later enrolled in the painting classes at the Glasgow School of Art. He then went to Paris and studied under Boulanger and Gerôme. While in Paris he met William Kennedy, John Lavery and Thomas Millie Dow. Following in the footsteps of their mentor Jules Bastien-Lepage, they painted together out-of-doors at the artists' colony of Grez-sur-Loing, south of Paris, producing naturalist subjects in the new style. On his return to Scotland in 1885 Roche settled in Glasgow and exhibited *The Dominie's Favourites* at the Glasgow Institute. That painting's whereabouts are now unknown, but it was the largest realist

painting in the exhibition. Later Roche moved away from this style of painting to a more decorative approach with an emphasis on pattern and design. He travelled widely, including to the United States of America, where he painted a portrait for the philanthropist Andrew Carnegie, depicting his wife and daughter. Although latterly he was partially paralysed on the right side by a brain haemorrhage, Roche went on to teach himself to paint with his left hand.

Catalogue number 63

William Stott of Oldham

Born 1857, Oldham, Lancashire
Died 1900, at sea

Stott studied art for some time in Manchester under J Houghton Hague, and at the Manchester School of Art. He continued his studies in Paris at the Ecole des Beaux-Arts under Bonnat and Gérôme. His summers were spent at Grez-sur-Loing, south-east of Paris, which in time attracted some of the Boys, including Lavery, Kennedy, Dow and Gauld. Two of the pictures Stott painted there, *The Bathers* and *The Ferry*, were exhibited at the Paris Salon of 1882 to much critical acclaim. The former picture was also exhibited at the Glasgow Institute of the Fine Arts where it made a considerable impression on Guthrie, Walton and Henry. Stott kept in touch with the Boys on his return to England and during the 1890s many of them exhibited with him at the New English Art Club. Stott also

provided them with a direct link to Whistler, who was for a time a close friend. Their friendship subsequently soured when Whistler took exception to Stott's changing style, which was reflected in a nude that he painted, of which Whistler was highly critical.

Catalogue number 37

Edward Arthur Walton RSA, RP, PRSW, HRWS

Born 1860, Glanderston House, near Barrhead, Renfrewshire
Died 1922, Edinburgh

Walton's family was artistically gifted – his father was an amateur artist, his brother George was an interior designer and his sisters Helen and Hannah were skilled in ceramic and glass design. After studying at the Düsseldorf Academy and the Glasgow School of Art, Walton met James Guthrie, who became his lifelong friend

and painting associate, as did Joseph Crawhall. The trio painted together at Rosneath, Brig o'Turk and Cockburnspath in the early 1880s, producing realistic landscapes and scenes of country people going about their daily tasks in a fresh, matter-of-fact manner which became the hallmark of the Glasgow Boys. In the 1890s, Walton moved to London, where he became a neighbour and close friend of Whistler, an artist much admired by the Boys. He returned to Scotland permanently in the early years of the twentieth century, settling in Edinburgh. He travelled abroad to Algiers and to Spain, and during the course of World War I spent much time in the Galloway area, concentrating on landscape painting.

Catalogue numbers 18, 20, 21, 27, 30, 34, 35, 62, 68, 72, 88, 89, 96, 117

Exhibition Checklist

All watercolours, drawings
and pastels are on paper
unless otherwise stated

Heroes and 'Gluepots'

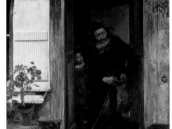

*1. *Le Mendiant*, also known as
The Beggar 1880
Jules Bastien-Lepage
(1848–1884)
oil on canvas, 199 x 181cm

Lent by Ny Carlsberg Glyptotek,
Copenhagen

First exhibited in UK:
1882 London, French Gallery
1883 Glasgow Institute of the
Fine Arts, No 107 as
'*The Mendicant*'

First exhibited abroad:
1881 Paris, Salon, No 97 as
'*Le Mendiant*'

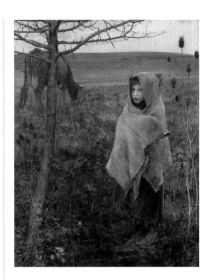

+2. *Pauvre Fauvette* 1881
Jules Bastien-Lepage
(1848–1884)
oil on canvas, 162.5 x 125.7cm

Lent by Kelvingrove Art Gallery and
Museum, Culture and Sport Glasgow
Bought by Glasgow Museums, 1913
Reg No 1323

First exhibited in UK:
1882 London, United Arts
Gallery, No 165

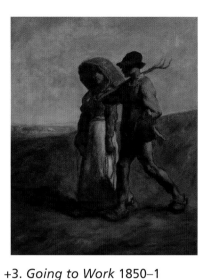

+3. *Going to Work* 1850–1
Jean-François Millet
(1814–1875)
oil on canvas, 55.9 x 46.4cm

Lent by Kelvingrove Art Gallery and
Museum, Culture and Sport Glasgow
Bequeathed by James Donald, 1905
Reg No 1111

First exhibited in UK:
1883 Glasgow Institute of the
Fine Arts, No 38 Lent by James
Donald

* denotes displayed at
 Kelvingrove Art Gallery and
 Museum only

+ denotes displayed at the Royal
 Academy of Arts, London only

Early Years

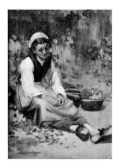

***4. *Seated Peasant Girl* 1878**
Arthur Melville (1855–1904)
watercolour, 54.5 x 38cm

Private Collection

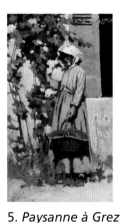

5. *Paysanne à Grez*
(*Peasant Girl at Grez*) 1880
Arthur Melville (1855–1904)
oil on canvas, 53.3 x 30.4cm

Lent by Bourne Fine Art, Edinburgh

First exhibited in UK:
Possibly 1880 Edinburgh,
Royal Scottish Academy, No 214
as '*A French Peasant*'

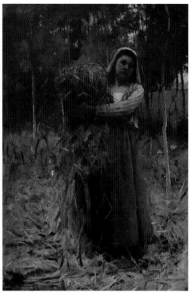

6. *A Peasant Girl* 1880
Arthur Melville (1855–1904)
oil on canvas, 96 x 65cm

Lent by Falmouth Art Gallery Collection

First exhibited in UK:
Possibly 1880 Edinburgh,
Royal Scottish Academy, No 214
as '*A French Peasant*'

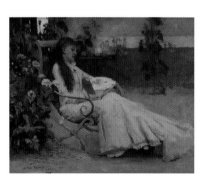

***7. *Summer* 1880**
Arthur Melville (1855–1904)
oil on board, 45.8 X 57.2cm

Lent by the Freeman Spogli Collection,
Los Angeles, CA

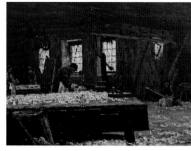

***8. *A Joiner's Shop* 1881**
WY Macgregor (1855–1923)
oil on canvas, 60 x 92cm

Private Collection

First exhibited in UK:
Possibly 1882 Edinburgh, Royal
Scottish Academy, No 59 as
'*A Carpenter's Shop*'

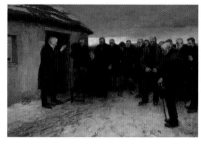

9. *A Funeral Service in the*
Highlands 1881–2
James Guthrie (1859–1930)
oil on canvas, 129.5 x 193cm

Lent by Kelvingrove Art Gallery and
Museum, Culture and Sport Glasgow
Bequeathed by James Gardiner, 1903
Reg No 1060

First exhibited in UK:
1882 London, Royal Academy,
No 146

First exhibited abroad:
1906 International Exhibition,
New Zealand

***10. *Brig o'Turk* 1882**
George Henry (1858–1943)
oil on canvas, 30.4 x 47cm

Lent by Kelvingrove Art Gallery and
Museum, Culture and Sport Glasgow
Presented by The Fine Art Society Ltd,
1977
Reg No 3337

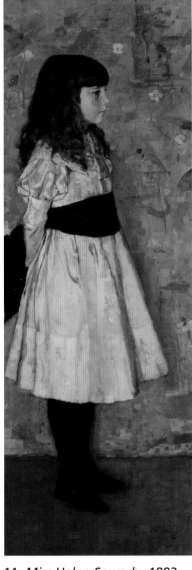

12. *A Lincolnshire Pasture* 1882
Joseph Crawhall (1861–1913)
oil on canvas, 91.4 x 127cm

Lent by Dundee Art Galleries and
Museums, Dundee City Council

First exhibited in UK:
1883 London, Royal Academy,
No 161

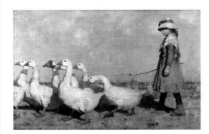

***13.** *To Pastures New* 1882–3
James Guthrie (1859–1930)
oil on canvas, 92 x 152.3cm

Lent by Aberdeen Art Gallery & Museums
Collections

First exhibited in UK:
1883 London, Royal Academy,
No 132

First exhibited abroad:
1907 International Exhibition,
New Zealand

11. *Miss Helen Sowerby* 1882
James Guthrie (1859–1930)
oil on canvas, 161 X 61.2cm

Lent by the National Gallery of Scotland
Purchased by Private Treaty Sale with the
aid of the Art Fund, 1999

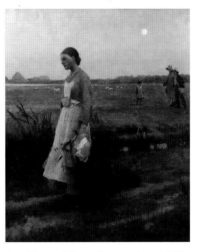

14. *Hop-pickers Returning* 1883
Alexander Mann (1853–1908)
oil on canvas, 117.1 x 96.7cm

Lent by Hunterian Museum and Art
Gallery, University of Glasgow

First exhibited in UK:
1884 Glasgow Institute of the
Fine Arts, No 661

At Home: Pursuing Nature

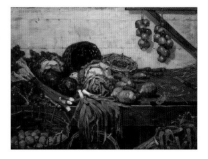

***15.** *The Vegetable Stall* 1882–4
WY Macgregor (1855–1923)
oil on canvas, 106.7 x 153cm

Lent by the National Gallery of Scotland

***16.** *Fieldworkers Crossing a Bridge* 1883
George Henry (1858–1943)
watercolour, 29 x 44.5cm

Private Collection

17. *A Cottage Garden, Crail* **1883**
WY Macgregor (1855–1923)
oil on canvas, 40.5 x 63.5cm

Private Collection

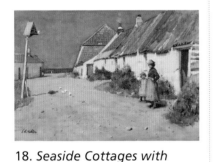

18. *Seaside Cottages with Dovecote*, **about 1883**
EA Walton (1860–1922)
watercolour, 34 x 52.7cm

Lent by Kelvingrove Art Gallery and
Museum, Culture and Sport Glasgow
Bought by Glasgow Museums, 1966
Reg No PR.1966.7

First exhibited in UK:
1883, Glasgow, Scottish Society
of Water Colour Painters, No 92
as '*A Sea-Side Village*'

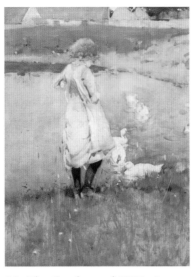

19. *The Duckpond* **1883–4**
Joseph Crawhall (1861–1913)
watercolour, 39.5 x 30.5cm

Lent by Michael DCC Campbell/The Ellis
Campbell Collection

First exhibited in UK: 1886,
Glasgow, Scottish Society of
Water Colour Painters, No 509

First exhibited abroad:
1890 Munich, Glaspalast, *Annual
International Exhibition,* No 1460
as '*Der Ententeich*'

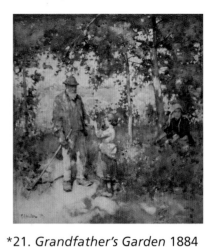

***20.** *Autumn Sunshine* **1883–4**
EA Walton (1860–1922)
oil on canvas, 53.4 x 71cm

Lent by Hunterian Museum and Art
Gallery, University of Glasgow

First exhibited in UK:
1883 Glasgow Institute of the
Fine Arts, No 609

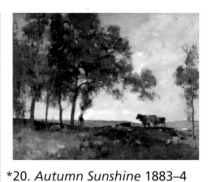

***21.** *Grandfather's Garden* **1884**
EA Walton (1860–1922)
watercolour, 57 x 53.5cm

Lent by The Robertson Collection, Orkney

First exhibited in UK:
1884, Glasgow, Scottish Society
of Water Colour Painters, No 49
as '*The Grandfather's Garden*'

First exhibited abroad:
1890 Munich, Glaspalast, *Annual
International Exhibition*, No 1551
as '*Grossvaters Garten*'

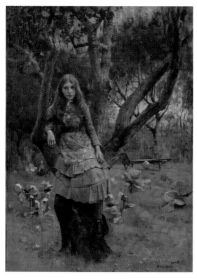

*22. *The Old Apple Tree, Moniaive* 1884–5
James Paterson (1854–1932)
oil on canvas, 107 x 84.5cm

Lent from The Ellis Campbell Collection

First exhibited in UK:
1887 Glasgow Institute of the Fine Arts, No 770 as '*The Old Apple Tree*'

23. *A Cottar's Garden* 1885
George Henry (1858–1943)
watercolour, 29.3 x 44.5cm

Lent by The National Trust for Scotland: Broughton House

24. *The Goose Girls* 1885
John Lavery (1856–1941)
oil on canvas, 45.7 x 55.8cm

Lent by The Fine Art Society, London

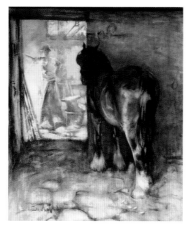

25. *The Forge* 1887
Joseph Crawhall (1861–1913)
watercolour, 63.5 x 55.5cm

Private Collection

First exhibited in UK:
1887 Glasgow, Royal Scottish Society of Water Colour Painters, No 184

First exhibited abroad:
1890 Munich, Glaspalast, *Annual International Exhibition*, No 1459 as '*Die Schmiede*'

26. *Auchenhew, Arran* 1886
James Nairn (1859–1904)
oil on canvas, 61 x 91.5cm

Private Collection, courtesy of The Fine Art Society, London

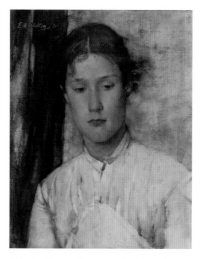

27. *A Gamekeeper's Daughter* OR *Phyllis* 1886
EA Walton (1860–1922)
watercolour, 43.5 x 34.5cm

Lent by Kelvingrove Art Gallery and Museum, Culture and Sport Glasgow
Given by Miss Betty Paterson, 1938
Reg No 2103

First exhibited in UK:
1886 Glasgow, Scottish Society of Water Colour Painters, No 120 as '*Phyllis*'

Cockburnspath: Reaching Maturity

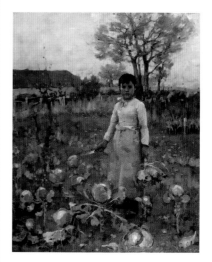

28. *A Hind's Daughter* 1883
James Guthrie (1859–1930)
oil on canvas, 91.5 x 76.2cm

Lent by the National Gallery of Scotland

First exhibited in UK:
1884 Glasgow Institute of the Fine Arts, No 197

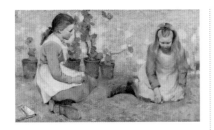

29. *Playmates* **1884**

George Henry (1858–1943)

oil on canvas, 69 x 122cm

Private Collection

First exhibited in UK:
1885 Glasgow Institute of the
Fine Arts, No 523

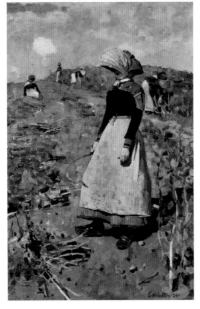

30. *Berwickshire Fieldworkers*
1884

EA Walton (1860–1922)

oil on canvas, 91.4 x 60.9cm

Lent by Tate: Purchased 1982

First exhibited in UK:
1884 Glasgow Institute of the
Fine Arts, No 631 as
'*A Berwickshire Field Worker*'

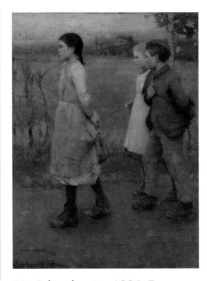

31. *Schoolmates* **1884–5**

James Guthrie (1859–1930)

oil on canvas, 118.2 x 91.6cm

Lent by Museum voor Schone Kunsten,
Gent, Belgium

First exhibited in UK:
1886 Glasgow Institute of the
Fine Arts, No 349

First exhibited abroad:
1892 Paris New Salon as '*Enfants
de notre village*' and 1892 Ghent,
Casino, Salon de 1892, No 352
as '*Enfants de notre village*'/
'*Kinderen van ons dorp*'

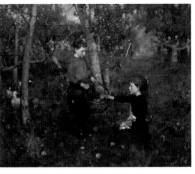

***32.** *In the Orchard* **1885–6**

James Guthrie (1859–1930)

oil on canvas,152.5 x 178cm

Private Collection

First exhibited in UK:
1887 Glasgow Institute of the Fine
Arts, No 246 as '*Apple Gatherers*'

First exhibited abroad:
1889 Paris, Salon as '*Un Verger
en Ecosse*'

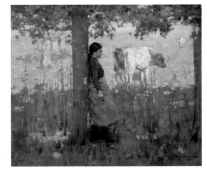

33. *Noon* **1885**

George Henry (1858–1943)

oil on canvas, 51 x 61cm

Private Collection

First exhibited in UK:
1886 Glasgow Institute of the
Fine Arts, No 126

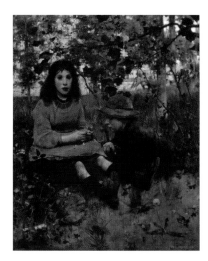

34. *A Daydream* 1885
EA Walton (1860–1922)
oil on canvas, 139.7 x 116.8cm

Lent by the National Gallery of Scotland

First exhibited in UK:
1887 Glasgow Institute of
the Fine Arts, No 212 as
'*A Day Dream*'

First exhibited abroad:
1890 Munich, Glaspalast, *Annual
International Exhibition*,
No 1352b as '*Ein Traum*'

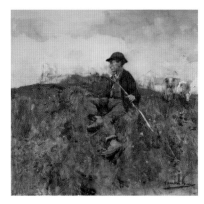

35. *The Herd Boy* 1886
EA Walton (1860–1922)
watercolour, 53.5 x 57cm

Lent by the National Gallery of Scotland
Purchased with the assistance of the Art
Fund, 2007

First exhibited in UK:
1886, Glasgow, Scottish Society
of Water Colour Painters, No 353
as '*A Herd Boy*'

First exhibited abroad:
1890 Munich, Glaspalast, *Annual
International Exhibition*, No 1554
as '*Der Hirte*'

Grez-sur-Loing: An Artists' Colony in France

***36. Les Laveuses**
(The Washerwomen)* 1880
Arthur Melville (1855–1904)
oil on panel, 11.5 x 44.5cm

Lent by CJT & KD Kitchen

First exhibited in UK:
1881 Edinburgh, Royal Scottish
Academy, No 233

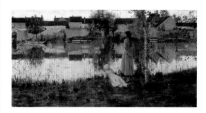

37. *The Ferry*, about 1882
William Stott of Oldham
(1857–1900)
oil on canvas, 109.2 x 214cm

Private Collection

First exhibited in UK: 1882
London, The Fine Art Society

First exhibited abroad:
1882 Paris Salon

***38. A Grey Summer's Day, Grez**
1883*
John Lavery (1856–1941)
oil on canvas, 19 x 24.3cm

Private Collection

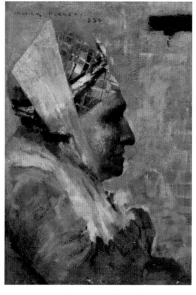

39. *A French Grandmother* 1884
William Kennedy (1859–1918)
oil on panel, 24.2 x 16.9cm

Lent by Hunterian Museum and Art
Gallery, University of Glasgow

First exhibited in UK:
1884 Edinburgh, Royal Scottish
Academy, No 501

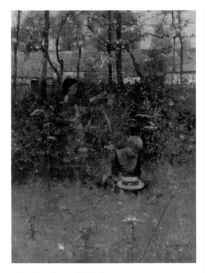

40. *Spring* **1884**
William Kennedy (1859–1918)
oil on canvas, 67.6 x 52cm

Lent by Paisley Museum, Renfrewshire
Council

First exhibited in UK:
Possibly 1893, Edinburgh, Royal
Scottish Academy, No 193. Lent
by HH Smiley Esq, Larne, Ireland

41. *The Hammock – Twilight,*
Grez-sur-Loing **1884**
John Lavery (1856–1941)
oil on canvas, 48.5 x 63.5cm

Private Collection, London

42. *On the Bridge at Grez* **1884**
John Lavery (1856–1941)
oil on canvas, 49 x 100.5cm

Lent by the National Gallery of Ireland,
Dublin
(Exhibited at Kelvingrove Art Gallery and
Museum from 30 July to 27 September 2010)

First exhibited in UK:
1886 London, Royal Academy,
No 52

43. *Sewing in the Shade* **1884**
John Lavery (1856–1941)
oil on canvas, 56 x 46.5cm

Private Collection, courtesy of Pyms
Gallery, London

44. *Under the Cherry Tree* **1884**
John Lavery (1856–1941)
oil on canvas, 79 x 76cm

Private Collection, courtesy of Pyms
Gallery, London

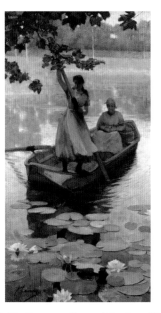

***45.** *Return from Market* **1884–7**
John Lavery (1856–1941)
oil on canvas, 118.8 x 62.3cm

Private Collection, courtesy of
The Fine Art Society, London
(Exhibited at Kelvingrove Art Gallery and
Museum from 9 April to 29 July 2010)

Kirkcudbright: New Friendships

46. *The Hedgecutter* **1885**
George Henry (1858–1943)
oil on canvas, 61 x 51cm

Private Collection, courtesy of the
Hunterian Museum and Art Gallery,
University of Glasgow

First exhibited in UK:
1887 Glasgow Institute of
the Fine Arts, No 437 as
'*A Hedge Cutter*'

*47. *In the Town Crofts, Kirkcudbright* 1885
EA Hornel (1864 –1933)
oil on canvas, 40.6 x 61cm
Private Collection

First exhibited in UK:
Possibly 1888 Glasgow Institute of the Fine Arts, No 392 as '*In the Crofts, Kirkcudbright*'

48. *Resting* 1885
EA Hornel (1864–1933)
oil on canvas, 38 x 28cm
Private Collection

First exhibited in the UK:
1886 Glasgow Institute of the Fine Arts, No 252

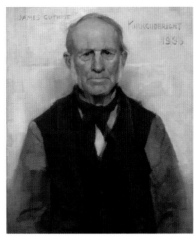

49. *Old Willie – the Village Worthy* 1886
James Guthrie (1859–1930)
oil on canvas, 60.8 x 50.8cm

Lent by Kelvingrove Art Gallery and Museum, Culture and Sport Glasgow
Bought by Glasgow Museums 1974
Reg No 3314

First exhibited in UK:
1894, Edinburgh, Royal Scottish Academy No 275 as '*Study*'

50. *Potato Planting* 1886
EA Hornel (1864–1933)
oil on canvas, 114.2 x 71.1cm
Private Collection

First exhibited in UK:
1887 Glasgow Institute of the Fine Arts, No 509

51. *Moniaive* 1885–6
James Paterson (1854–1932)
oil on canvas, 102 x 152.5cm

Lent by Hunterian Museum and Art Gallery, University of Glasgow

First exhibited in UK:
1910 London, Whitechapel Art Gallery, No 374

Symbolism: A New Aesthetic

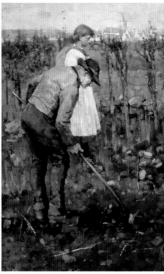

52. *The Hudson River* 1884
Thomas Millie Dow (1848 –1919)
oil on canvas 123.2 x 97.8cm

Lent by Kelvingrove Art Gallery and Museum, Culture and Sport Glasgow
Bequeathed by Allan McLean, 1928
Reg No 1739

First exhibited in UK:
1885 Glasgow Institute of the Fine Arts, No 610

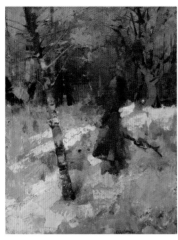

*53. *Autumn* 1888

EA Hornel (1864–1933)

oil on canvas, 44.5 x 33cm

Private Collection

First exhibited in UK:
1889 Glasgow Institute of the
Fine Arts, No 423

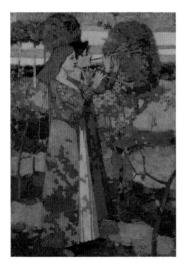

*54. *Music* 1889

David Gauld (1865–1936)

oil on canvas, 35.5 x 25.6cm

Lent by Hunterian Museum and Art
Gallery, University of Glasgow

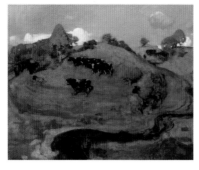
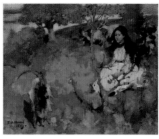

55. *A Galloway Landscape* 1889

George Henry (1858–1943)

oil on canvas, 121.9 X 152.4cm

Lent by Kelvingrove Art Gallery and
Museum, Culture and Sport Glasgow
Given by the Trustees of Sir Thomas
Dunlop, 1940
Reg No 2208

First exhibited in UK:
1890 Glasgow Institute of the
Fine Arts, No 676

First exhibited abroad:
1890, Munich, Glaspalast, *Annual
International Exhibition*, No 515 as
'*Galloway–Landschaft*'

56. *The Goatherd* 1889

EA Hornel (1864–1933)

oil on canvas, 38 x 43.2cm

Private Collection

First exhibited in UK: 1890
Glasgow Institute of the Fine
Arts, No 749 as '*Girl with Goats*'

First exhibited abroad:
Possibly 1890 Munich, Glaspalast,
Annual International Exhibition,
No 571 as '*Ziegen*'

57. *Saint Agnes* 1889–90

David Gauld (1865–1936)

oil on canvas, 61.3 x 35.8cm

Lent by the National Gallery of Scotland
Purchased with the aid of the Art Fund,
1999

First exhibited abroad:
1890 Munich, Glaspalast, *Annual
International Exhibition*, No 404

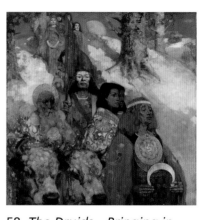

58. *The Druids – Bringing in
the Mistletoe* 1890

George Henry (1858–1943) and
EA Hornel (1864 –1933)

oil on canvas, 152.5 x 152.5cm

Lent by Kelvingrove Art Gallery and
Museum, Culture and Sport Glasgow
Bought by Glasgow Museums 1922
Reg No 1534

First exhibited in UK:
1890 London, Grosvenor Gallery,
No 173

First exhibited abroad:
1890 Munich, Glaspalast, *Annual
International Exhibition*, No 517b
as '*Die Druiden den Mistelzeig
bringend*'

***59. *A Galloway Idyll* 1890**
EA Hornel (1864–1933)
oil on canvas, 50.8 x 40.5cm

Lent by The Robertson Collection, Orkney

60. *The Dance of Spring* 1892–3
EA Hornel (1864–1933)
oil on canvas, 142.4 x 95.2cm

Lent by Kelvingrove Art Gallery and
Museum, Culture and Sport Glasgow
Bought by Glasgow Museums 1960
Reg No 3138

First exhibited in UK:
1893 Edinburgh, Royal Scottish
Academy, No 296 as '*Springtime*'
(later divided into two pictures)

Painters of Modern Life

***61. *Les Derniers Jours des
Tuileries* (*The Last Days of
the Tuileries*) 1883**
William Kennedy (1859–1918)
oil on canvas, 29.1 x 55cm

Private Collection

First exhibited in UK:
1884 Glasgow Institute of the
Fine Arts, No 133 as '*Les Derniers
Jours de Tuileries*'

***62. *Victoria Road, Helensburgh*
1883**
EA Walton (1860–1922)
watercolour, 33.6 x 53.5cm

Private Collection

First exhibited in UK:
1884 London, Royal Academy,
No 1034

First exhibited abroad:
1893 Munich Sezession

***63. *An Interruption* 1884**
Alexander Roche (1861–1921)
oil on canvas, 47 x 61cm

Private Collection

**64. *Lady on a Safety Tricycle*
1885**
John Lavery (1856–1941)
watercolour, 35 x 52cm

Lent by Government Art Collection

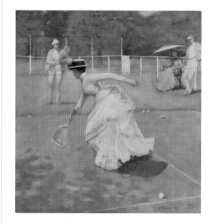

65. *A Rally* 1885
John Lavery (1856–1941)
watercolour, 65.9 x 63.4cm

Lent by Kelvingrove Art Gallery and
Museum, Culture and Sport Glasgow
Presented by Sir John Lavery, 1935
Reg No 1916

First exhibited in UK:
1885 Glasgow, Scottish Society of
Water Colour Painters, No 484

66. *The Tennis Party* 1885

John Lavery (1856–1941)

oil on canvas, 76.2 x 183cm

Lent by Aberdeen Art Gallery & Museums
Collections

First exhibited in UK:
1886 London, Royal Academy,
No 740 as '*The Tennis Match*'

First exhibited abroad:
1888 Paris Salon, No 1527 as
'*Une partie de tennis*'

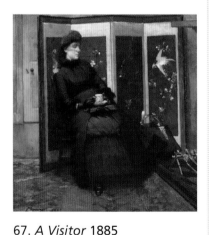

67. *A Visitor* 1885

John Lavery (1856–1941)

oil on canvas, 46 x 46cm

Lent by National Gallery of Ireland, Dublin

First exhibited in UK:
1885, Edinburgh, Royal Scottish
Academy, No 301

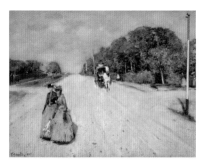

**68. *En Plein Air* OR
An Afternoon Walk 1885**

EA Walton (1860–1922)

watercolour, 44.5 x 59.7cm

Private Collection

First exhibited in UK:
1885 Glasgow, Scottish Society
of Water Colour Painters, No 34
as '*An Afternoon Walk*'

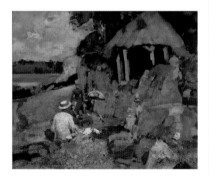

**69. *The Summer House, St
Mary's Isle, Kirkcudbright* 1886**

James Guthrie (1859–1930)

oil on panel, 25.4 x 30.5cm

Private Collection

**70. *Sundown* OR *River
Landscape by Moonlight* 1887**

George Henry (1858–1943)

oil on canvas, 30.5 x 36.8cm

Lent by Hunterian Museum and Art
Gallery, University of Glasgow

First exhibited in UK:
1888 Glasgow Institute of the
Fine Arts, No 642 as '*Sundown*'

71. *Stirling Station* 1887

William Kennedy (1859–1918)

oil on canvas, 54 x 81.6cm

Lent by Kelvingrove Art Gallery and
Museum, Culture and Sport Glasgow
Bought with the assistance of the Heritage
Lottery Fund, the Art Fund, the Hamilton
Bequest and the Friends of Glasgow
Museums, 2008
Reg No 3664

First exhibited in UK:
1888 Glasgow Institute of the
Fine Arts, No 203

First exhibited abroad:
1890 Munich, Glaspalast, *Annual
International Exhibition*, No 646

*72. Flower Seller, Kensington High Street, about 1890

EA Walton (1860–1922)
watercolour and gouache on paper on board, 44.8 x 27.6cm

Private Collection

First exhibited in UK:
1894 Glasgow, Paterson Gallery, 'EA Walton'

First exhibited abroad:
1895 Berlin Sezession

*73. Ebbing Tide, about 1896

James Whitelaw Hamilton (1860–1932)
oil on canvas, 45.7 x 61cm

Lent by Yale Center for British Art, Gift of Isabel S Kurtz in memory of her father, Charles M Kurtz

First exhibited abroad:
1896 St Louis Exposition

Henry and Hornel: The Lure of Japan

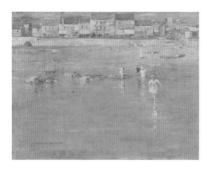

*74. An At-home in Japan OR Salutations 1894

George Henry (1858–1943)
watercolour, 30.5 x 56cm

Lent by Kelvingrove Art Gallery and Museum, Culture and Sport Glasgow Bequeathed by William McInnes, 1944 Reg No 2433

75. Japanese Lady with a Fan 1894

George Henry (1858–1943)
oil on canvas, 61 x 40.6cm

Lent by Kelvingrove Art Gallery and Museum, Culture and Sport Glasgow Given by Mrs MD Lindsay in memory of Col Barclay Shaw, 1927 Reg No 1704

First exhibited in UK:
1929, York, Jubilee Exhibition 1879–1929, No 126

***76.** *The Koto Player, Tokyo*
1894

George Henry (1858–1943)
watercolour, 71 x 40.3cm

Lent by Kelvingrove Art Gallery and
Museum, Culture and Sport Glasgow
Given by Mrs MD Lindsay in memory of
Col Barclay Shaw, 1927
Reg No 1703

First exhibited in UK:
1895 Glasgow Art Club
exhibition, No 95

***77.** *The Balcony, Yokohama*
1894

EA Hornel (1864–1933)
oil on canvas on panel,
40.6 x 50.5cm

Lent by Yale Center for British Art, Gift
of Isabel S Kurtz in memory of her father,
Charles M Kurtz

First exhibited in UK:
Possibly 1895 Glasgow,
La Société des Beaux-Arts
(Alexander Reid's gallery)

First exhibited abroad:
1895 St Louis Exposition, No 276

***78.** *Figures with Lanterns and Bridge* **1894**

EA Hornel (1864–1933)
oil on canvas, 59.8 x 39.4cm

Lent by Hunterian Museum and Art
Gallery, University of Glasgow

First exhibited in UK:
Possibly 1895 Glasgow, La Société
des Beaux-Arts (Alexander Reid's
gallery)

***79.** *The Lotus Flower* **1894**

EA Hornel (1864–1933)
oil on canvas, 76 x 48.5cm
Private Collection

First exhibited in UK:
1895 Glasgow, La Société des
Beaux-Arts (Alexander Reid's
gallery)

80. *A Music Party* 1894
EA Hornel (1864–1933)
oil on canvas mounted on board,
76 x 35.6cm
Lent by Aberdeen Art Gallery & Museums
Collections

First exhibited in UK:
Possibly 1895 Glasgow, La Société
des Beaux-Arts (Alexander Reid's
gallery)

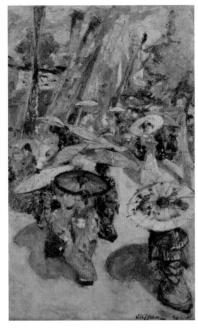

81. *Street Scene, Tokyo* 1894
EA Hornel (1864–1933)
oil on canvas, 75.9 x 47.6cm
Lent by Yale Center for British Art, Gift
of Isabel S Kurtz in memory of her father,
Charles M Kurtz

First exhibited in UK:
Possibly 1895 Glasgow, La
Société des Beaux-Arts (Alexander
Reid's gallery)

First exhibited abroad:
1895 St Louis Exposition, No 277

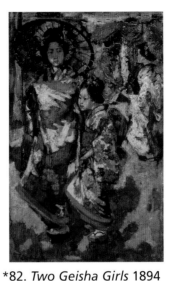

***82. *Two Geisha Girls* 1894**
EA Hornel (1864–1933)
oil on board on panel,
71.6 x 45.9cm
Lent by Hunterian Museum and Art
Gallery, University of Glasgow

First exhibited in UK:
Possibly 1895 Glasgow,
La Société des Beaux-Arts
(Alexander Reid's gallery)

***83. *A Japanese Silk Shop* 1896**
EA Hornel (1864–1933)
oil on canvas, 46.8 x 74.3cm
Private Collection

First exhibited in UK:
1897 Edinburgh, Royal Scottish
Academy, No 38

The Boys in the 1890s

***84. *Red Poppies* 1885**
Arthur Melville (1855–1904)
oil on canvas, 56 x 76cm
Private Collection

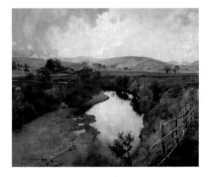

85. *Autumn in Glencairn* 1887
James Paterson (1854–1932)
oil on canvas, 101.5 x 127cm
Lent by the National Gallery of Scotland
Purchased with the aid of the Barrogill
Keith Bequest Fund, 1985

First exhibited in UK:
1888 Glasgow Institute of the
Fine Arts, No 143 as '*Glen-Cairn
in Autumn*'

***86.** *Yellow Roses* **1889**

Stuart Park (1862–1933)

oil on canvas, 46 x 73cm

Private Collection

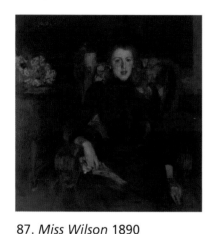

87. *Miss Wilson* **1890**

James Guthrie (1859–1930)

oil on canvas, 105.5 x 108cm

Private Collection

First exhibited in UK:
1893 London, Grafton Gallery

First exhibited abroad:
1892 Paris, New Salon as
'*Jeune Fille*'

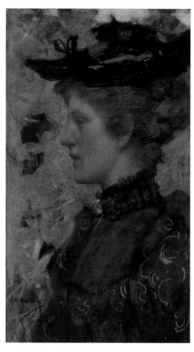

***88.** *Miss Elizabeth D Reid* OR
Auburn, about 1890

EA Walton (1860–1922)

pastel on board, 67 x 37cm

Lent by Kelvingrove Art Gallery and
Museum, Culture and Sport Glasgow
Given by Mr and Mrs AJ McNeill Reid
1964
Reg No PR.1964.4

First exhibited in UK:
1893 Manchester City Art Gallery

First exhibited abroad:
1895 St Louis Exposition as
'*Auburn*'

89. *Bluette* **1891**

EA Walton (1860–1922)

oil on canvas, 75 x 78cm

Lent by the National Gallery of Scotland

First exhibited in UK:
1892 Edinburgh, Royal Scottish
Academy, No 259 as '*Bluette*'

90. *The Contrabandista* **1892**

Arthur Melville (1855–1904)

oil on canvas 101.5 x 56cm

Collection Miss Flure Grossart

+91. *RB Cunninghame Graham*
1893

John Lavery (1856–1941)

oil on canvas, 203.2 x 108.2cm

Lent by Kelvingrove Art Gallery and
Museum, Culture and Sport Glasgow
Bought by Glasgow Museums 1906
Reg No 1181

First exhibited in UK:
1895 Edinburgh Royal Scottish
Academy, No 330

First exhibited abroad:
1894 Paris Salon, No 693

92. *Tangier – the White City* **1893**

John Lavery (1856–1941)

oil on canvas, 58 x 79.5cm

Private Collection, courtesy of Karen Reihill Fine Art, Dublin

First exhibited in UK:
1904 London, Guildhall Art Gallery, *Works by Irish Painters*, No 167

First exhibited abroad:
Possibly 1902 Ghent

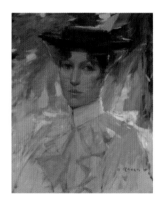

***93.** *Portrait*, about 1893–4

David Gauld (1865–1936)

oil on canvas, 51 x 40.5cm

Private Collection

First exhibited in UK:
Possibly 1896 Royal Glasgow Institute of the Fine Arts, No 493

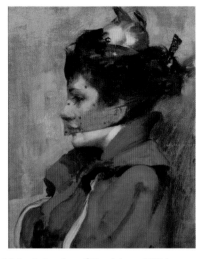

***94.** *A Lady of Fashion* **1894**

George Henry (1858–1943)

oil on canvas, 67 x 100cm

Private Collection

95. *The White Drake*, about 1895

Joseph Crawhall (1861–1913)

gouache on linen, 40.7 x 57.1cm

Lent by the National Gallery of Scotland Purchased with support by the National Lottery through the Heritage Lottery Fund and the Art Fund, 1996

First exhibited in UK:
1906 London, WB Paterson's Gallery, *Drawings in Watercolour and Black and White*, No 26

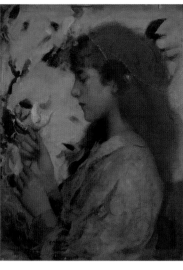

***96.** *The White Flower* **1897**

EA Walton (1860–1922)

oil on canvas, 54 x 41cm

Lent by Fife Council Libraries and Museums: Kirkcaldy Museum and Art Gallery

First exhibited in UK:
1898 Edinburgh, Royal Scottish Academy, No 269 as '*Head of a Girl*'

First exhibited abroad:
1897 Paris, Société Nationale des Beaux Arts as '*Portrait*'

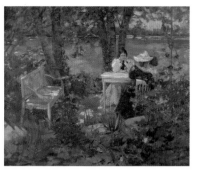

97. *A Garden in France* **1898**

John Lavery (1856–1941)

oil on canvas, 101 x 127cm

Private Collection

First exhibited in UK:
1898 London, International Society of Sculptors, Painters and Gravers, No 242

Image not available

+98. *Harriet, Lady Findlay* **1905**

James Guthrie (1859–1930)

oil on canvas, 213.4 x 111.7cm

Lent by The Royal Bank of Scotland PLC

First exhibited in UK:
1906 Edinburgh, Royal Scottish Academy, No 219 as *Mrs John R Findlay of Aberlour*

First exhibited abroad:
1910 Pittsburgh

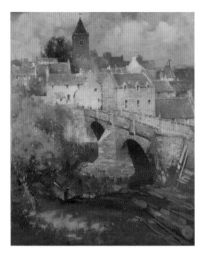

99. *An East Lothian Village
1906
James Paterson (1854–1932)
oil on canvas, 118.5 x 97.5cm
Lent by Collection of Gallery Oldham

First exhibited in UK:
1907 Royal Glasgow Institute of
the Fine Arts, No 196

John Lavery at the Glasgow International Exhibition, 1888

***100. *The Blue Hungarians at
the Glasgow International
Exhibition* 1888**
John Lavery (1856–1941)
oil on canvas, 30.4 x 35.5cm
Lent by Fleming–Wyfold Art Foundation

First exhibited in UK:
1888 Glasgow, Craibe Angus
Gallery

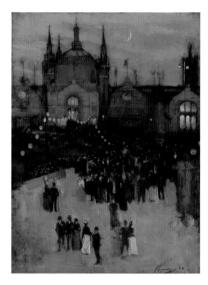

101. *The Dutch Cocoa House*
1888
John Lavery (1856–1941)
oil on canvas, 45.8 x 35.7cm

Lent by the National Gallery of Scotland
Purchased with the aid of the Barrogill
Keith Bequest Fund, 1985

First exhibited in UK:
1888 Glasgow, Craibe Angus
Gallery

**102. *The Glasgow
International Exhibition* 1888**
John Lavery (1856–1941)
oil on canvas, 61 x 45.7cm

Lent by Kelvingrove Art Gallery and
Museum, Culture and Sport Glasgow
Bought by Glasgow Museums 1945
Reg No 2504

First exhibited in UK:
1888 Glasgow, Craibe Angus
Gallery

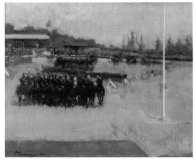

103. *The Musical Ride of the 15th Hussars during the Military Tournament at the Glasgow International Exhibition* 1888
John Lavery (1856–1941)
oil on canvas, 30.4 x 38cm
Lent by Dundee Art Galleries and Museums, Dundee City Council

First exhibited in UK:
1888 Glasgow, Craibe Angus Gallery

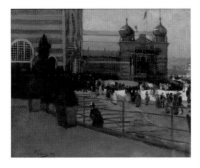

104. *On the Verandah at the Glasgow International Exhibition* 1888
John Lavery (1856–1941)
oil on canvas, 35 x 44.7cm
Private Collection

First exhibited in UK:
1888 Glasgow, Craibe Angus Gallery

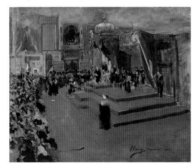

*105. *Study for The State Visit of Queen Victoria to the International Exhibition, Glasgow* 1888
John Lavery (1856–1941)
oil on canvas, 63.5 x 76.9cm
Lent by Aberdeen Art Gallery & Museums Collections

First exhibited in UK:
1933 Liverpool, Walker Art Gallery

106. *Sunshine and Shade* 1888
John Lavery (1856–1941)
oil on canvas, 30 x 24cm
Private Collection

First exhibited in UK: 1888 Glasgow, Craibe Angus Gallery

*107. *A View from the Canal at the Glasgow International Exhibition* 1888
John Lavery (1856–1941)
oil on panel, 35.5 x 24.3cm
Lent by Cecil Higgins Art Gallery, Bedford

First exhibited in UK:
1888 Glasgow, Craibe Angus Gallery

Artists and Studios

*108. *Joseph Crawhall* 1881
J Pittendrigh Macgillivray (1856–1938)
Bronze bas-relief sculpture, 31.5cm diameter
Lent by Kelvingrove Art Gallery and Museum, Culture and Sport Glasgow
Given by Alexander Reid and Son, 1927
Reg No S.168

First exhibited in UK:
1895 Edinburgh Royal Scottish Academy, No 348

***109.** *WY Macgregor,*
about 1881

J Pittendrigh Macgillivray
(1856–1938)

Bronze bas-relief sculpture,
31.5cm diameter

Lent by Kelvingrove Art Gallery and
Museum, Culture and Sport Glasgow
Given by Mrs WY Macgregor, 1924
Reg No S.155

First exhibited in UK:
1935 Glasgow, Kelvingrove Art
Gallery and Museum, *A Century
of Art in Glasgow*, No 177

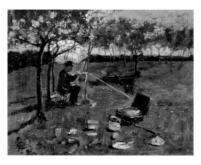

110. *Poppleton* 1882

James Guthrie (1859–1930)

oil on canvas, 34.3 x 54.8cm

Lent by Hunterian Museum and Art
Gallery, University of Glasgow

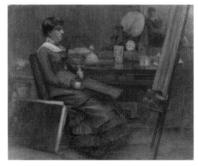

***111.** *Her Portrait* 1882

John Lavery (1856–1941)

chalk, 25.9 x 33cm

Lent by Kelvingrove Art Gallery and
Museum, Culture and Sport Glasgow
Bought by Glasgow Museums 1979
Reg No PR.1979.6

First Exhibited in UK:
1882 Glasgow Institute of the
Fine Arts, *Black and White
Exhibition*, No 451

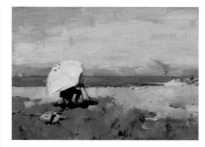

112. *Hard at it* 1883

James Guthrie (1859–1930)

oil on canvas, 31.1 x 46cm

Lent by Kelvingrove Art Gallery and
Museum, Culture and Sport Glasgow
Bought by Glasgow Museums 1967
Reg No 3248

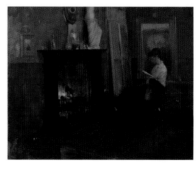

***113.** *A Quiet Day in the Studio*
1883

John Lavery (1856–1941)

oil on canvas, 41.9 x 52.1cm

Lent by Kelvingrove Art Gallery and
Museum, Culture and Sport Glasgow
Bought by Glasgow Museums 1944
Reg No 2364

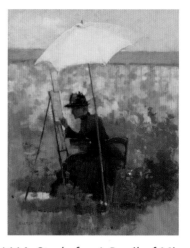

***114.** *Study for A Pupil of Mine,
Grez-sur-Loing* 1883

John Lavery (1856–1941)

oil on canvas, 24x 18.5cm

Private Collection, Switzerland

First exhibited in UK:
Possibly 1883, Glasgow Art Club

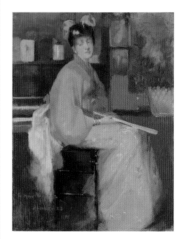

115. *Woman in Japanese Dress*
1883

John Lavery (1856–1941)

oil on panel, 27.9 x 21cm

Lent by Yale Center for British Art, Paul
Mellon Fund

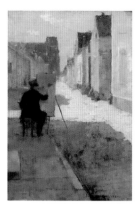

116. *The Principal Street in Gretz* 1884

John Lavery (1856–1941)

oil on canvas, 32.5 x 22.5cm

Private Collection, courtesy of Pyms Gallery, London

First exhibited in UK:
1884 Paisley Institute, No 327

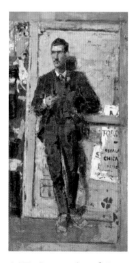

117. *Portrait of Joseph Crawhall* 1884

EA Walton (1860–1922)

oil on canvas, 74.3 x 36.8cm

Lent by the Scottish National Portrait Gallery

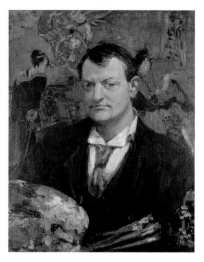

***118. *Portrait of EA Hornel* 1896**

Bessie MacNicol (1869–1904)

oil on canvas, 76.2 x 61cm

Lent by The National Trust for Scotland: Broughton House

First exhibited in UK:
1897 Royal Glasgow Institute of the Fine Arts, No 456 as '*EA Hornel*'

James Guthrie: Pastels

***119. *Pastureland* 1888**

James Guthrie (1859–1930)

pastel, 24.7 x 30.5cm

Lent by Kelvingrove Art Gallery and Museum, Culture and Sport Glasgow Bequeathed by William McInnes, 1944 Reg No 2442

First exhibited in UK:
Possibly 1890 London, New English Art Club, No 117 as '*September Afternoon*'

120. *The Ropewalk* 1888

James Guthrie (1859–1930)

pastel, 63 x 49.5cm

Private Collection

First exhibited in UK:
Possibly 1889 London, New English Art Club, No 71 as '*In the Rope Walk*'

First exhibited abroad:
1890 Munich, Glaspalast, *Annual International Exhibition*, No 1480 as '*In der Seilerbahn*'

***121. *Candlelight* 1890**
James Guthrie (1859–1930)
pastel, 42.5 x 51.5cm
Private Collection

First exhibited in UK:
1890–1 London, Dowdeswell's
Gallery and Glasgow, Lawrie's
Gallery, *Guthrie Pastel Exhibition*

122. *Firelight Reflections* 1890
James Guthrie (1859–1930)
pastel, 61 x 52cm
Paisley Art Institute Collection, held by
Paisley Museum, Renfrewshire Council

First Exhibited in UK:
Possibly 1890 London, Grosvenor
Gallery, *Pastel Society*, as
'*Firelight*'

123. *The Morning Paper* 1890
James Guthrie (1859–1930)
pastel, 48.2 x 61cm
Private Collection

First exhibited in UK:
1890–1 London, Dowdeswell's
Gallery and Glasgow, Lawrie's
Gallery, *Guthrie Pastel Exhibition*

124. *Tennis* 1890
James Guthrie (1859–1930)
pastel, 49.5 x 42cm
Private Collection

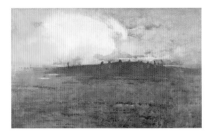

***125. *Causerie (Chatting)* 1892**
James Guthrie (1859–1930)
pastel, 50.5 x 57cm
Lent by Hunterian Museum and Art
Gallery, University of Glasgow

First exhibited abroad:
1892, New Salon, Paris as '*Le Thé
de l'après–midi*'

Arthur Melville:
Watercolours
and Pastels

***126. *The Stones of Stennis* 1885**
Arthur Melville (1855–1904)
watercolour 75 x 125cm
Private Collection, courtesy of
The Fine Art Society, London

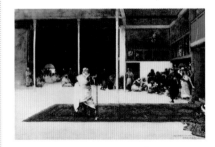

**127. *Awaiting an Audience
with the Pasha* 1887**
Arthur Melville (1855–1904)
watercolour, 66 x 100cm
Private Collection

First exhibited in UK:
Possibly 1888 London, Royal
Watercolour Society, No 199

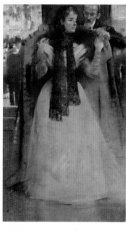

128. *After the Play* 1890
Arthur Melville (1855–1904)
pastel, 99.1 x 55.9cm

Lent by Duncan R Miller Fine Arts, London

First exhibited in UK:
1890 London, The Grosvenor
Gallery, *First Exhibition of the
Society of British Pastellists*,
No 21

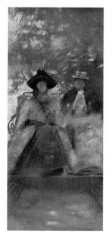

***129.** *Two Girls in a Boat* 1890
Arthur Melville (1855–1904)
pastel, 74 x 32cm

Private Collection

***130.** *Passages (Pasajes de San
Juan)* 1892
Arthur Melville (1855–1904)
watercolour, 58.4 x 76.2cm

Lent by Fleming–Wyfold Art Foundation

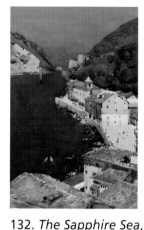

***131.** *The Port of Passages* 1892
Arthur Melville (1855–1904)
watercolour, 51.3 x 78.2cm

Lent by Kelvingrove Art Gallery and
Museum, Culture and Sport Glasgow
Given by Mrs MD Lindsay in memory of
Colkf Barclay Shaw, 1927
Reg No 1702

132. *The Sapphire Sea,
Passages* 1892
Arthur Melville (1855–1904)
watercolour, 78 x 50.5cm

Lent by kind permission of the Scottish
Gallery, Edinburgh and Ewan Mundy Fine
Art, Glasgow

First exhibited in UK:
1893 London, Grafton Gallery

133. *The Little Bullfight: 'Bravo
Toro'*, about 1892
Arthur Melville (1855–1904)
watercolour, 56 x 78.8cm

Lent by Victoria and Albert Museum
Given by Mrs Arthur Melville

First exhibited in UK:
Possibly 1899, London, Royal
Watercolour Society, No 73

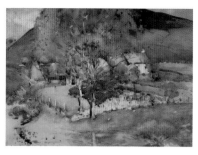

134. *Brig o'Turk* 1893
Arthur Melville (1855–1904)
watercolour, 60.8 x 86.4cm

Lent by The Robertson Collection, Orkney

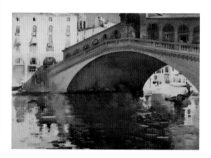

***135.** *The Rialto, Venice* 1894
Arthur Melville (1855–1904)
watercolour, 58.5 x 84cm

Lent by The Robertson Collection, Orkney

First exhibited in UK:
1896 Glasgow Institute of the
Fine Arts, No 778

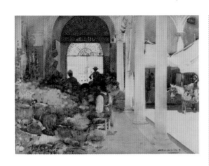

*136. *The Flower Market, Granada* 1896
Arthur Melville (1855–1904)
watercolour, 59.7 x 85.1cm

Private Collection

Joseph Crawhall: Watercolours

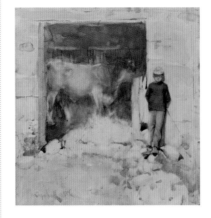

*137. *The Byre*, 1887
Joseph Crawhall (1861–1913)
watercolour, 33.2 x 31.5cm

Lent by Kelvingrove Art Gallery and
Museum, Culture and Sport Glasgow
Bequeathed by Mr John Keppie, 1945
Reg No 2487

First exhibited in UK:
1887 Glasgow, Royal Scottish
Society of Water Colour Painters,
No 95 as '*Left in Charge*'

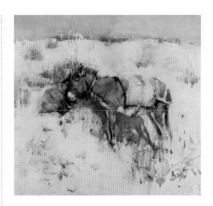

*138. *Donkey, Tangier* 1887
Joseph Crawhall (1861–1913)
watercolour, 39.5 x 42.9cm

Lent by Yale Center for British Art,
Paul Mellon Collection

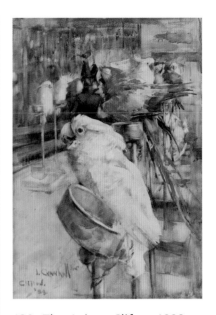

139. *The Aviary, Clifton* 1888
Joseph Crawhall (1861–1913)
watercolour, 50.5 x 34.5cm

Lent by the Burrell Collection, Culture and
Sport Glasgow
Reg No 35.77

First exhibited in UK:
1888 Glasgow, Messrs Thomas
and Paterson;
1889 Glasgow, Royal Scottish
Society of Painters in Water
Colours, No 177 as '*In the Aviary,
Clifton*'

First exhibited abroad:
1890 Munich, Glaspalast, *Annual
International Exhibition*, No 1461
as '*Im Vogelhaus, Clifton*'

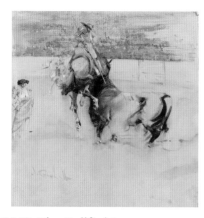

*140. *The Bullfight*,
about 1889–91
Joseph Crawhall (1861–1913)
watercolour, 37.7 x 35.5cm

Lent by the Burrell Collection, Culture and
Sport Glasgow
Reg No 35.85

First exhibited in UK:
Possibly 1891, Glasgow, Royal
Scottish Society of Painters in
Water Colours, Nos 194 or 195,
both titled '*Spanish Bull-Fight*'

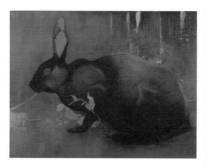

141. *A Black Rabbit*, about 1894
Joseph Crawhall (1861–1913)
gouache on linen, 23.5 x 33.7cm

Lent by Yale Center for British Art, Paul
Mellon Collection

First exhibited in UK: 1895
Glasgow Institute of the Fine
Arts, No 602 as '*Rabbit*'.
Lent by George Burrell.

First exhibited abroad:
1895 Chicago, Art Institute,
No 2 as '*The Rabbit*'. Lent by
George Burrell.

142. *Horse and Cart with Lady*,
about 1894–1900
Joseph Crawhall (1861–1913)
gouache on linen, 22.8 X 31.2cm

Lent by Kelvingrove Art Gallery and
Museum, Culture and Sport Glasgow
Bequeathed by Hugh Locke Anderson Jr,
1943
Reg No 2327

First exhibited in UK:
Possibly 1912 London,
WB Paterson's Gallery,
*Watercolour Drawings by Joseph
Crawhall*, No 39 as '*The Dog
Cart*'

*143. *The Race Course*,
about 1894–1900
Joseph Crawhall (1861–1913)
gouache on linen, 28.8 x 32.4cm

Lent by Kelvingrove Art Gallery and
Museum, Culture and Sport Glasgow
Bequeathed by Col CL Spencer, 1952
Reg No 2961

*144. *Pigeons on the Roof*,
about 1895
Joseph Crawhall (1861–1913)
gouache on linen, 38.8 x 32.4cm

Lent by the Burrell Collection, Culture and
Sport Glasgow
Reg No 35.173

First exhibited in UK:
1905 Royal Glasgow Institute of
the Fine Arts, No 589 as '*Pigeons*'

Index

Compiled by Fiona Barr, Fellow of the Society of Indexers.

Page references to illustrations are in italics.

Benefactors of the Royal Academy of Arts

ROYAL ACADEMY TRUST

MAJOR BENEFACTORS

The Trustees of the Royal Academy Trust are grateful to all its donors for their continued loyalty and generosity. They would like to extend their thanks to all those who have made a significant commitment, past and present, to the galleries, the exhibitions, the conservation of the Permanent Collection, the Library collections, the Royal Academy Schools, the education programme and other specific appeals.

HM The Queen
Her Majesty's Government
The 29th May 1961 Charitable Trust
Barclays Bank
BAT Industries plc
The late Tom Bendhem
The late Brenda M Benwell-Lejeune
British Telecom
John and Susan Burns
Mr Raymond M Burton CBE
Sir Trevor and Lady Chinn
The John S Cohen Foundation
Sir Harry and Lady Djangoly
The Dulverton Trust
Alfred Dunhill Limited
The John Ellerman Foundation
The Eranda Foundation
Ernst & Young
Esso UK plc
Mr and Mrs Eugene V Fife
The Foundation for Sports and the Arts
Friends of the Royal Academy
John Frye Bourne
Jacqueline and Michael Gee
Glaxo Holdings plc
Diane and Guilford Glazer
Mr and Mrs Jack Goldhill
Maurice and Laurence Goldman
Mr and Mrs Jocelin Harris
The Philip and Pauline Harris Charitable Trust
The Charles Hayward Foundation
Robin Heller Moss
Heritage Lottery Fund
The Malcolm Hewitt Wiener Foundation
IBM United Kingdom Limited
The Idlewild Trust
Lord and Lady Jacobs
The JP Jacobs Charitable Trust
The Japan Foundation
Gabrielle Jungels-Winkler
Mr and Mrs Donald Kahn
Lillian Jean Kaplan Foundation
The Kresge Foundation
The Samuel H Kress Foundation
The Kirby Laing Foundation
The late Mr John S Latsis
The Leverhulme Trust
Lex Service plc

The Linbury Trust
Sir Sydney Lipworth QC and Lady Lipworth
John Lyons Charity
Ronald and Rita McAulay
McKinsey and Company Inc
John Madejski OBE DL
The Manifold Trust
Mr and Mrs John L Marion
Marks and Spencer
The Mercers' Company
The Monument Trust
The Henry Moore Foundation
The Moorgate Trust Fund
Mr and Mrs Minoru Mori
The Museums, Libraries and Archives Council
National Westminster Bank
Stavros S Niarchos
The Peacock Charitable Trust
The Pennycress Trust
PF Charitable Trust
The Pidem Fund
The Pilgrim Trust
The Edith and Ferdinand Porjes Trust
The Porter Foundation
John Porter Charitable Trust
Rio Tinto
John A Roberts FRIBA
Simon and Virginia Robertson
The Ronson Foundation
The Rose Foundation
Rothmans International plc
Dame Jillian Sackler DBE
Jillian and Arthur M Sackler
Mrs Jean Sainsbury
The Saison Foundation
The Basil Samuel Charitable Trust
Mrs Coral Samuel CBE
Sea Containers Ltd
Shell UK Limited
Miss Dasha Shenkman
William and Maureen Shenkman
The Archie Sherman Charitable Trust
Sir Hugh Sykes DL
Sir Anthony and Lady Tennant
Ware and Edythe Travelstead
The Trusthouse Charitable Foundation
The Douglas Turner Trust
Unilever plc
The Weldon UK Charitable Trust
The Welton Foundation
The Garfield Weston Foundation
The Maurice Wohl Charitable Foundation
The Wolfson Foundation

and others who wish to remain anonymous

PATRONS

The Royal Academy is delighted to thank all its Patrons for generously supporting the following areas over the past year: exhibitions, education, the Royal Academy Schools, the Permanent Collection and Library, and Anglo-American initiatives; and for assisting in the general upkeep of the Academy.

Platinum

Mr and Mrs John Coombe
Mr and Mrs Patrick Doherty
Mrs Helena Frost
Mr and Mrs David Shalit

Gold

His Excellency the American Ambassador
Sir Ronald and Lady Cohen
The Cowley Foundation
Lady Getty
Mr and Mrs Ronald Lubner
Prof Anthony Mellows CBE TD and Mrs Mellows
Lady Jane Rayne
Mrs Inna Vainshtock
Mr and Dr Winkler
W Randall Work and Mandy Gray

Silver

Mrs Cynthia Arno
Mrs Leslie Bacon
Mrs Gary Brass
Mrs Elie Brihi
Lady Brown
Sir Charles and Lady Chadwyck-Healey
Sir Trevor and Lady Chinn
Mrs Jennifer Cooke
The de Laszlo Foundation
Benita and Gerald Fogel
Mrs George Fokschaner
Mrs Anthony Foyle
Mr and Mrs Eric Franck
Jaqueline and Jonathan Gestetner
Michael and Morven Heller
Mr and Mrs Alan Hobart
Mr and Mrs Jon Hunt
S Isern-Feliu
Mr and Mrs S Kahan
Mr Nand Khemka and Princess Jeet Nabha Khemka
Mr D H Killick
Mrs Aboudi Kosta
Lady Lever of Manchester
Mark and Liza Loveday
Mr Nicholas Maclean
Mr and Mrs Richard Martin
The Mulberry Trust
Mr and Mrs D J Peacock
The Lady Henrietta St George
Mr and Mrs Kevin Senior
The Countess of Shaftesbury
Mrs Stella Shawzin
Mrs Lesley Silver

Richard and Veronica Simmons
Jane Spack
Mrs Elyane Stilling
Sir Hugh Sykes DL

Bronze

Lady Agnew
Miss H J C Anstruther
Mrs Marina Atwater
Jane Barker
Stephen Barry Charitable Settlement
James M Bartos
The Duke of Beaufort
Mrs J K M Bentley
Mr Michael Bradfield
Mrs Marcia Brocklebank
Mr and Mrs Charles H Brown
Jeremy Brown
Lord Browne of Madingley
Mr Raymond M Burton CBE
Mr F A A Carnwath CBE
Jean and Eric Cass
Mrs Vivien Chappell
Mr and Mrs George Coelho
Denise Cohen Charitable Trust
Mrs Cathy Corbett
Mr and Mrs Sidney Corob
Julian Darley and Helga Sands
The Countess of Dartmouth
Peter and Andrea De Haan
Mrs Norah de Vigier
Dr Anne Dornhorst
Lord Douro
Ms Noreen Doyle
Mr and Mrs Maurice Dwek
Mrs Sheila Earles
Lord and Lady Egremont
Miss Caroline Ellison
Mary Fedden RA
Mr and Mrs David Fenton
Bryan Ferry
Mrs Pamela Foster-Brown
Mrs Jocelyn Fox
Mr Monty Freedman
Arnold Fulton
Patricia and John Glasswell
Mark Glatman
Lady Gosling
Piers Gough
Sir Ewan and Lady Harper
Mr Mark Hendriksen
Mr and Mrs Christoph Henkel
Ms Alexandra Hess
Ms Joanna Hewitt
Mrs Pauline Hyde
Mrs Sabine Israel
Sir Martin and Lady Jacomb
Mrs Raymonde Jay
Fiona Johnstone
Mrs Joseph
Dr Elisabeth Kehoe
Mr Gerald Kidd
Mr and Mrs James Kirkman
Mr Leon Krayer

Norman A Kurland and Deborah A David
Mr Peter Lloyd
The Marquess of Lothian
Mr and Mrs Henry Lumley
Gillian McIntosh
Andrew and Judith McKinna
Sally and Donald Main
Mr and Mrs Eskandar Maleki
Mr Michael Manser RA and Mrs Jose Manser
Mr Marcus Margulies
Zvi and Ofra Meitar Family Fund
Dean Menegas
Mrs Carole Myers
Mrs Alan Morgan
Mrs Joy Moss
Marion and Guy Naggar
Dr Ann Naylor
Elaine and David Nordby
Ann Norman-Butler
North Street Trust
Mr Michael Palin
John H Pattisson
Mr and Mrs A Perloff
Mr Philip Perry
Mrs Eve Pilkington
Mr and Mrs Anthony Pitt-Rivers
Mr Harry Plotnick
Mrs Jasmin Prokop
Mr Mike Pullen
John and Anne Raisman
Miss Myrna Rassam
Mrs Bianca Roden
Mrs Jenifer Rosenberg OBE
Lord Rothschild
Mr and Mrs K M Rubie
Ms Edwina Sassoon
H M Sassoon Charitable Trust
Carol Sellars
Dr Lewis Sevitt
Mr Robert N Shapiro
Victoria Sharp
Mr James B Sherwood
Mr David Shovel
Mrs Victor Silverton
Alan and Marianna Simpson
Brian D Smith
Mr Malcolm Smith
Mrs D Susman
Lord and Lady Taylor
Mr Ian Taylor
Miss M L Ulfane
John and Carol Wates
Edna and Willard Weiss
Anthony and Rachel Williams

and others who wish to remain anonymous

BENEFACTOR PATRONS

Mr and Mrs William Brake
Lord and Lady Foley
Mrs Mary Graves
Mrs Sue Hammerson
Joan H Lavender

The Swan Trust
Sir Anthony and Lady Tennant

BENJAMIN WEST GROUP PATRONS
Chairman
Lady Judge

Gold
Lady J Lloyd Adamson

Silver
Mrs Spindrift Al Swaidi
Mrs Adrian Bowden
Mr and Mrs Paul Collins
Charles and Kaaren Hale
Lady Judge
Scott and Christine Morrissey
Mr and Mrs John R Olsen
Mr Leigh Seippel
Frank and Anne Sixt
Mr and Mrs Dave Williams

Bronze
Ms Ruth Anderson
Ms Michal Berkner
Wendy Brooks and Tim Medland
Mrs Kathie Child-Villiers
Ms Maryn Coker
Mr Mark Dichter
Mr Jeffrey E Eldredge
Ms Clare Flanagan
Cyril and Christine Freedman
Mr Metin Guvener
Mr Andrew Hawkins
Suzanne and Michael Johnson
Mr and Mrs Kenneth Lieberman
Charles G Lubar
Neil Osborn and Holly Smith
Lady Purves
Mr and Mrs K M Rubie
Sylvia Scheuer
Carl Stewart
Carole Turner Record
Frederick and Kathryn Uhde
Mrs Yoon Ullmo
Prof Peter Whiteman QC
John and Amelia Winter
Mary Wolridge

and others who wish to remain anonymous

SCHOOLS PATRONS GROUP
Chairman
John Entwistle OBE

Platinum
Mr Campbell Rigg
Matthew and Sian Westerman

Silver
Lord and Lady Aldington
John Entwistle OBE

Bronze
Mrs Inge Borg Scott
Ian and Tessa Ferguson
Prof Ken Howard RA and Mrs Howard
Mr Philip Marsden
Peter Rice Esq

Anthony and Sally Salz
Mr Ray Treen

and others who wish to remain anonymous

CONTEMPORARY PATRONS GROUP
Chairman
Susie Allen

Patrons
Viscountess Bridgeman
Alla Broeksmit
Dr Elaine C Buck
Jenny Christensson
Loraine da Costa
Helen and Colin David
Belinda de Gaudemar
Chris and Angie Drake
Caroline Hansberry
Mrs Susan Hayden
Mr and Mrs Stephen Mather
Jean-Jacques Murray
Barbara Pansadoro
Mr Andres Recoder and Mrs Isabelle
 Schiavi
Mrs Catherine Rees
Richard and Susan Shoylekov
John Tackaberry
Inna Vainshtock
Cathy Wills
Mary Wolridge

and others who wish to remain anonymous

TRUSTS AND FOUNDATIONS
The Atlas Fund
The Ove Arup Foundation
Aurelius Charitable Trust
The Peter Boizot Foundation
The Bomonty Charitable Trust
The Charlotte Bonham-Carter Charitable
 Trust
William Brake Charitable Trust
The Britten-Pears Foundation
R M Burton 1998 Charitable Trust
C H K Charities Limited
P H G Cadbury Charitable Trust
The Carew Pole Charitable Trust
The Carlton House Charitable Trust
The Clore Duffield Foundation
John S Cohen Foundation
The Ernest Cook Trust
The Sidney and Elizabeth Corob Charitable
 Trust
The Coutts Charitable Trust
Alan Cristea Gallery
The de Laszlo Foundation
The D'Oyly Carte Charitable Trust
The Dovehouse Trust
The Gilbert and Eileen Edgar Foundation
The Eranda Foundation
Lucy Mary Ewing Charitable Trust
The Fenton Arts Trust
The Margery Fish Charity
The Flow Foundation
Gatsby Charitable Foundation
Goethe Institut London
The Golden Bottle Trust
The Great Britain Sasakawa Foundation

Sue Hammerson Charitable Trust
The Charles Hayward Foundation
The Hellenic Foundation
Heritage Lottery Fund
A D Hill 1985 Discretionary Settlement
The Harold Hyam Wingate Foundation
Institut fuer Auslandsbeziehungen e.V.
The Ironmongers' Company
The Japan Foundation
Stanley Thomas Johnson Foundation
The Emmanuel Kaye Foundation
The Kindersley Foundation
The Kobler Trust
The Lankelly Chase Foundation
Lapada Association of Art & Antique
 Dealers
Lark Trust
The David Lean Foundation
The Leche Trust
A G Leventis Foundation
The Leverhulme Trust
The Lynn Foundation
The Maccabaeans
The McCorquodale Charitable Trust
Mactaggart Third Fund
The Simon Marks Charitable Trust
The Paul Mellon Centre for Studies in
 British Art
The Paul Mellon Estate
The Mercers' Company
Margaret and Richard Merrell Foundation
The Millichope Foundation
The Henry Moore Foundation
The Mulberry Trust
The J Y Nelson Charitable Trust
Newby Trust Limited
OAK Foundation Denmark
The Old Broad Street Charity Trust
The Peacock Charitable Trust
The Pennycress Trust
PF Charitable Trust
The Stanley Picker Charitable Trust
The Pidem Fund
The Edith and Ferdinand Porjes Charitable
 Trust
The Fletcher Priest Trust
The Privy Purse Charitable Trust
Pro Helvetia
Mr and Mrs J A Pye's Charitable
 Settlement
The Radcliffe Trust
Rayne Foundation
T Rippon & Sons (Holdings) Ltd
The Rootstein Hopkins Foundation
The Rose Foundation
The Rothschild Foundation
Schroder Charity Trust
The Sellars Charitable Trust
The Archie Sherman Charitable Trust
The South Square Trust
Spencer Charitable Trust
Stanley Foundation Limited
Oliver Stanley Charitable Trust
The Steel Charitable Trust
Peter Storrs Trust
Strand Parishes Trust
The Joseph Strong Frazer Trust
The Swan Trust
Swiss Cultural Fund in Britain

Thaw Charitable Trust
Sir Jules Thorn Charitable Trust
Tiffany & Co
Tillotson Bradbery Charitable Trust
The Albert Van den Bergh Charitable Trust
The Bruce Wake Charity
Celia Walker Art Foundation
Warburg Pincus International LLC
The Wax Chandlers' Company
Weinstock Fund
The Garfield Weston Foundation
Wilkinson Eyre Architects
The Spencer Wills Trust
The Maurice Wohl Charitable Foundation
The Wolfson Foundation
The Hazel M Wood Charitable Trust
The Worshipful Company of Painter-
 Stainers
The Xander Foundation

AMERICAN ASSOCIATES OF THE ROYAL ACADEMY TRUST
Burlington House Trust
Mrs James C Slaughter

Benjamin West Society
Mr Francis Finlay
Mrs Deborah Loeb Brice
Mrs Nancy B Negley

Benefactors
Mrs Edmond J Safra
The Hon John C Whitehead

Sponsors
Mrs Drue Heinz HON DBE
David Hockney CH RA
Mr Arthur L Loeb
Mrs Lucy F McGrath
Mr and Mrs Hamish Maxwell
Diane A Nixon
Mr and Mrs Frederick B Whittemore

Patrons
Mr and Mrs Steven Ausnit
Mr Donald A Best
Mrs Mildred C Brinn
Mrs Benjamin Coates
Anne S Davidson
Ms Zita Davisson
Mr and Mrs Stanley De Forest Scott
Mrs June Dyson
Mr Jonathan Farkas
Mr and Mrs Lawrence S Friedland
Mr and Mrs Leslie Garfield
Ms Helen Harting Abell
Dr Bruce C Horten
The Hon W Eugene Johnston and Mrs
 Johnston
Mr William W Karatz
Mr and Mrs Wilson Nolen
Lady Renwick
Mr and Mrs Peter M Sacerdote
Mrs Mary Sharp Cronson
Mrs Frederick M Stafford
Ms Louisa Stude Sarofim
Ms Joan Stern
Martin J Sullivan OBE
Mr Arthur O Sulzberger and Ms Allison

S Cowles
Ms Britt Tidelius
Dr and Mrs Robert D Wickham
Mr Robert W Wilson

Donors
Mr James C Armstrong
Mr Constantin R Boden
Dr and Mrs Robert Bookchin
Mrs Edgar H Brenner
Mr and Mrs Philip Carroll
Laura Christman and William Rothacker
Mr Richard C Colyear
Mrs Beverley C Duer
Mr Robert H Enslow
Mr Ralph A Fields
Mrs Katherine D Findlay
Mr and Mrs Christopher Forbes
Mr and Mrs Gordon P Getty
Mr O D Harrison Jr
Mr and Mrs Gustave M Hauser
Mrs Judith Heath
Ms Elaine Kend
Mr and Mrs Gary Kraut
The Hon Samuel K Lessey Jr
Annette Lester
Ms Clare E McKeon
Ms Christine Mainwaring-Samwell
Ms Barbara T Missett
The Hon William Nitze and Mrs Nitze
Mrs Charles W Olson III
Cynthia Hazen Polsky and Leon B Polsky
Mrs Patsy Preston
Mrs Martin Slifka
Mr and Mrs Albert H Small
Mrs Judith Villard
Mr and Mrs William B Warren

Corporate and Foundation Support
Annenberg Foundation
Bechtel Foundation
The Blackstone Charitable Foundation
The Brown Foundation
Fortnum & Mason
Gibson, Dunn & Crutcher
The Horace W Goldsmith Foundation
Hauser Foundation
Leon Levy Foundation
Loeb Foundation
Henry Luce Foundation
Lynberg & Watkins
Sony Corporation of America
Starr Foundation
Thaw Charitable Trust

CORPORATE MEMBERS OF THE ROYAL ACADEMY
Launched in 1988, the Royal Academy's
Corporate Membership Scheme has
proved highly successful. Corporate
membership offers benefits for staff,
clients and community partners and access
to the Academy's facilities and resources.
The outstanding support we receive from
companies via the scheme is vital to the
continuing success of the Academy and
we thank all members for their valuable
support and continued enthusiasm.

Premier Level Members
A T Kearney Limited
The Arts Club
Barclays plc
BNY Mellon
CB Richard Ellis
Deutsche Bank AG
FTI Consulting
GlaxoSmithKline plc
Goldman Sachs International
Hay Group
Insight Investment
JTI
King Sturge LLP
KPMG
LECG Ltd
Lombard Odier Darier Hentsch
Schroders plc
Smith and Williamson

Corporate Members
All Nippon Airways
Aon
Apax Partners LLP
AXA Insurance
BNP Paribas
The Boston Consulting Group
Bovis Lend Lease Limited
British American Business Inc.
British American Tobacco
Calyon
Canon Europe
Capital International Limited
Christie's
Clifford Chance LLP
Concateno Plc
Control Risks
The Economist
Ernst & Young LLP
ExxonMobil
F & C Asset Management plc
GAM
Heidrick & Struggles
Jefferies International
John Lewis Partnership
JP Morgan
Lazard
Louis Vuitton
Man Group plc
Mizuho International plc
Momart Limited
Morgan Stanley
Nedrailways
Northern Trust
Novo Nordisk
Pentland Group plc
Rio Tinto
The Royal Bank of Scotland
The Royal Society of Chemistry
Slaughter and May
Société Générale
Timothy Sammons Fine Art Agents
Trowers & Hamlins
Veredus Executive Resourcing
Vision Capital
Weil, Gotshal & Manges

SPONSORS OF PAST EXHIBITIONS
The President and Council of the Royal
Academy would like to thank the
following sponsors and benefactors
for their generous support of major
exhibitions in the last ten years:
2010
Sargent and the Sea
 2009–2013 Season supported by JTI
 Hazlitt, Gooden & Fox
 Lowell Libson Ltd
242nd Summer Exhibition
 Insight Investment
*Paul Sandby RA (1731–1809): Picturing
Britain, a Bicentenary Exhibition*
 2009–2013 Season supported by JTI
*The Real Van Gogh: The Artist and His
Letters*
 BNY Mellon
 Heath Lambert
 Hiscox
 Travel Partner: Cox & Kings

2009
GSK Contemporary
 GlaxoSmithKline
Wild Thing: Epstein, Gaudier-Brzeska, Gill
 2009–2013 Season supported by JTI
 BNP Paribas
 The Henry Moore Foundation
Anish Kapoor
 JTI
 Richard Chang
 Richard and Victoria Sharp
 Louis Vuitton
 The Henry Moore Foundation
*J. W. Waterhouse: The Modern Pre-
Raphaelite*
 2009–2013 Season supported by JTI
 Champagne Perrier-Jouët
 GasTerra
 Gasunie
241st Summer Exhibition
 Insight Investment
*Kuniyoshi. From the Arthur R. Miller
Collection*
 2009–2013 Season supported by JTI
 Canon
 Travel partner: Cox & Kings
Premiums and RA Schools Show
 Mizuho International plc
RA Outreach Programme
 Deutsche Bank AG

2008
GSK Contemporary
 GlaxoSmithKline
Byzantium 330–1453
 J. F. Costopoulos Foundation
 A. G. Leventis Foundation
 Stavros Niarchos Foundation
 Travel Partner: Cox & Kings
*Miró, Calder, Giacometti, Braque: Aimé
Maeght and His Artists*
 BNP Paribas
*Vilhelm Hammershøi: The Poetry of
Silence*
 OAK Foundation Denmark
 Novo Nordisk

240th Summer Exhibition
 Insight Investment
Premiums and RA Schools Show
 Mizuho International plc
RA Outreach Programme
 Deutsche Bank AG
*From Russia: French and Russian Master
Paintings 1870–1925 from Moscow and
St Petersburg*
 E.ON
2008 Season supported by Sotheby's

2007
*Paul Mellon's Legacy: A Passion for British
Art*
 The Bank of New York Mellon
Georg Baselitz
 Eurohypo AG
239th Summer Exhibition
 Insight Investment
Impressionists by the Sea
 Farrow & Ball
Premiums and RA Schools Show
 Mizuho International plc
RA Outreach Programme
 Deutsche Bank AG
The Unknown Monet
 Bank of America

2006
238th Summer Exhibition
 Insight Investment
Chola: Sacred Bronzes of Southern India
 Travel Partner: Cox & Kings
Premiums and RA Schools Show
 Mizuho International plc
RA Outreach Programme
 Deutsche Bank AG
Rodin
 Ernst & Young

2005
China: The Three Emperors, 1662–1795
 Goldman Sachs International
*Impressionism Abroad: Boston and French
Painting*
 Fidelity Foundation
*Matisse, His Art and His Textiles: The Fabric
of Dreams*
 Farrow & Ball
Premiums and RA Schools Show
 The Guardian
 Mizuho International plc
*Turks: A Journey of a Thousand Years,
600–1600*
 Akkök Group of Companies
 Aygaz
 Corus
 Garanti Bank
 Lassa Tyres

2004
236th Summer Exhibition
 A T Kearney
*Ancient Art to Post-Impressionism:
Masterpieces from the Ny Carlsberg
Glyptotek, Copenhagen*
 Carlsberg UK Ltd
 Danske Bank

Novo Nordisk
The Art of Philip Guston (1913–1980)
 American Associates of the Royal
 Academy Trust
The Art of William Nicholson
 RA Exhibition Patrons Group
*Vuillard: From Post-Impressionist to
Modern Master*
 RA Exhibition Patrons Group

2003
235th Summer Exhibition
 A T Kearney
*Ernst Ludwig Kirchner: The Dresden and
Berlin Years*
 RA Exhibition Patrons Group
Giorgio Armani: A Retrospective
 American Express
 Mercedes-Benz
*Illuminating the Renaissance: The
Triumph of Flemish Manuscript Painting
in Europe*
 American Associates of the Royal
 Academy Trust
 Virginia and Simon Robertson
Masterpieces from Dresden
 ABN AMRO
 Classic FM
Premiums and RA Schools Show
 Walker Morris
*Pre-Raphaelite and Other Masters:
The Andrew Lloyd Webber Collection*
 Christie's
 Classic FM
 UBS Wealth Management

2002
234th Summer Exhibition
 A T Kearney
Aztecs
 British American Tobacco
 Mexico Tourism Board
 Pemex
 Virginia and Simon Robertson
*Masters of Colour: Derain to Kandinsky.
Masterpieces from The Merzbacher
Collection*
 Classic FM
Premiums and RA Schools Show
 Debenhams Retail plc
*RA Outreach Programme**
 Yakult UK Ltd
*Return of the Buddha:
The Qingzhou Discoveries*
 RA Exhibition Patrons Group

2001
233rd Summer Exhibition
 A T Kearney
*Botticelli's Dante: The Drawings for
Dante's Divine Comedy*
 RA Exhibition Patrons Group
*The Dawn of the Floating World
(1650–1765). Early Ukiyo-e Treasures from
the Museum of Fine Arts, Boston*
 Fidelity Foundation
*Forty Years in Print: The Curwen Studio
and Royal Academicians*
 Game International Limited

*Frank Auerbach, Paintings and Drawings
1954–2001*
 International Asset Management
*Ingres to Matisse: Masterpieces of French
Painting*
 Barclays
Paris: Capital of the Arts 1900–1968
 BBC Radio 3
 Merrill Lynch
Premiums and RA Schools Show
 Debenhams Retail plc
*RA Outreach Programme**
 Yakult UK Ltd
Rembrandt's Women
 Reed Elsevier plc

* Recipients of a Pairing Scheme Award,
managed by Arts + Business. Arts +
Business is funded by he Arts Council of
England and the Department for Culture,
Media and Sport

OTHER SPONSORS
Sponsors of events, publications and other
items in the past five years:

Carlisle Group plc
Castello di Reschio
Cecilia Chan
Country Life
Guy Dawson
Derwent Valley Holdings plc
Dresdner Kleinwort Wasserstein
Lucy Flemming McGrath
Fosters and Partners
Helena Frost
Goldman Sachs International
Gome International
Gucci Group
Hazlitt, Gooden & Fox
Hines
IBJ International plc
John Doyle Construction
Harvey and Allison McGrath
Martin Krajewski
Marks & Spencer
Michael Hopkins & Partners
Morgan Stanley Dean Witter
The National Trust
Prada
Radisson Edwardian Hotels
Richard and Ruth Rogers
Rob van Helden
Warburg Pincus
The Wine Studio

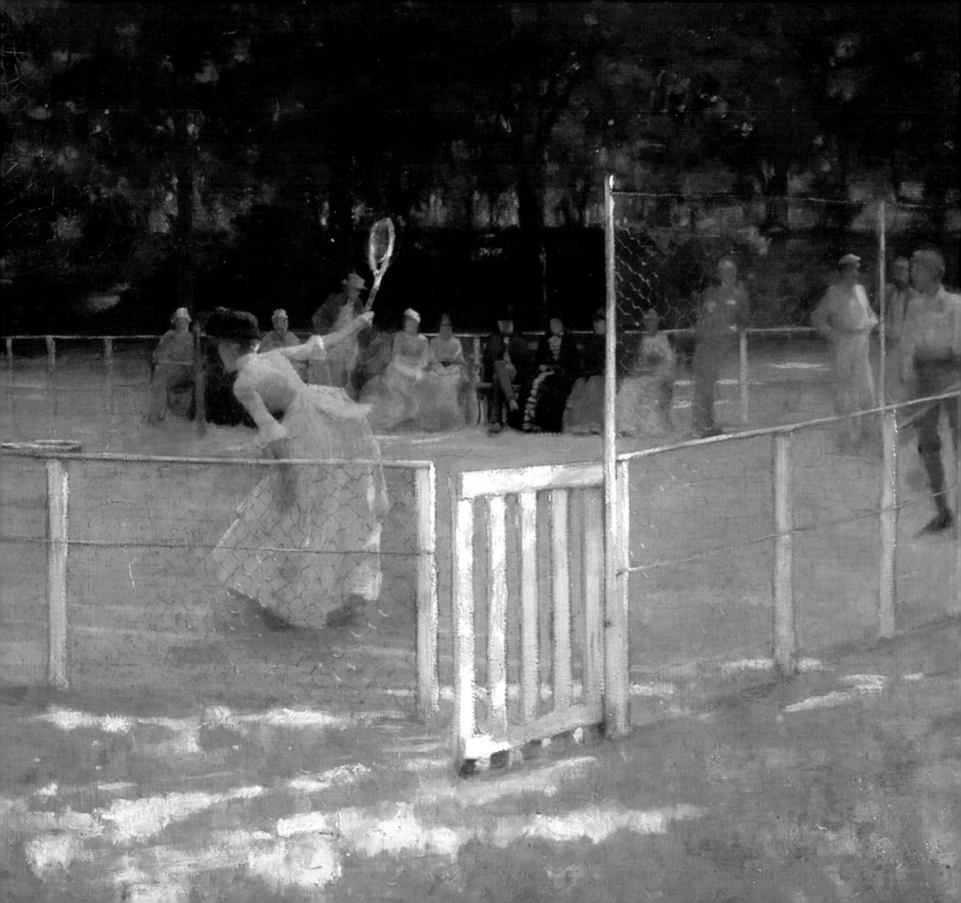